The Complete Guide to Becoming a Bett

Drawing Manga

Tell Exciting Stories with Amazing Characters and Skillful Compositions

Naoto Date
Kiyoshi Nitou

TUTTLE Publishing

Tokyo | Rutland, Vermont | Singapore

Contents

Why We Wrote This Book

Learn How to Improve Your Drawing Skills!

How can you improve? What can you do to lift the level of your illustrations if you don't know how exactly? Practice makes perfect, but sometimes a little guidance is needed along the way.

In this book, I talk about the most common problems young artists face when drawing, based on students I have taught as well as my own experiences. I also focus on issues that a lot of people are pondering, such as the ways in which we think about practice and what it means for our drawings to progress and improve.

Stress and painful effort are totally unnecessary. People who can draw well do not think of effort as effort; they just have fun drawing what they like, and don't think of it as effort at all. You, too, should draw what you like in the way you want to. And if you hit a hurdle with your drawing, if you're stuck—do something else instead. You can go see a movie, read a book, go to a museum, or just gaze at the sky. Having fun talking to your friends is good too.

Activities that might seem unrelated to art at first glance can become the energy you need to improve. And most importantly, your drawing only improves when you feel like you want to draw. So wait patiently until the moment comes when you want to draw, and when that moment comes, try reading this book.

I'm sure you'll find the answers to the questions that are bothering you in here. Now, let's get started!

—Naoto Date

Learn How to Improve Your Use of Composition!

If you want to make creating art your profession, you must acquire both drawing and production skills.

As long as you keep drawing, you can acquire the ability to draw well and use that as a springboard—a point of departure to acquire other skills and creative avenues that might lead to a professional career or a lifelong hobby and joy.

Production skills are required for illustrations when you need to apply your work to different mediums or assignments. Or inspiration. Production skills are learned by looking rather than doing as opposed to drawing skills. You learn to "look" even in environments where you cannot draw them, it's possible to absorb these skills in an unlimited way.

As you look at pictures or movies, manga, photographs, advertisements or objects that you like, ask yourself "Why does this appeal to me?" "Why do I feel that this is beautiful?" Break it down and unravel it. If you can use the Composition sections of this book to help you out in that regard, I'll be happy.

Even if you don't have this book around, I want you to keep your eyes peeled, to always be on the lookout—watching, observing, and analyzing, nurturing your eye for composition.

—Kiyoshi Nitou

How to Use This Book

This is an instruction book for people who want to improve and expand their abilities, for those who can draw but want to make their illustrations more attractive.

Each section starts with a question. The answers to this and tips are explained on the page.

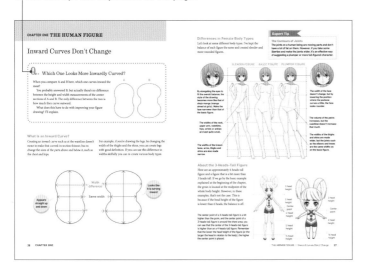

Here we explain what we corrected to achieve the after result.

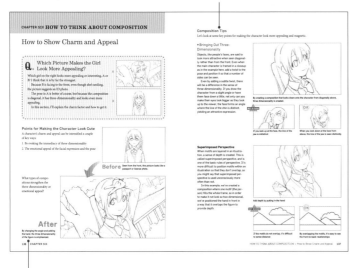

An explanation of the before-and-after process, integrating the tips and suggestions.

Getting Started

In this section, we break down what you can do to improve your illustrations.

Figure Drawing Sections

CHAPTER 1 The Human Figure
CHAPTER 2 How to Draw the Face
CHAPTER 3 How to Draw the Body
CHAPTER 4 How to Draw Clothing

In this section, we explain how to draw the figure more effectively. Since we have divided it up by body part, you can start reading about the part that is your weak point first.

Composition Sections

CHAPTER 5 How to Think About Poses
CHAPTER 6 How to Think About Composition
CHAPTER 7 How to Express Relationships
CHAPTER 8 Compositions to Avoid

In this section, we break down the impressions given by poses or compositional choices. In the Poses chapter, we explain the tips for poses that depict a sense of energy, quiet, strength and so on. In the Composition category, we share tips for adjusting the examples to more closely jibe with the impression you're trying to make.

Getting Started

Let's start with the basics: what should you be targeting first in order to improve your illustrations?

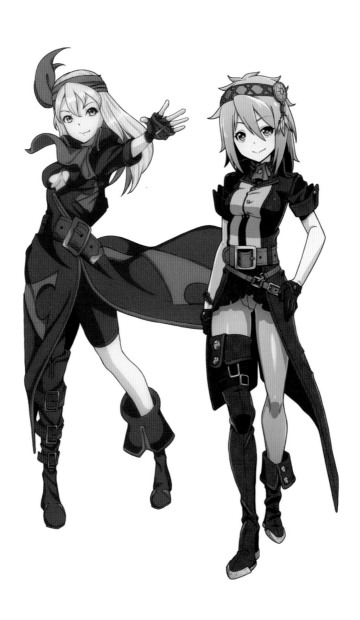

How Can You Improve as an Artist?

BY NAOTO DATE

What does croquis mean and how can it help me?

Croquis is a French term meaning a quick sketch of a live model. Intended to be done in a few lines or with a few broad strokes, it's often a silhouette. Some artists call it a study, a preliminary sketch that can be used as the foundation for another work, such as a painting, or can stand on its own.

What Is Figure Drawing?

Drawing from a live model or from images of the human body are essential steps in every artist's development.

It's likely that most people think that the objective of figure drawing is to solely improves one's drawing abilities. But that's just one of its aspects.

The process helps train and conditions the artist's eye, enhancing and embelling the illustrator's basic ability to "see."

The fact is, drawing isn't learned solely by the hand. It's also learned through the eyes.

The ability to look at a drawing and instantly recognize the configuration of lines comprising it, or measure the balance appropriately, or correct the lines drawn…

When you're drawing a figure, you must prioritize seeing over drawing. By doing so, you're acquiring the the power of observation and the fluency and skill needed to create a variety of memorable characters.

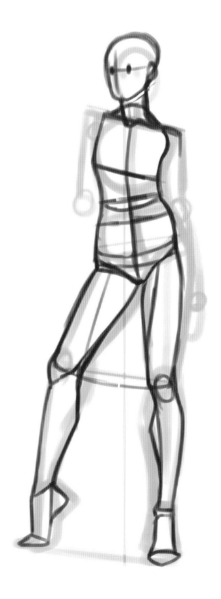

What Is a Copy?

Next, let's talk about copies and originals.

Copying is a way of borrowing the knowledge and experience of those who came before us. What did experienced artists choose based on the skills they acquired as part of their own drawing practice?

The important thing is to make note of what they left on the page or the screen and what they discarded.

Some of you might think that it's easier to just create copies of other's work rather than learning the fundamentals of figure drawing. But that's when potential problems arise.

If you only copy, you won't understand what elements and details previous artists omitted. So then you might not understand or note what they intentionally left in either.

That's why you need to practice figure drawing. By comparing it with the information about the composition of the human figure that you acquired by figure drawing, you'll be able to understand what our predecessors decided to keep and discard.

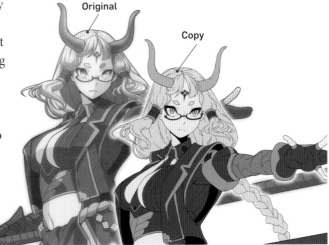

Original

Copy

What Is an Original?

So then, an original is the result of learning about our predecessors' choices and omissions by copying others' pictures, applying the knowledge we've acquired through figure drawing and coming up with our own unique vision and version of reality.

The important thing here is that originals are never created from scratch. They're the combination of various inspirations. As you work through your drafts and revisions, you own style emerges from the range of influences you've been exposed to.

What Is a Drawing?

Finally we return to croquis drawing. Croquis drawing is a great way to speed up your improvement and development and to increase the fluency of your lines and renderings.

It's an easy progressions. The silhouette is set down, then the features are quickly added in. In 30 seconds, a figure emerges on the page or screen. A shadow figure who will potentially take on life, grow and develop into a signature character of your own creation.

What Is Needed to Improve Your Art?

When we have come this far, you will know the answer to the question we asked at the start: "Of figure drawing, copying and croquis drawing, what is necessary and what is unnecessary".

You're right, they are "all necessary".

The factions that are talked about on the internet such as the figure drawing faction, the copying faction, and the croquis drawing faction are all meaningless; they all come together to form one purpose.

Let's say for example that you have secured 60 minutes to practice every day. And let's say that you have become able to finish a practice drawing within that 60 minutes every time.

If you can practice croquis drawing which makes you able to finish that same drawing in 30 minutes instead of 60 minutes, you'll be able to complete 2 drawings in that allotted 60 minutes, so you will grow at twice the speed, right?

In this manner, you grow as an artist by learning various elements. So to the question, "What is needed to improve your art?", everyone who came before you and writes in books or on the internet can only tell you "The only thing is to draw".

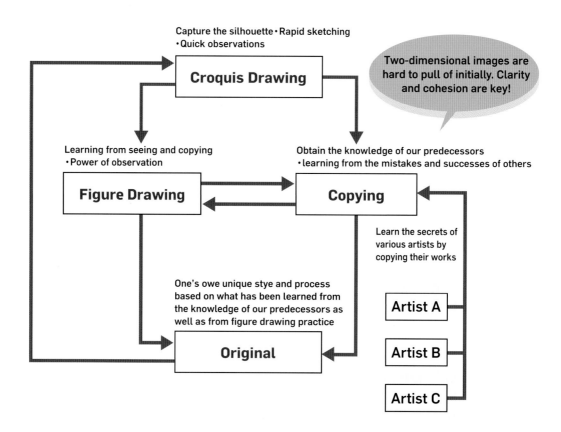

Capture the silhouette · Rapid sketching · Quick observations

Croquis Drawing

Two-dimensional images are hard to pull of initially. Clarity and cohesion are key!

Learning from seeing and copying · Power of observation

Figure Drawing

Obtain the knowledge of our predecessors · learning from the mistakes and successes of others

Copying

Learn the secrets of various artists by copying their works

One's owe unique stye and process based on what has been learned from the knowledge of our predecessors as well as from figure drawing practice

Original

Artist A

Artist B

Artist C

What's Your Personal Process?

BY NAOTO DATE

Keep the Process in Mind

Now let's talk about what we can actually do to grow and improve as artists. First of all, there's an awareness or an understanding I want you to keep in the forefront of your mind as you're drawing.

Always be aware of the process of observation and its various components: hypothesis, experimentation and consideration.

The power of figure drawing lies in the power of observation. Figure drawing forms the basis of every thing from copying predecessors to croquis drawing to creating originals. In other words, without the power of observation, you have no point of origin and no artistic trajectory to follow.

This process of observation, hypothesis, experimentation and consideration is important when figure drawing, so let's take a closer look at these elements step by step.

Figure Drawing = The Power of Observation

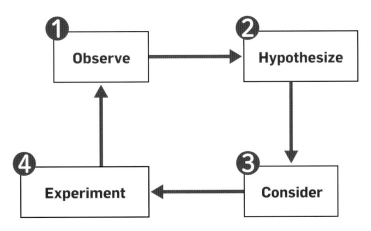

Input and Output

Input is observation, conversion is hypothesizing and output is experimentation plus consideration.

Some artists face difficulties or fail to grow because this critical conversion step isn't being executed. By conversion, I'm talking about the work of combining the knowledge, observation, practice and technical skills.

Knowledge and technical skills are useless without the power of observation and transformation. The techniques and tricks acquired along the way might just pass through without being absorbed at all.

In other words, to convert means "to be aware". By observing what it is that you are trying to absorb now, and in what scenarios you can use it, and then creating your hypotheses, you will become aware. Then put your questions and queries, your goals and hypotheses to the test through a considered process of revision and refinement. It's then, when you're solving the problems directly on the page or on-screen, that your own unique solutions emerge. You take risks, you experiment with new techniques and approaches. Most of all, you grow as an artist and the fluency you're aquired is evident in your cohesive images and compelling illustrations.

The Difference Between People Who Can Grow and Those Who Can't

In order to grow as an artist, there are basically just two steps:

Stage 1: Become aware of things you'd not aware of

Stage 2: By becoming aware of it, make it an instinctive part of your practice

Experienced artists and illustrators aren't concentrating on the result for most of the time they're drawing. This is Stage 2, where they're able to sketch instinctively.

Let's make use a wizard in a role-playing game (RPG) as an analogy.

2 There are various levels to knowledge and proficiency. With Level 1 Knowledge and Level 1 Proficiency, you can execute Level 1 Magic. And by executing that magic repeatedly, you can master Level 1 Magic.

1 If we think of drawing skills as magic, knowledge and proficiency (training) are required. Knowledge of magical spells is not enough if it's not coupled with an awareness of how and when to use them. In drawing terms, training means figure drawing and copying.

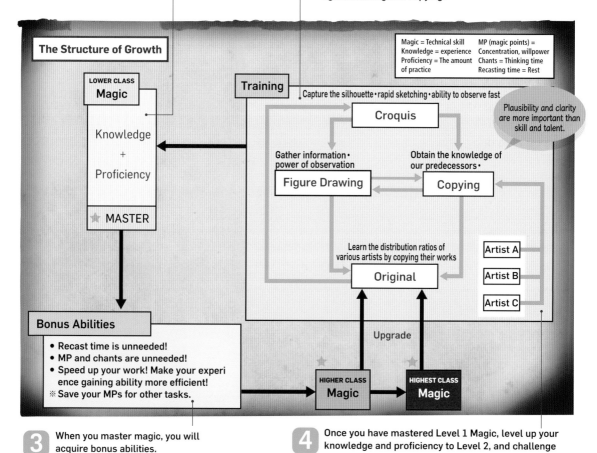

3 When you master magic, you will acquire bonus abilities.

4 Once you have mastered Level 1 Magic, level up your knowledge and proficiency to Level 2, and challenge yourself to master Level 2 Magic. In drawing terms, that means training yourself by drawing and copying.

To use magic, you need MP (magic points) and chanting time, right?

If we think of MP as concentration or willpower, and chanting time as practice and training, a newbie wizard must use their meager allotments to make their magic work.

After casting a spell, they also need time to rest,

assess and reconsider.

After mastering magic, as a bonus ability, magical powers, chanting time and consideration time all become totally unnecessary. On top of that, you'll gain experience more efficiently and speed up the rate at which you work your magic.

People who can draw, or in other words upper-

level wizards, are simply those who can work all kinds of magic without the need for MP, chanting time or reconsideration and assessment.

The reason why skilled artists can draw while live casting or while watching television is because like upper-level wizards, they aren't wasting their powers of concentration or expending any unnecessary efforts.

Instead they're using their leftover energy and amassing power to conjure higher levels of magic.

How Do You Assess and Improve Your Drawing Skills?

To put it simply, you don't need any "talent" at all in order to be able to draw.

Or to put it another way, the talent that you may think you need and the actual skills and abilities required are totally different things.

I am often asked, "What is required in order to becoming good at drawing?" I ask the following:
1) Can your manga drawings be recognized as people?
2) Can you sit and draw for a long period of time?
3) Is there anything you particularly want to draw? If you can reply "Yes" to all of the above, then you have the talent to draw.

The biggest obstacle maybe be the second point. In order for you to become good at drawing, a huge amount of time is required, so the problem becomes whether you can find and devote the time needed.

This can be overcome by making it a habit or regular practice. For example, if you can draw every day for an hour or even 30 minutes, write down the time and what you did on a sticky note and stick it up on the wall—in about 4 months, your drawing abilities will vastly improve. This is a method that one of my students used successfully and why I'm passing it along to you.

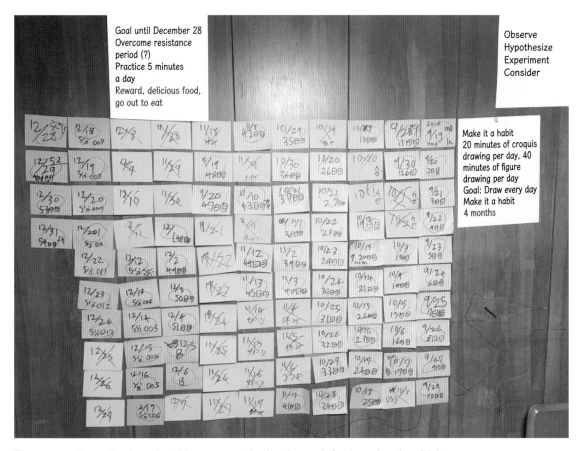

The orange notes are for days when this person practiced, and green is for days when they didn't. By differentiating the colors, it's easy to see what you did.

What's Wrong with This Picture?

The illustration below is an example of one that may look like it's drawn properly, but it lacks appeal. Can you tell what you need to be corrected? As you read through this book, you'll be able to see what needs to be rectified. So let's look at the points that need fixing.

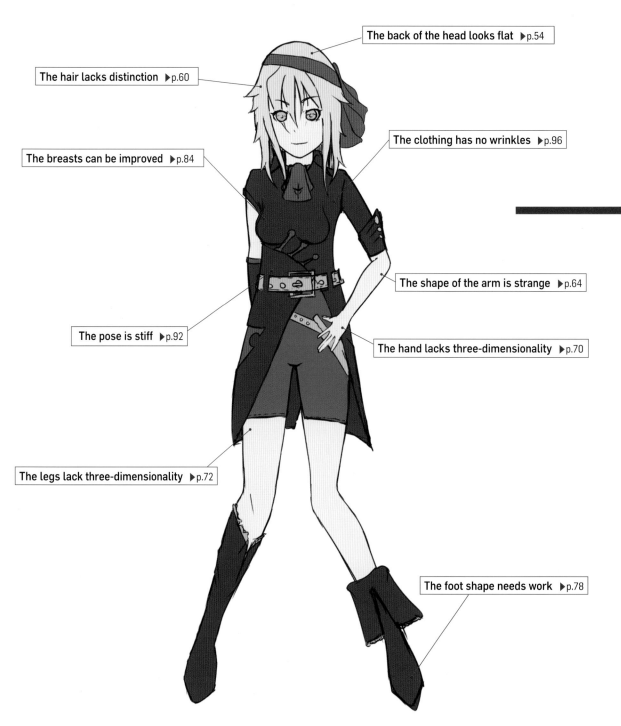

The back of the head looks flat ▶p.54

The hair lacks distinction ▶p.60

The clothing has no wrinkles ▶p.96

The breasts can be improved ▶p.84

The shape of the arm is strange ▶p.64

The pose is stiff ▶p.92

The hand lacks three-dimensionality ▶p.70

The legs lack three-dimensionality ▶p.72

The foot shape needs work ▶p.78

This book is packed with hints throughout. Use the tips and suggestions and note your improvement. Skip around, if you want, targeting the topics that most address your needs.

A CORRECTED EXAMPLE

I've tried correcting the points raised in the illustration on the previous page. I think it's a much more attractive illustration now.

A VARIATION EXAMPLE

This is an example of a further variation I made from the corrected example. In order to make the silhouette easier to see, I've made the upper garment asymmetrical. I've increased the color in the clothing, and added more accessories and wrinkles to the garments.

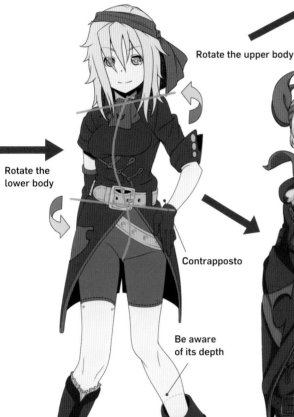

Rotate the upper body

Rotate the lower body

Contrapposto

Be aware of its depth

Shift to the back

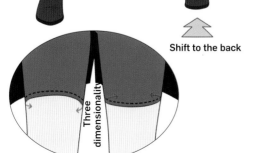

Three dimensionality

GOOD POINTS

The upper body is drawn from a lower angle

The lower body is drawn from an upper angle/overhead view

The positioning of the legs and arms

Three dimensionality

Awareness of depth

Contrapposto

The balance of the silhouette

CORRECTIONS MADE BY THE STUDENT

This is a corrected illustration drawn by the same student tho drew the one on Page 14. You can see that the problematic points have been firmly corrected and that they have improved, right?

To Create Attractive Illustrations, Let's Learn about Composition

BY KIYOSHI NITO

Directing Your Designs

Composition is a method of directing your pictures, and by using it skillfully you can increase the strength and narrative quality of your illustrations. However, just because you're able to create a good sketch doesn't mean that will lead to a successful manga illustrations. If you keep in mind that composition is just one element that supports the illustration, and not its essence, you can avoid a trap or obstacle where you're bound by the compositional scheme or approach and cannot successfully proceed with your drawing.

There are various composition patterns that give different impressions, such as ones that make an object look bigger or three-dimensional or give it movement.

Think of the content of the picture that you want to emphasize and what you want to omit. Then combine this with a composition that fits the impression you want to make to create a scene that people can easily relate to, and remember!

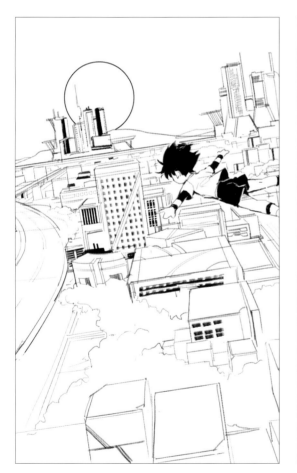

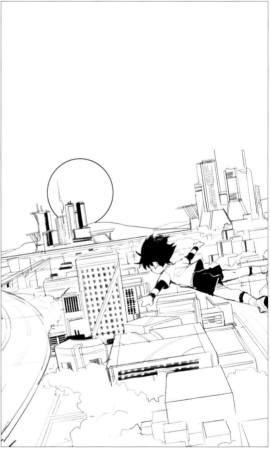

Even if it's the same picture, the theme and mood change depending on how it's framed, cropped and presented.

What Is Direction?

The direction of your illustration allows you to identify and focus on its key and defining elements. The shape of objects change according to the illustration's needs, and the viewer is guided effectively toward the theme and general impression you want to convey.

For example, if you're involved in the design direction of a cute stuffed animal, for the main motif (a cute and charming plush toy that resembles an actual animal), you can exaggerate the roundness of the design and embellish its softness and texture to achieve the desired results in an accessible way.

In the same way, if you're drawing an androgynous, cool male character, you can exaggerate his features, and alter his bone structure to capture his slick vibe. I think that direction has the purpose of breaking down the heart of the work you're creating into easy-to-understand bites, and heightening the experience when the work is complete and received by viewers.

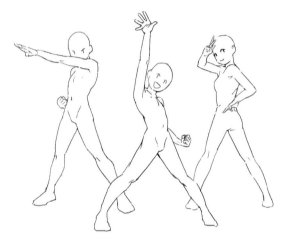

Exaggerated versions of the extended, wide-stance poses struck by transforming heroes and battle heroines.

Directing the pose to reveal a tranforming hero or heroine

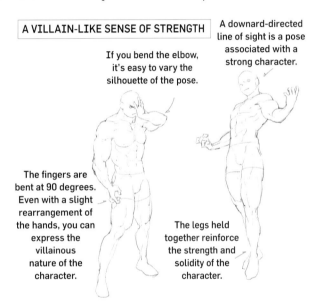

A VILLAIN-LIKE SENSE OF STRENGTH

A downard-directed line of sight is a pose associated with a strong character.

If you bend the elbow, it's easy to vary the silhouette of the pose.

The fingers are bent at 90 degrees. Even with a slight rearrangement of the hands, you can express the villainous nature of the character.

The legs held together reinforce the strength and solidity of the character.

Directing the personality of the character through the line of sight and the movement of his hands

Things to Consider with Compositions

Various compositions are explained in this book, and although it's a good idea to match your content, characters and narrative with the right compositional scheme, don't forget that the real objective is not to show a pretty picture that fits a certain composition.

It's important to add something to the compositional scheme, to shift it or break it up, or to not think about the composition at all when you're at the stage of roughing out your idea. No matter what, don't get too caught up in the composition when you're drawing.

Look at the Patterns of Compositions

In the Composition section (starting on page 109), I've tried fitting certain direction goals into the compositional patterns, so try using the ones you like after you've absorbed their various differences.

It's not a question of thinking there's only one compositional structure and then setting out to find it. I've written this Composition section with the understanding that these are the formulas and tools you'll apply to a variety of illustration settings and challenges. No one solution prevails.

Even if the composition initially looks wrong, you can fix things by changing the color, shape or perpective. I hope that you'll keep on using compositions experimentally as you forge your way forward to finding your own style.

What Is a Slump?

A lot of people have probably experienced falling into slumps while drawing, right?

I like to explain it to my students and clients in terms of wizards and wizardry to explain the gap created by a difference between the level of knowledge and the level of experience and proficiency an illustrator brings to the page of the screen.

Let's say that a certain wizard has Level 3 magic knowledge. Magic can be fully used when knowledge and proficiency are at the same level, but this wizard only had Level 3 knowledge and Level 2 proficiency. So although they can only use Level 2 magic, they have Level 3 knowledge of it. And this wizard mistakenly believes that they can use Level 3 magic.

But however much they try, they can only cast Level 2 magic spells, right?

When that happens, the wizard thinks "My Level 3 magic is weak, weaker than that of other people. Although my level of knowledge is high and I can see where my proficiency lacks, I don't know what to do about it."

So in this situation, the way to forge ahead, to escape the slump is to increase your proficiency. In the most simplistic directive, the problem is solved if you keep doing figure drawings. Your technical skills can only improve through this practice.

In contrast, when your proficiency level is higher than your knowledge level, you should consult technical manuals like this one. Seek out refence material online and in old-school books to learn from your predecessors.

You'll absorb the elements and style points you're most taken with, as your illustrations take on greater depth and complexity .

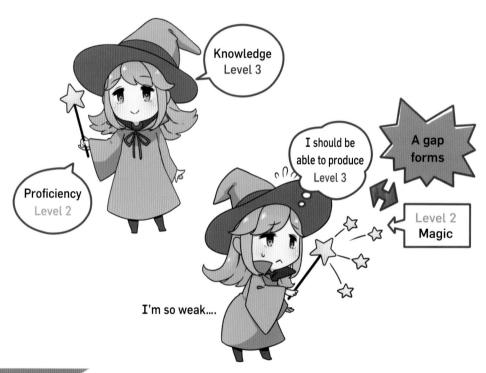

Expert Tip

Breaking Bad Artistic Habits

For some people who don't grow or improve as artists, they start and continue to draw out of habit. Or they fail to closely observe the world around them.

Do a figure drawing off the top of your head. Now do another after observing an actual person (or object). Which one is better?

If such a big difference occurs just by being aware of what you're drawing, pay attention to other areas where your artistry can be improved. Good practice replaces bad habits as your skill and fluency grow.

Figure Drawing

In this section, I'll explain the overall balance needed when drawing the human figure, as well as how to draw individual parts such as the eyes and mouth. You can read it straight through, or just focus on the areas that are your weak points.

BY NAOTO DATE

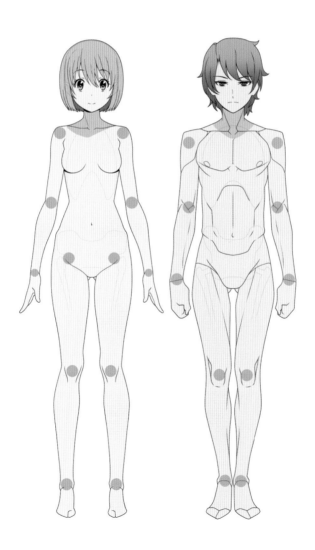

Body Proportions

Q. Which Is More Balanced?

We'll start by explaining the basic proportions of the human figure, with A and B, which figure looks better balanced to you?

Actually, both are bad examples where the balances of the figures are off.

A has long hands, which look even longer because the position of the hips is high. On the other hand B had short hands and low hips, so even though the waist is contoured the body looks as if it's straight up and down.

Let's look at what the basic balance of the human figure looks like.

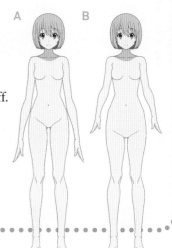

The Basic Rule of Head Height

Let's start by explaining the often used 5.5 to 8 head height proportions. 5.5 to 8 head tall proportions can all be drawn in the same way.

Here I will explain using a 6.5 head tall proportion as the example. Memorize this basic balance.

Expert Tip

Be aware that if your figure is 2 heads tall or 3 heads tall or more, and doesn't fit within the 5.5 to 8 head height proportions you can't use this balance.

1 Draw the head

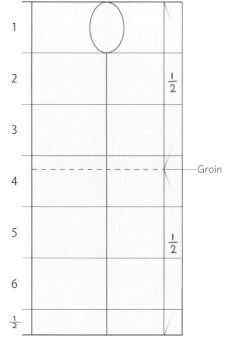

The groin is the center point of the height of the figure.

2 Draw the torso

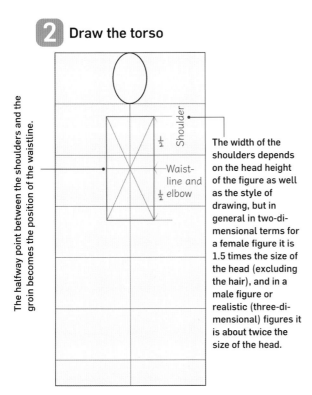

Shoulder

½ Waist-line and **¼** elbow

The halfway point between the shoulders and the groin becomes the position of the waistline.

The width of the shoulders depends on the head height of the figure as well as the style of drawing, but in general in two-dimensional terms for a female figure it is 1.5 times the size of the head (excluding the hair), and in a male figure or realistic (three-dimensional) figures it is about twice the size of the head.

Be aware of the length of the neck and draw the shoulders a bit lower than the bottom of the head.

3 Draw the waistline

Make the waistline about the same width as the head.

4 Draw the arms

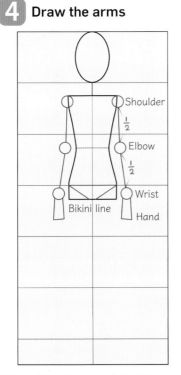

Shoulder

½

Elbow

½

Wrist

Bikini line

Hand

The waistline and the elbows are at about the same position. The wrist is at the same position as the groin, and the lengths of the shoulder to the elbow and the elbow to the wrist are the same.

5 Draw the legs

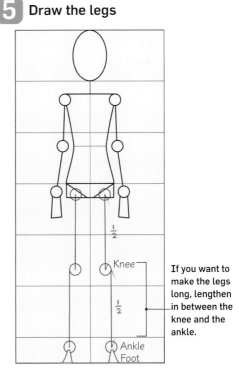

½

Knee

½

Ankle
Foot

If you want to make the legs long, lengthen in between the knee and the ankle.

The halfway point between the joint of the femur and the ankle is where the knee is positioned. (The thigh and the calf are basically the same length.)

The Difference Between a 6-Heads-Tall Figure and a 6.5-Heads-Tall Figure

Now let's try drawing an actual figure.

Here I'll explain the often used 6-heads-tall figure and the 6.5-heads-tall figure. The ways the positions of the shoulders are drawn differ between the two sizes so be aware of the subtle differences.

Instructions for drawing the detailed parts will follow in each appropriate section.

◆ How to draw a 6-heads-tall figure

The balance is the same for male or female figures.

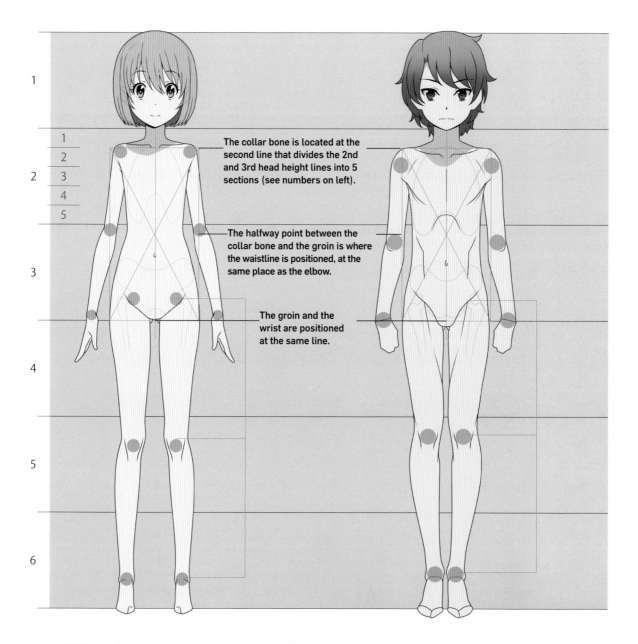

The collar bone is located at the second line that divides the 2nd and 3rd head height lines into 5 sections (see numbers on left).

The halfway point between the collar bone and the groin is where the waistline is positioned, at the same place as the elbow.

The groin and the wrist are positioned at the same line.

◆ How to draw a 6.5-heads-tall figure

Now for a slight but significant enlargement.

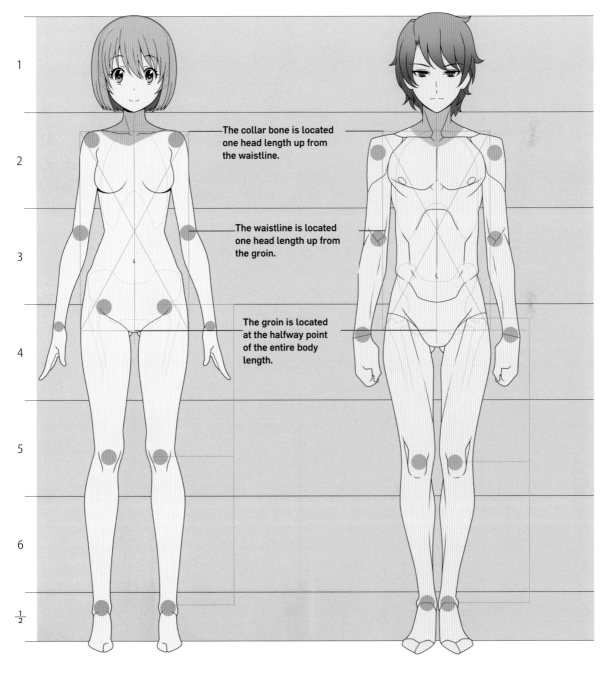

The collar bone is located one head length up from the waistline.

The waistline is located one head length up from the groin.

The groin is located at the halfway point of the entire body length.

How to Draw the Figure from Other Directions

Let's look at the side view of the 6.5-heads-tall figure. Even when you're looking at it in profile or diagonally, the proportions don't change, so be aware of the balance when looking at the figure from the front as you decide on the positions of each part.

♦ Side view

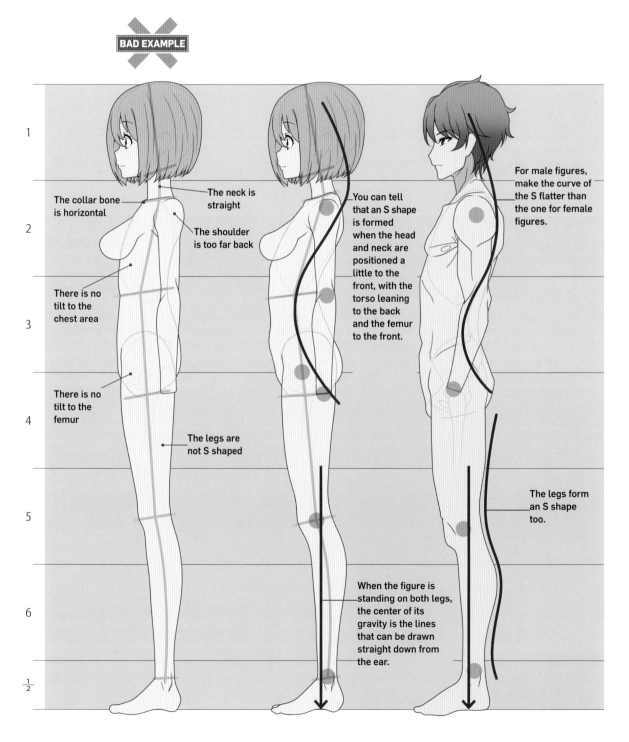

BAD EXAMPLE

The collar bone is horizontal

The neck is straight

The shoulder is too far back

There is no tilt to the chest area

There is no tilt to the femur

The legs are not S shaped

You can tell that an S shape is formed when the head and neck are positioned a little to the front, with the torso leaning to the back and the femur to the front.

When the figure is standing on both legs, the center of its gravity is the lines that can be drawn straight down from the ear.

For male figures, make the curve of the S flatter than the one for female figures.

The legs form an S shape too.

◆Diagonal View

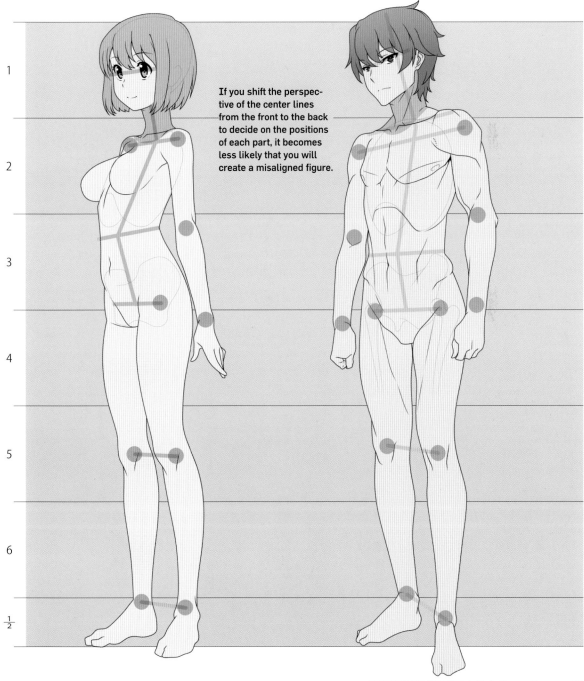

If you shift the perspective of the center lines from the front to the back to decide on the positions of each part, it becomes less likely that you will create a misaligned figure.

Inward Curves Don't Change

Q. Which One Looks More Inwardly Curved?

When you compare A and B here, which one curves inward the most?

You probably answered B, but actually there's no difference between the height and width measurements of the center sections of A and B. The only difference between the two is how much they curve outward.

What does this have to do with improving your figure drawing? I'll explain.

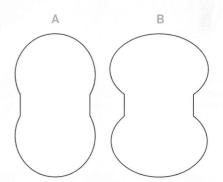

What Is an Inward Curve?

Creating an inward curve such as at the waistline doesn't mean to make that curved-in section thinner, but to change the sizes of the parts above and below it, such as the chest and hips.

For example, if you're drawing the legs, by changing the width of the thighs and the shins, you can create legs with good definition. If you can use this difference in widths skilfully you can re-create various body types.

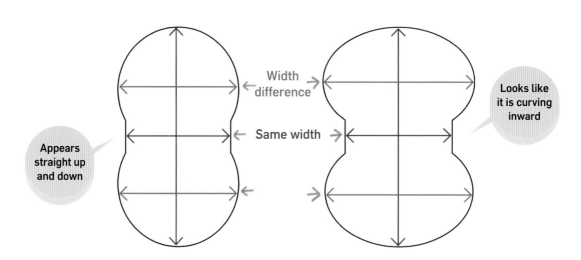

Differences in Female Body Types

Let's look at some different body types. I've kept the balance of each figure the same and created slender and more rounded figures.

Expert Tip

The Contours of Joints
The joints on a human being are moving parts and don't have a lot of fat on them. However, if you take some liberties and make the joints wider, it's an effective way of suggesting a plumper or more full-figured character.

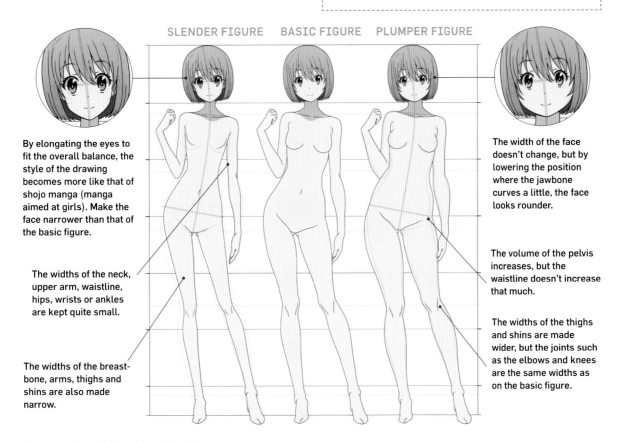

SLENDER FIGURE BASIC FIGURE PLUMPER FIGURE

By elongating the eyes to fit the overall balance, the style of the drawing becomes more like that of shojo manga (manga aimed at girls). Make the face narrower than that of the basic figure.

The widths of the neck, upper arm, waistline, hips, wrists or ankles are kept quite small.

The widths of the breast-bone, arms, thighs and shins are also made narrow.

The width of the face doesn't change, but by lowering the position where the jawbone curves a little, the face looks rounder.

The volume of the pelvis increases, but the waistline doesn't increase that much.

The widths of the thighs and shins are made wider, but the joints such as the elbows and knees are the same widths as on the basic figure.

About the 3-Heads-Tall Figure

Here are an approximately 4-heads-tall figure and a figure that is a bit more than 3 heads tall. If we go by the basic example explained at the beginning of the chapter, the groin is located at the midpoint of the whole body height. However, in these examples, that's not the case. This is because if the head height of the figure is lower than 6 heads, the balance is off.

The center point of a 4-heads-tall figure is a bit higher than the groin, and the center point of a 3-heads-tall figure is around the chest area; you can see that the center of the 3-heads-tall figure is higher than on a 4-heads-tall figure. Remember that the lower the head height of the figure (or the larger the head in relation to the body), the higher the center point is placed.

1 head height

1 head height

Center point

1 head height

1 head height

⅓ head height

1 head height

Center point

1 head height

¼ head height

Men Are Square, Women Are Triangular?

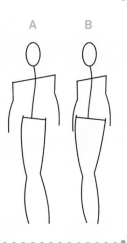

Q. Which Figure Is Male?

First, look at the figures on the right. Both A and B are made up of circles and lines, but which do you all think is male, and which looks like a female?

Most people will probably say that A is a male, and B is a female, but why is that?

That's right, the differences are the widths of the shoulders and the hips. There are many differences between males and females, such as the way muscles are formed or the shapes of the bone structures, but the definitive differences are the widths of the shoulders and hips.

You can even see the difference between males and females in these stick figures, so there is a clear distinction.

Body Shape Differences

MALE FEMALE

The shape of the pelvis is different. See Differences in Bone Structure (Page 30)

◆ The Different Positions of the Body Parts

Let's look at the different positions of the parts of the body. However, keep in mind that this is just the basic positioning. If you know the basics, you can depart from these strict gender distinctions to pursue your own directions. Challenge yourself to do that.

CHIN
Chins are positioned high on males, and low on females.

NIPPLES
Nipples are positioned high on males, and low on females.

WAISTLINE
The waistline is low on males, and high on females

BELLY BUTTON
The belly button is low on males, and high on females.

HIPS
The hips are high on males, and low on females.

GROIN
The groin is low on males, and high on females.

◆ Turning the Figures Into Simple Shapes

If we consider the previous elements and turn them into simple shapes, these illustrations result.

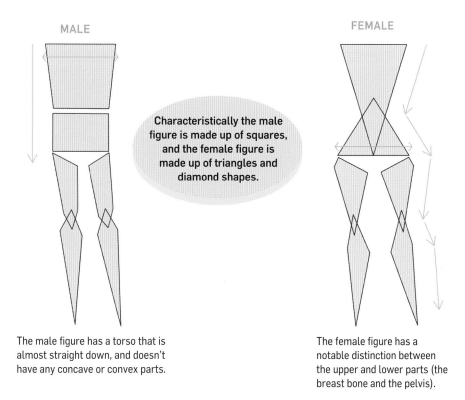

MALE

FEMALE

Characteristically the male figure is made up of squares, and the female figure is made up of triangles and diamond shapes.

The male figure has a torso that is almost straight down, and doesn't have any concave or convex parts.

The female figure has a notable distinction between the upper and lower parts (the breast bone and the pelvis).

Face Shape Differences

Let's look at the characteristics of each face type. The most remarkable differences between male and female face types are the shapes of the cheeks, chins and jawlines. A male face has high cheeks, and a chin and jawline that sticks out, giving the whole face a rugged appearance. A female face has low cheeks, and the chin and jawline are sharp and have a rounded impression.

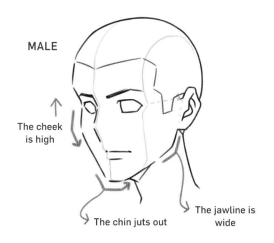

MALE

The cheek is high

The chin juts out

The jawline is wide

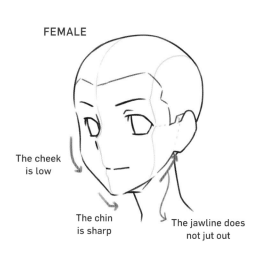

FEMALE

The cheek is low

The chin is sharp

The jawline does not jut out

Differences in Bone Structure

The reason why males and females have different body structures is because they have different bone structures.

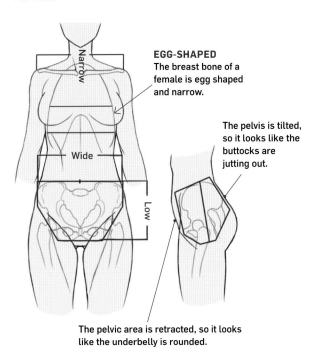

EGG-SHAPED
The breast bone of a female is egg shaped and narrow.

Narrow

Wide

Low

The pelvis is tilted, so it looks like the buttocks are jutting out.

The pelvic area is retracted, so it looks like the underbelly is rounded.

The pelvis is wide horizontally and low vertically.

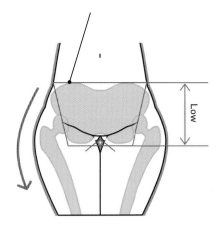

Low

MALE

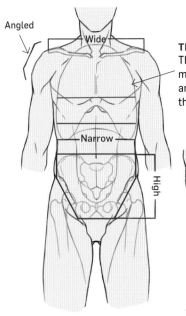

Angled

Wide

Narrow

High

TRAPEZOIDAL
The chest bone of the male is trapezoidal, and wider than that of the female.

The pelvis is upright, so the buttocks do not look like they are jutting out.

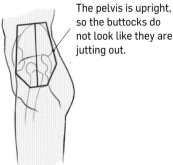

The genitals protrude, so the belly looks flat.

The breastbone of the male is shaped like a trapezoid and narrow, but on the other hand it is quite tall.

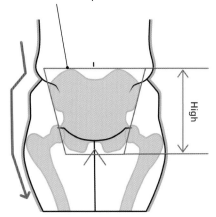

High

Use Guide Lines to Draw Figures from Photographs

The illustration below shows a figure drawing that was done from a photograph.
The photograph has various guide lines drawn on it, right? Start by studying the photograph well and sketching or drawing from those.

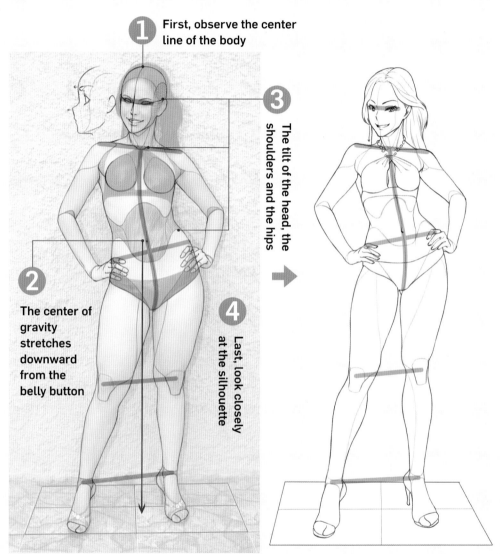

1 First, observe the center line of the body

3 The tilt of the head, the shoulders and the hips

2 The center of gravity stretches downward from the belly button

4 Last, look closely at the silhouette

Start with points **1** and **2** and draw your guide lines. If you understand these points, you'll be able to create drawings of this calibre easily.

There are a lot of things to learn, but keep trying—just a little at a time is fine. Once you acquire the skills and experience, there's no doubt this knowledge will help guide your artistic endeavours.

Age Difference Is Not Just Shown with Wrinkles

Q. Which Picture Looks the Youngest?

Let's start by looking at the illustrations below. All of them have the eyes and mouths in the same position, but which one looks the youngest?

If you think of A as the base picture, the chin on B is positioned lower, and the chin on C is lowered even more than on B. The eyes have been elongated vertically.

When you compare the three, don't you get the impression that the face looks younger from A to B to C?

When you're indicating a difference in age, paying attention to the position of the chin (the position of the curve) and the height of the eyes can make a differentiation.

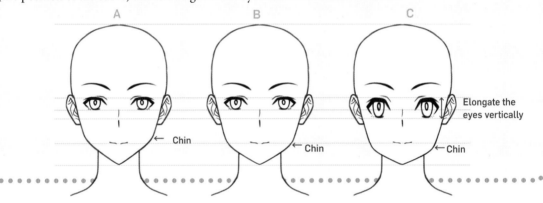

A B C

← Chin ← Chin ← Chin

Elongate the eyes vertically

Differences Made by Age

The right illustration shows a man and a woman who are in their 20s to 30s. Using these as the base, let's look at the changes that come with age.

The main differences are the two points below. Be well aware of them.

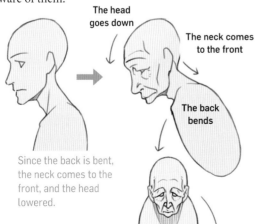

The head goes down

The neck comes to the front

The back bends

Since the back is bent, the neck comes to the front, and the head lowered.

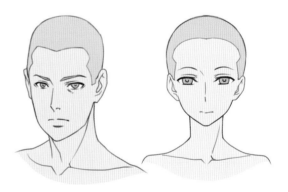

1. The skin becomes looser
The skin sags and wrinkles appear.

2. The chin area shrinks
Because teeth are lost or are ground down, the chin becomes smaller.

◆ The 40s onward

The skin starts to sag, and wrinkles around the eyes and mouth become more prominent.

Since males lose muscle, their faces become more rugged looking.

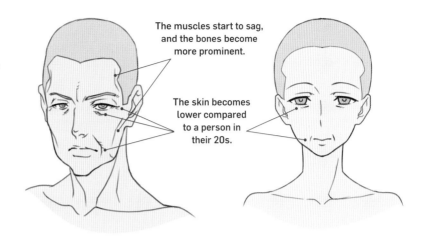

The muscles start to sag, and the bones become more prominent.

The skin becomes lower compared to a person in their 20s.

There is less muscle, and the bones become more prominent.

The skin around the eyes start to sag

The chin looks as if it is rising

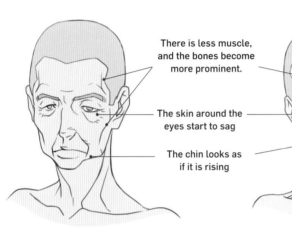

◆ The 50s onward

Women also lose muscle in their faces.

The skin around their eyes and the fat under their cheeks sag, and the corners of the eyes start sagging as well.

◆ The 60s, 70s onward

The skin and muscles of the neck start to sag, not just those on the face.
The hairlines for both males and female recede.

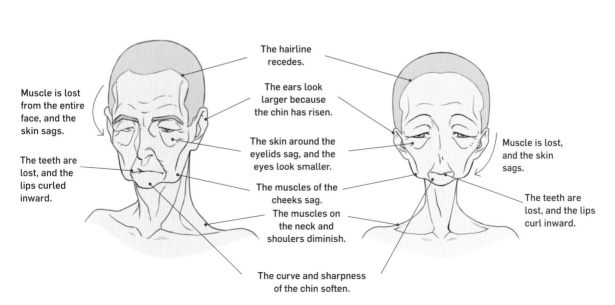

Muscle is lost from the entire face, and the skin sags.

The teeth are lost, and the lips curled inward.

The hairline recedes.

The ears look larger because the chin has risen.

The skin around the eyelids sag, and the eyes look smaller.

The muscles of the cheeks sag.

The muscles on the neck and shoulers diminish.

Muscle is lost, and the skin sags.

The teeth are lost, and the lips curl inward.

The curve and sharpness of the chin soften.

How to Draw a Well-Proportioned Face

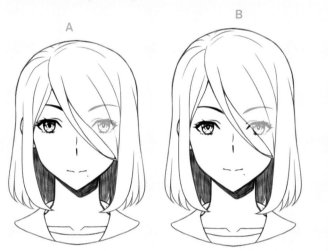

Q. Which Face Looks More Naturally Proportioned?

Let's start by looking at the illustrations on the right. Doesn't A give the impression of being out of balance?

When drawing a human figure are you aware of the positions of each part of the face? The position of the eyes, of the nose, of the mouth?

Let's start by properly learning the basic positions of each part.

A

B

The Proportions of the Face

Let's compare the proportions of male and female faces.

You can see that they're quite different.

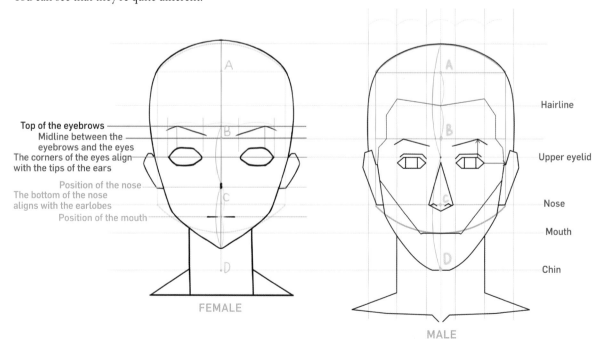

Top of the eyebrows
Midline between the eyebrows and the eyes
The corners of the eyes align with the tips of the ears
Position of the nose
The bottom of the nose aligns with the earlobes
Position of the mouth

Hairline

Upper eyelid

Nose

Mouth

Chin

FEMALE

MALE

Try Drawing a Face

◆ Female

1 Draw a square in a circle

Draw a cross in the center of the circle, and draw a square.

Cut off both sides, and create point D to be the same distance as the length of A to B and B to C.

2 Cut off both sides

3 Draw guide lines

Center point between the eyes and eyebrows

Put in the length of the chin in between points C and D. The longer this is, the more realistic the drawing will be. In this case we are drawing an adult female, so we've positioned this at the one-third point.

4 The proportions of each part

The closer the triangle that connects the centers of the eyes to the center of the mouth is to an equilateral triangle, the better proportioned the face is.

The inner end of the eyebrows are closer to the center of the face than the inner corners of the eyes

It's better to draw the neck so that is inside the line leading from the center of the eyes

5 Draw the volume of the hair

Draw the volume of the hair so that it's a bit larger than the head.

6 Clean up the drawing

Clean up the drawing and you're done!

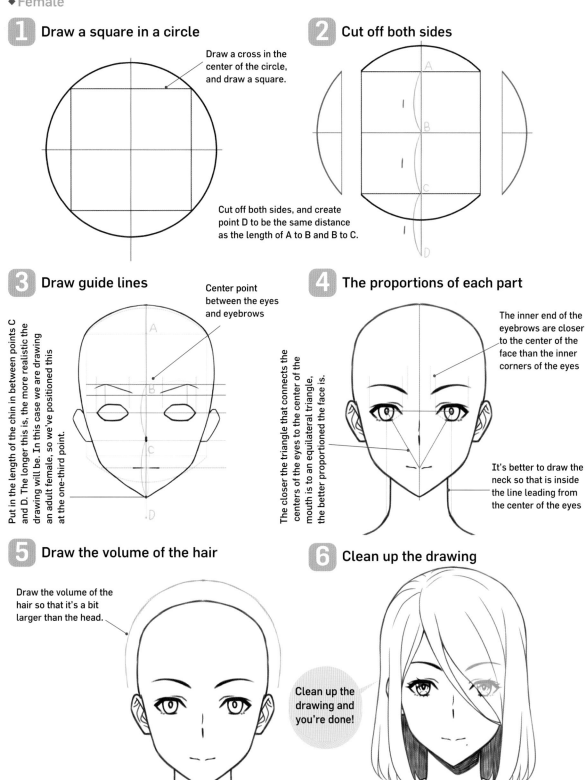

35

◆ Male

1 **Draw the guide lines**

2 **Draw in the parts**

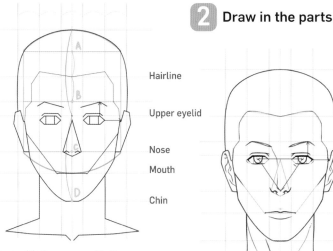

Hairline

Upper eyelid

Nose

Mouth

Chin

Start with the same guide lines as the female face, and make the chin longer for a male. Here it is positioned at point D.

On a male face, if the triangle connecting the centers of the eyes with the tip of the nose is equilateral, the face looks better proportioned.

3 **In the case of a two-dimensional male**

A two-dimensional male face can be drawn with the same proportions, by just changing the parts.

TAKE A CLOSER LOOK

Realistic Pictures and Two-Dimensional Pictures

When you are creating an illustration from a photo-graph or an actual person, if you draw them as is, don't you get the feeling that something is wrong? When you are creating a two dimensional illustration, various parts are encoded.

A is a realistic picture, C is a two-dimensional picture, and B is in between the two, let's call it a 2.5-dimensional picture.

The biggest difference between the three is the difference in the encoding of the nose and mouth from the center. Let's look at each of them.

REALISTIC PICTURE

2.5-DIMENSIONAL PICTURE
Compare to A

The ridge line of the nose is drawn in

This part is encoded as is. Compared to B, the mouth looks like it is protruding more.

The center line of the nose is drawn

The center line of the mouth is drawn

◆ Female

1 Draw the guide lines from the front view of the face

Draw the guide lines for the locations of the parts of the face from the front view. The locations of the parts are the same in the side view as they are on the front view.

2 Draw a oval for the head

The profile is an oval, not a circle.

3 Draw in the parts following the positioning guide lines

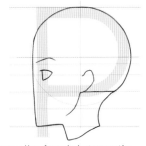

Draw a line from in between the eyebrows down to the chin. Try envisioning the shape of a capital "P" as the overall shape.

4 Add the parts from the nose to the chin

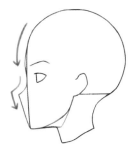

Add the parts from the nose to the chin.

5 Clean up the outline

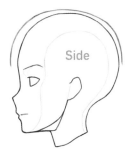

Side

Be conscious of the fact that the blue part is the side of the face.

6 Clean up the lines

Clean up the lines and you're done!

2-DIMENSIONAL PICTURE

Compare to B

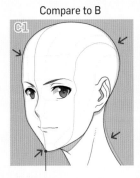

Compare to A

If you compare A and C, you can see the differences between the thicknesses of the heads and the different positioning of the ears.

As the illustration changes from A to C, you can see that the head gets wider and that the position of the ear shifts.

This is strongly connected to the size of the eyes. When the eyes become bigger, you have to enlarge the back of the head to maintain balance.

However, if the back of the head is enlarged, the head itself becomes too big and the height is reduced. Therefore, in 2-dimensional illustrations, this has been solved by shifting the position of the ear, and by making the head seem bigger than it actually is.

When you are drawing a 2-dimensional illustration from a photograph, if you pay attention to this point, you can create a well-balanced figure. (For how to draw the head, see Page 54.)

Let's Look at Pupils

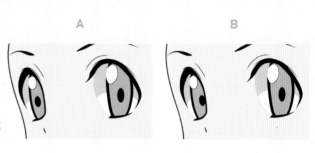

Q. ## Which One Looks as If the Eyes Are Focused?

Look at the illustrations on the right. Both may look O.K., but doesn't it seem as though the line of sight of A is a bit off?

That is because even though the right eye is in the back and is angled, the pupil is in the center of the eye. Since the pupil of the eye is shaped like a bowl, it looks different depending on which angle it's viewed at.

A B

The Structure of the Eye

The eyeball is largely made up of the whites, the iris, the lens (the pupil) and the cornea.

The eye is covered with a dome-shaped transparent membrane called the cornea.

When the face is turned to the side as in the illustration above, the position of the eye in the back shifts toward the center of the face. Otherwise you can't tell which way the figure is looking.

Clearly it's important to draw eyes that are looking in the right direction.

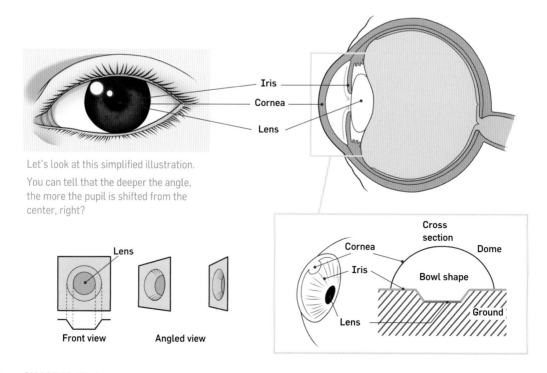

Iris
Cornea
Lens

Let's look at this simplified illustration.

You can tell that the deeper the angle, the more the pupil is shifted from the center, right?

Lens

Front view Angled view

Cross section
Cornea
Iris
Dome
Bowl shape
Lens
Ground

Consider Real vs. Distorted

◆ Encode the Eye

Let's see which parts are encoded compared to an actual eye. You'll be able to tell which parts correspond to an actual eye and which need enhancement or distortion.

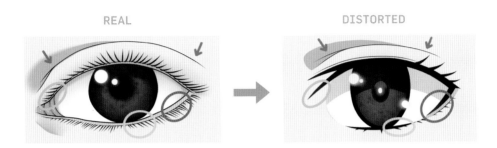

◆ Angled Eyes

The eye itself is not flat, but is shaped like a gently curving ball.

Be aware of the eye at different angles such as seen from below, seen from above, seen diagonaly and so on, and be aware of how the outer corners of the eyes and the curves of the inner corners change.

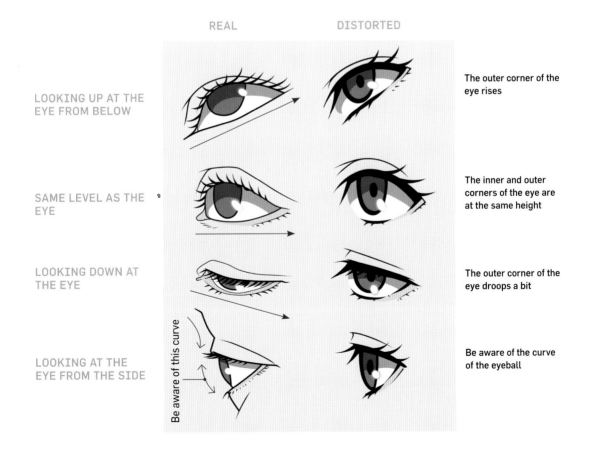

The Eye at the Back of an Angled Face

At first glance, it may seem as though only the width of the eyes in the front and back are different, but there are actually some key points to consider in regard to the eye in the back.

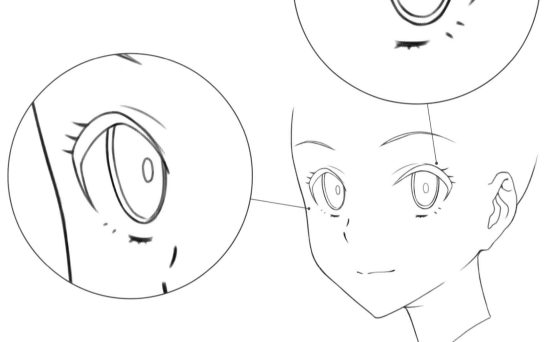

The Eye in the Back Has Perspective

When you draw a face with an angle, don't you draw the back eye smaller?

Why do you do that?

If we simplify the shapes to squares, it becomes easier to understand. The eye in the front has almost no perspective so it looks square. The eye in the back has perspective so it's squeezed and the width looks different.

Because that eye has perspective applied, you can see that the angle of the eye is different.

Be aware of the width and angle of the eye as you draw it.

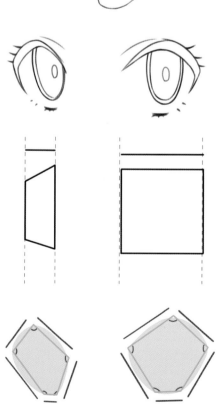

◆ Compare the Widths

First, let's compare the front-facing eye and the inverted back eye.

The widths are different!

The eyes are connected to the curve of the face. Since the eye in the back is at the end of the curve, it is narrower.

◆ Make the Eyes the Same Width and Compare

Next, let's make both the back and front eyes the same width and compare them. Even if the widths are made the same, the eyes differ in shape, right?

THE FRONT-FACING FRONT EYE MADE THE SAME WIDTH AS THE BACK EYE

INVERTED BACK EYE

The shapes are different!

If you observe them, you can see that the curves of the outer eyes differ.
If you look at the outlines only, it's easy to understand.

Expert Tip

Pay Attention to the Curve of the Eye
If you look at realistic eyes, you can see that the line along the outer eye curves sharply.
 If you draw the back eye while being aware of this curve, you can create a three-dimensional face.

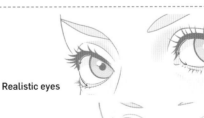

Realistic eyes

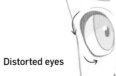

Distorted eyes

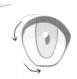

About Eye Shapes

◆ The Eye Is Basically a Hexagon

The eye is basically shaped like a hexagon. By distorting this hexagon, you can draw different types of eyes.

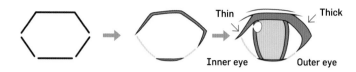

Thin Thick
Inner eye Outer eye

BASIC

BRIGHT

UPWARD-SLANTING EYE 1

UPWARD-SLANTING EYE 2

DOWNWARD-SLANTING EYE 1

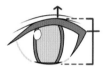

DOWNWARD-SLANTING EYE 2

 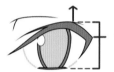

THIN EYE 1

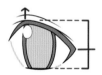

THIN EYE 2

GLARING EYE

How to Create Expression in Eyes

Let's add expression to the basic eye on the previous page by adding eyelids.

GLAD

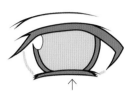

↑
The lower eyelid is raised to express gladness or sorrow

SURPRISED

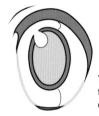

The pupil is separated from the eyelids, to express surprise

EMPHASIZING DOWNWARD-SLANTING EYES (WEAKNESS, LACK OF CONFIDENCE)

By slanting the lower eyelid down as well, the downward slant is emphasized

EMPHASIZING UPWARD-SLANTING EYES (STRENGTH, CONFIDENCE)

By slanting the lower eyelid up as well, the upward slant is emphasized

FIERCENESS

This state where the whites of the eyes are revealed all around the pupil is called a sanpaku-gan (sanpaku eye). This is used for an expression of insanity, or to indicate a gap between a character's appearance and personality.

SLEEPINESS

By separating the crease of the upper eyelid, you can express sleepiness or an impression of quietness

By drawing the upper eyelid straight across, you can easily suggest fatigue

Expert Tips

There Are 3 Key Points for Eyes

Create the emotion with the eyebrows
You can show whether the character is angry or sad.

Create the personality with the height of the outer corners of the eyes
You can create a character with a strong or weak personality.

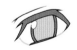

Eyelashes express individuality (of the artist)
The way you draw the eyelashes expresses your own individual style.

How to Draw Attractive Eyebrows and Eyelashes

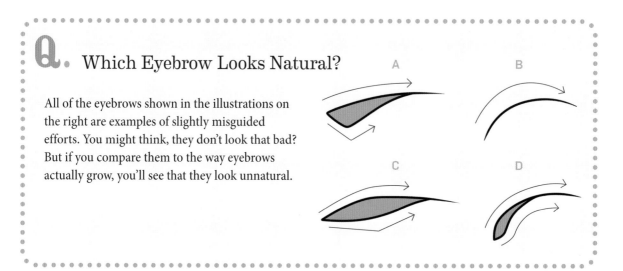

Q. Which Eyebrow Looks Natural?

All of the eyebrows shown in the illustrations on the right are examples of slightly misguided efforts. You might think, they don't look that bad? But if you compare them to the way eyebrows actually grow, you'll see that they look unnatural.

Learn About the Direction Eyebrows Grow

The eyebrows can be divided into 3 parts: the inner end or start of the eyebrows, the middle, and the outer end of the eyebrows.

Be aware that the upper line curves gently and that the lower line forms a large S shape.

If we look at the examples shown above, we can see that they differ from the way actual eyebrows grow. If you draw eyebrows like these, they'll lack expression and have an unnatural appearance.

Unless you want to use them purposefully, such as when you intend for the character to lack expression, it's best not to avoid these examples.

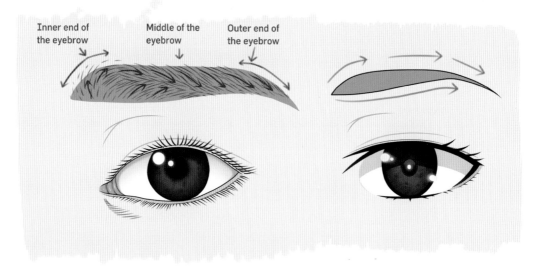

REAL DISTORTED

How to Draw Eyebrows That Aren't Out of Place

DIAGONAL VIEW ANGER

1 Create curved lines that fit the emotion

Create curved lines along the form of the face where the eyebrows will be.

2 Erase the center

Erase the center of the eyebrow line.

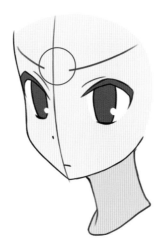

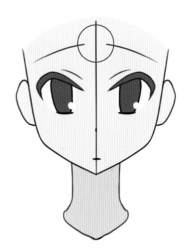

3 Adjust the shapes of the eyebrows

Draw the eyebrows along the lines in Step 2 and you are done.

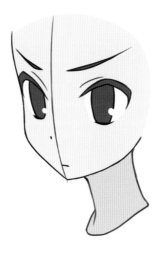

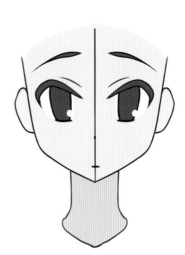

The Directions Eyelashes Grow

Eyelashes grow in a radial pattern from the center of the eyes. Each eyelash hair doesn't grow straight, and the roots are curved. If you follow the curve from the root, you can draw beautiful eyelashes.

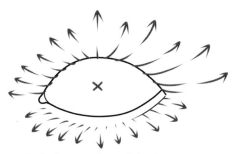

Eyelashes grow in a radial pattern
from the center of the eyes

EYELASH

Gentle curve

Curve

Be conscious of where
the stroke starts to where
it ends in a swoosh

Eyelashes are curled at the roots!

More About Eyelashes

I've tried creating various eyelash patterns using the same eye.

These are only a small sampling what what's possible.

Since my style these days is to not put much differentiation in my characters' faces, I make distinctions in the way I treat the irises and how I draw the eyelashes.

In the end, these are just distortions of real eye shapes and how real eyelashes grow, so observe real eyes carefully and try to draw them.

NO EYELASHES

VERY FEW EYELASHES

LOTS OF EYELASHES

EYELASHES ONLY ON THE OUTER CORNER

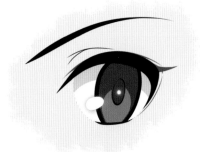

The Facial Expression Is Determined by the Height of the Eyebrows

Some of you may be feeling this: "My pictures lack expression. My characters don't look like they're happy or sad."

Let's look at the heights of the eyebrows of the female and male characters pictured here. If you just glance at them, they may look like they all have different expressions, but in actuality there are no differences between the shapes of the eyebrows. When an actual human being expresses emotions, they don't form easy-to-understand shapes like >< or (•_•) emojis, right?

How human beings change their expressions are based on the muscles that move the eyebrows according to the study of micro-expressions. Before using easy-to-understand manga-like expressions, I think you can depict different expressions by just being aware of the height of the eyebrows.

Try hiding the eyebrows of this worried face with your finger. Doesn't the face look expressionless? Now, take your finger off and look at the face again. It looks worried once more. In other words, it's not an exaggeration to say that many expressions are decided by the eyebrows.

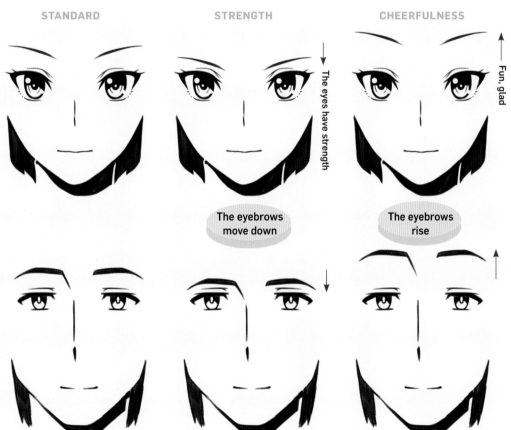

STANDARD STRENGTH CHEERFULNESS

The eyes have strength

Fun, glad

The eyebrows move down

The eyebrows rise

What Is the Gap in the Middle of the Mouth?

Q. Which Is the More Natural Way to Draw a Mouth?

Let's start by looking at the two illustrations on the right. Both have a gap in the middle of the mouth. This is a form of expression that is often seen in illustrations and manga.

So, which looks more natural, A or B?

The right answer is A. The reason why A looks more natural will be evident when you learn about the structure of the lips.

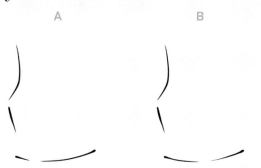

A B

Learn About the Structure of the Mouth

A real mouth has an M-shaped valley in the middle of the lips, but if you draw that part, the shape becomes too realistic.

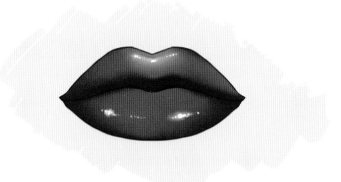

THE MUSCLES OF THE LIPS

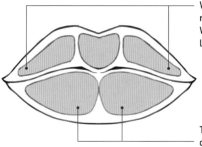

The illustration on the right shows the lips divided into parts.

When the person laughs, the left and right muscles of the upper lip move up. When they are worried or sad, the lower lip moves down.

The lower lips are thicker. In two-dimensional pictures, one is often only conscious of the lower lips.

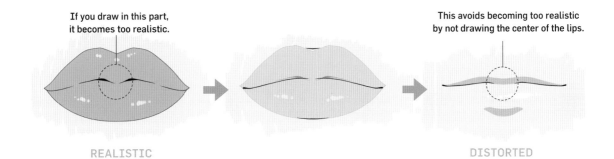

If you draw in this part, it becomes too realistic.

This avoids becoming too realistic by not drawing the center of the lips.

REALISTIC

DISTORTED

REALISTIC DISTORTED

◆ Be Aware of the Center

When drawing a diagonal face, it's good to be aware that teeth are curved and to be conscious of the center line of the mouth.

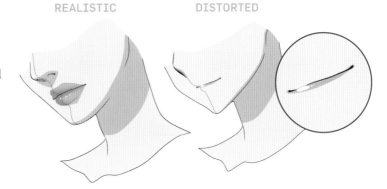

Expert Tip

The "M" in the Middle of the Lips
When the lips are closed, the line in the center forms an M shape.

When you draw a diagonal face, by being just a little bit aware of that M shape, the lips will be more three-dimensional.

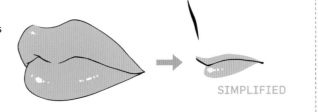

SIMPLIFIED

Be Aware of the Curve of the Teeth

◆ How Teeth Are Attached

When drawing a wide-open mouth or a mouth that is open a little bit, the teeth don't grow straight—they curve inward toward the bite. By making a space in between the teeth and the lips, you can create a drawing with three-dimensionality.

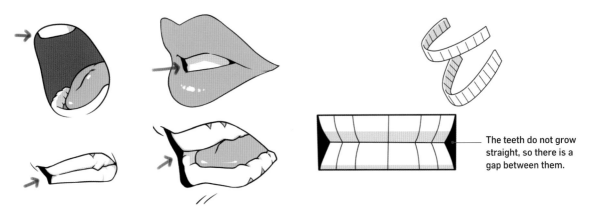

The teeth do not grow straight, so there is a gap between them.

Tips for Drawing Clean Lines

When you draw lines, where are you looking? You may not be very conscious of that. The people who come to me saying "I can't draw lines very well" "My lines are zigzaggy and wobbly" always have the same problem.

That is that they are "looking at the tip of the pen or the cursor as they draw.

People who can draw clean lines don't look at the tip of the pen or the cursor at all.

If you watch videos of people who are good at drawing you can see this.

This is the same as practicing your swing in baseball or golf. By imagining what movement you want to make, you can draw accurate and clean lines.

As with handwriting, when you apply pressure and remove it, where you stop, swoosh and taper off are important, so be aware of these points.

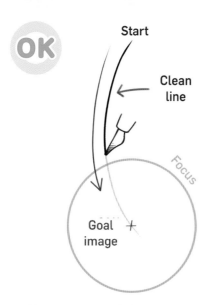

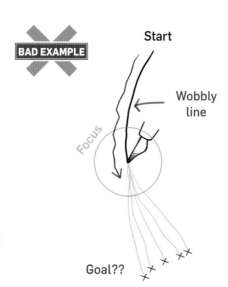

Create Expressions with the Corners of the Mouth

By stopping the pen at the corner of the mouth, you can emphasize it and create expression. By raising or lowering the mouth just a little bit, you can create subtle expressions.

Expert Tip

The Starting Points of Lines
In Japanese calligraphy, there are techniques for creating beautiful writing such as "tome" (stopping the pen or brush) and "harai" (lifting up the pen or brush and making a stroke that thins toward the end). By emphasizing (making thicker) the ends or the parts that overlap with lines in illustrations, you can also depict three-dimensionality and make the lines more lively.

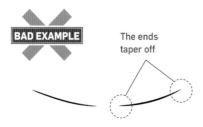

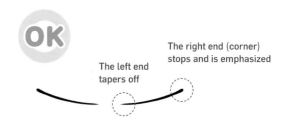

More About Expressions

If you draw the expression of a mouth and do not emphasize the corners, the expression becomes weak. So be sure to emphasize the corners, so that the expression is easy to read even if the face is seen from a distance.

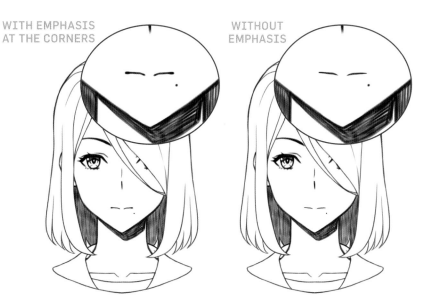

WITH EMPHASIS AT THE CORNERS

WITHOUT EMPHASIS

By adding a distinct end point to the corners of the mouth, the expression becomes easy to see, even from a distance.

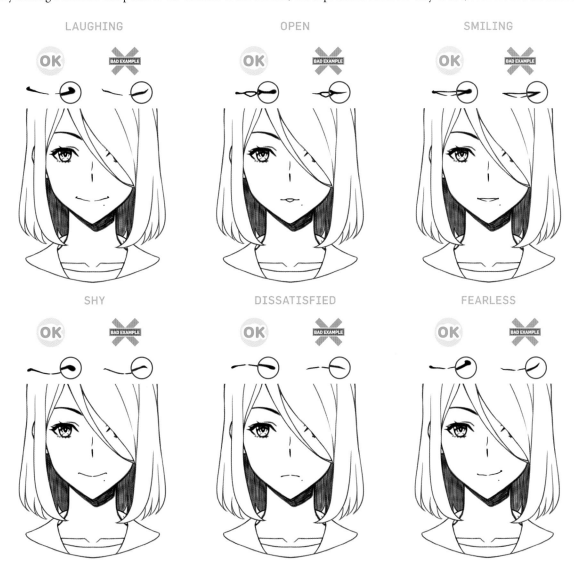

LAUGHING

OK BAD EXAMPLE

OPEN

OK BAD EXAMPLE

SMILING

OK BAD EXAMPLE

SHY

OK BAD EXAMPLE

DISSATISFIED

OK BAD EXAMPLE

FEARLESS

OK BAD EXAMPLE

Let's Learn About Different Nose Shapes

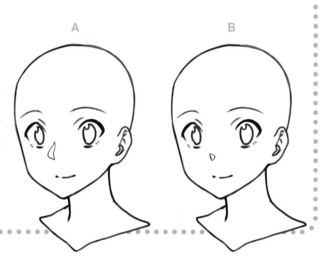

A B

Q. Which Nose Is Correct?

Which nose looks correct, A or B? Do they both look O.K.? You're right!

In fact, neither nose is wrong. The nose can be depicted with a variety of shapes, depending on which part of it is drawn.

Try drawing your noses to fit your style as well as your character's face!

Let's Learn about the Structure of the Nose

Of all the parts of the face, the nose in particular can be drawn in various ways,
but as long as you know which line of the nose you are taking, it's easy to differentiate them.

Let's start by learning what three-dimensional surfaces are hiding on the nose.

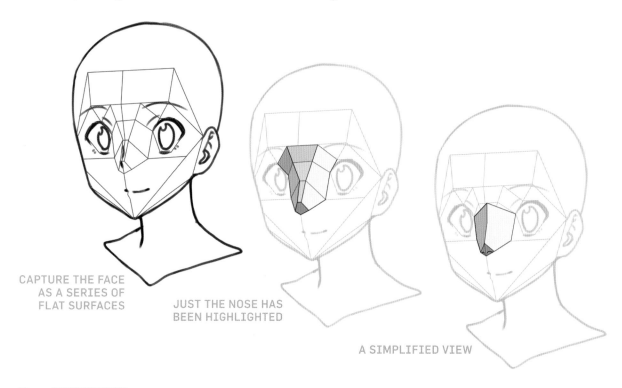

CAPTURE THE FACE
AS A SERIES OF
FLAT SURFACES

JUST THE NOSE HAS
BEEN HIGHLIGHTED

A SIMPLIFIED VIEW

This and That About Nose Shapes

So let's actually look at different nose patterns.

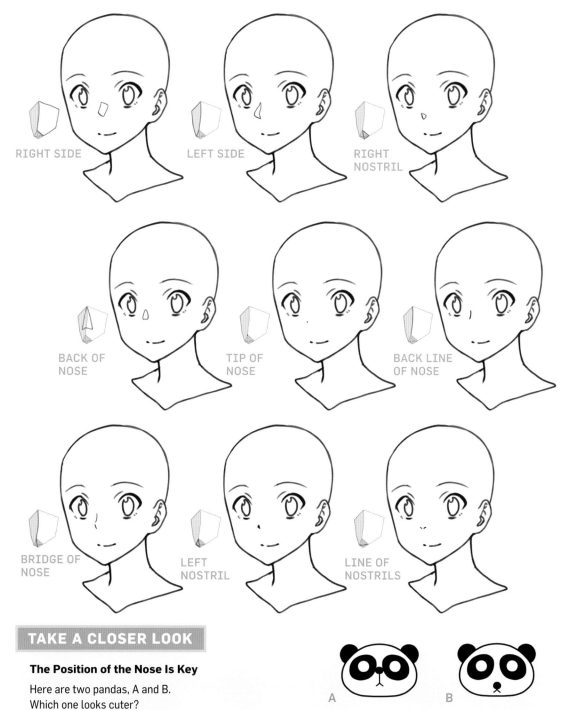

RIGHT SIDE

LEFT SIDE

RIGHT NOSTRIL

BACK OF NOSE

TIP OF NOSE

BACK LINE OF NOSE

BRIDGE OF NOSE

LEFT NOSTRIL

LINE OF NOSTRILS

TAKE A CLOSER LOOK

The Position of the Nose Is Key

Here are two pandas, A and B.
Which one looks cuter?

Probably most people will reply A.

The difference between these two pandas is the position of the noses and mouths. The position of the nose in particular is important; what mascot type characters like Hello Kitty, Doraemon and Anpanpan have in common is that they're drawn with the awareness that positioning the nose near the eyes makes them look cuter.

A

B

The Reason the Face Looks Large Is the Back of the Head

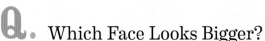 **Which Face Looks Bigger?**

Which face looks bigger, A or B? Although B has the bigger head, doesn't the face on A look bigger?

The outlines of both faces are exactly the same. Then why does A's face look bigger? This is not because there's a problem with the parts of the faces, but because the head, especially the back of the head, lacks volume.

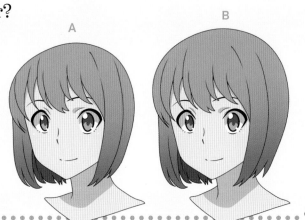

Let's Learn About the Balance of the Head

◆ Diagonal

Do the faces of the characters you draw look like they have unusually large faces?

When a head is out of balance, you shrink the parts of the face, only to find that the proportions of the whole are off, then you have to redraw it all again.

Let's look at the head shown above but removing the hair.

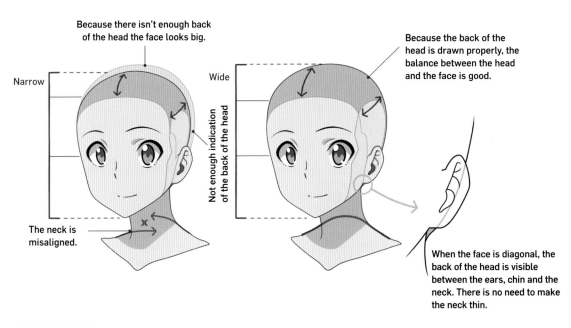

Because there isn't enough back of the head the face looks big.

Narrow

The neck is misaligned.

Not enough indication of the back of the head

Because the back of the head is drawn properly, the balance between the head and the face is good.

Wide

When the face is diagonal, the back of the head is visible between the ears, chin and the neck. There is no need to make the neck thin.

◆ Profile

In the same way, if the back of the head is small, the face in profile looks big.

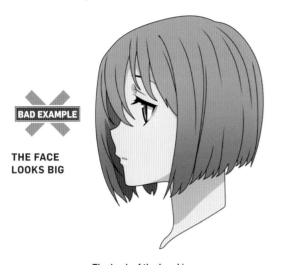

BAD EXAMPLE

THE FACE LOOKS BIG

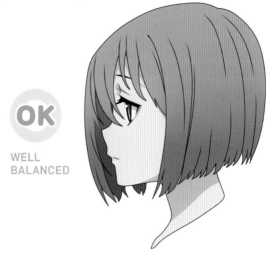

OK

WELL BALANCED

The back of the head is narrow from the hairline

Narrow

Because the distance between the bridge of the nose to the eye is long, the face looks large

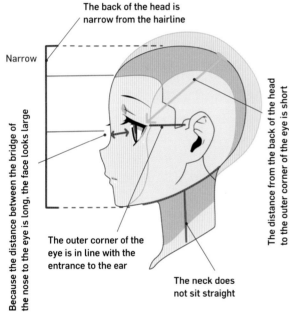

The outer corner of the eye is in line with the entrance to the ear

The neck does not sit straight

The distance from the back of the head to the outer corner of the eye is short

Wide

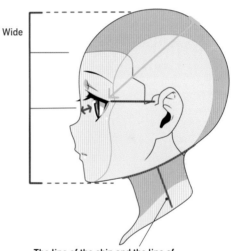

The line of the chin and the line of the back of the head are connected
The neck is connected diagonally

Expert Tip

Envision the Shape of a Helmet to Capture the Head
When drawing the head, if you envision a full face helmet, it's easier to create good proportions.

If you focus on the line from the chin to the back of the head in particular, you will see that it rises diagonally.

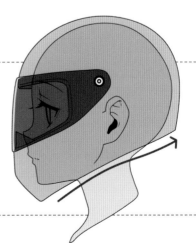

Tips for Making the Face Look Three-Dimensional

Q. Which Is the View from Below, and Which Is the View from Above?

The illustrations below illustrate a view from below, a view from above or a bird's eye view, and an eye level view. Can you tell which is which?

From left to right, they are an eye level view, a view from below and a view from above. These three illustrations are all drawn with the same outlines. The differences are the relative positions of the parts of the face (the eyes, ears and mouth). In other words, regardless of the shape of the eyes, the important thing is the position of the parts.

Remember that for a view from below, if you position the features of the face on the upper part and the ears lower, it looks plausible; for a bird's eye view, if you position the features on the lower part and the ears higher, it too looks convincing.

A B C

View from Below and View from Above

I have created some illustrations based on the ones from the question above.

Look at the NG (bad) examples. Even though the shape of the face is being viewed from above or below, because the eyes are positioned incorrectly they look wrong.

It is important to be properly aware of the shape of the face, the position of the eyes, and the position of the ears.

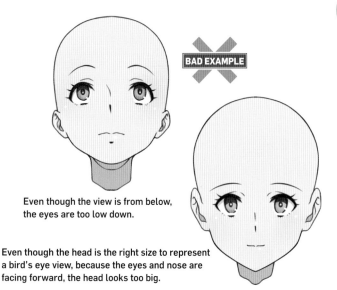

BAD EXAMPLE

Even though the view is from below, the eyes are too low down.

Even though the head is the right size to represent a bird's eye view, because the eyes and nose are facing forward, the head looks too big.

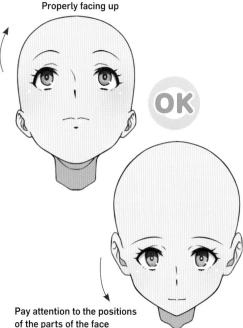

Properly facing up

OK

Pay attention to the positions of the parts of the face

Various Facial Angles

The following are depictions of front-facing, diagonal and profile views of the face from below, above and straight on.

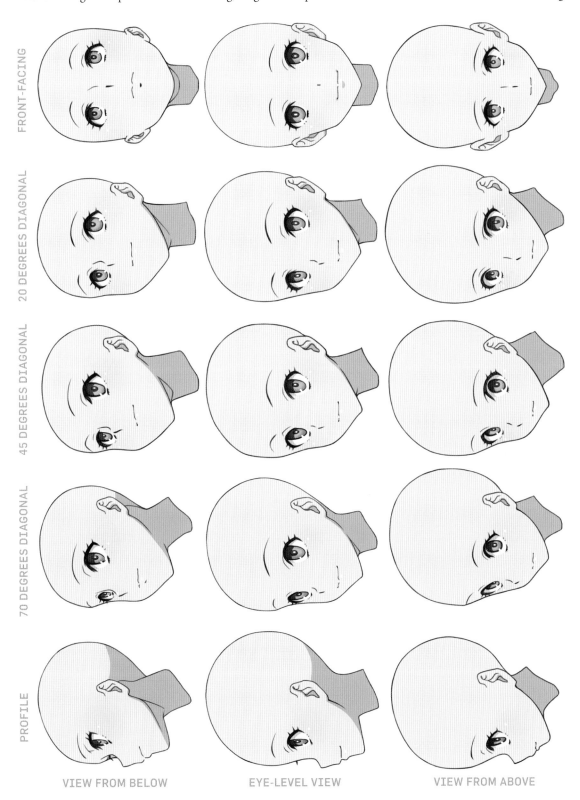

FRONT-FACING

20 DEGREES DIAGONAL

45 DEGREES DIAGONAL

70 DEGREES DIAGONAL

PROFILE

VIEW FROM BELOW EYE-LEVEL VIEW VIEW FROM ABOVE

Three-Dimensionality Seen in Three Views

When you're drawing a face, you often draw cross-shaped guide lines on it, right? But I often see people misunderstanding their purpose when drawing a diagonal view or a face in profile.

The straight cross-shaped guide lines you draw on a full frontal face, when seen from the side, go outside the forehead, nose and mouth. The vertical of the guide lines when seen from the front is the center line between the eyebrows.

Therefore, when you're drawing a profile, be aware that there is a cross shape in between the eyebrows.

If you're conscious of the fact that the bumps and dips of the profile of the face are reflected in the center line when it's viewed diagonally, it becomes easier to understand its three-dimensionality.

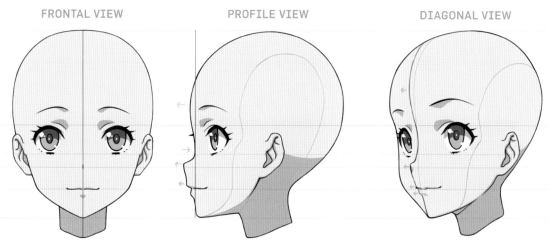

FRONTAL VIEW · PROFILE VIEW · DIAGONAL VIEW

The forehead, nose and mouth jut out.

TAKE A CLOSER LOOK

Angles That Makes Your Drawings Look More Skillful

Frontal view, profile view, diagonal view . . . do you know which angle makes your drawing look better?

Actually, a 70-degree diagonal view makes your picture look more skilfully done. This is because it's an angle at which a lot of parts overlap each other and look three-dimensional.

Focus in particular on the nose, the back eye and the line of the chin.

Their front-to-back positions are quite clear, right? If you draw a face at this angle, it 'll easily become cohesive, so try it out!

Three-Dimensionality with Lighting

Here I've created some common examples of rough lighting on faces.

If you know what surfaces the face has, you can draw even more fine-tuned shadows.

◆ Front view

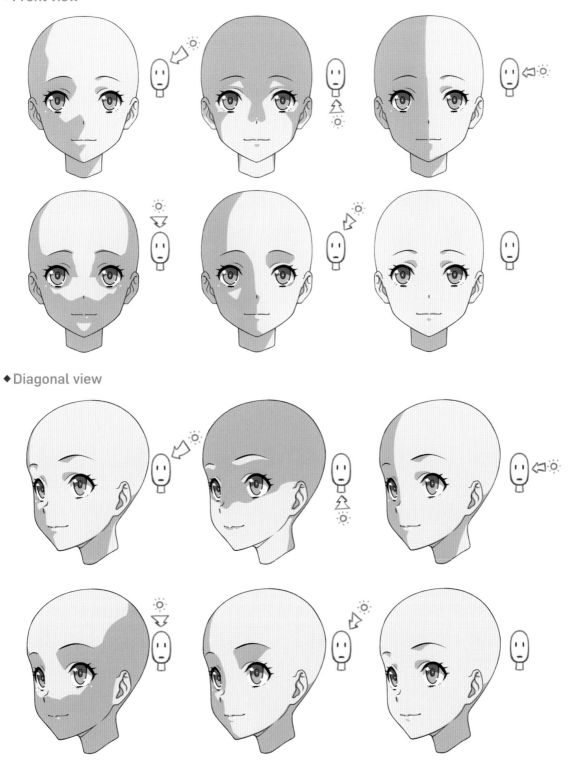

◆ Diagonal view

Let's Draw Hair

Q. Which Hair Looks More Realistic?

The illustrations to the right are of hair fringes. Which one looks better? Doesn't B look better? A gives a rather monotonous impression. Some of you might be worried that the hair you draw lacks movement or realism. What is the reason for that?

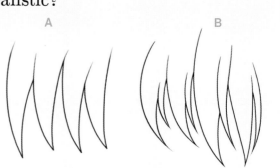

A B

Let's Try Drawing Hair

The reason why hair can look flat and without dimension is, in most cases, because the front-to-back relationships between the tufts of hair that are overlapping each other is not working.

◆ Let's Sort Out the Information

Let's start by sorting out the information about simple tufts of hair.

1. Make the basic directional flow clear.

2. Sort out the front-to-back positioning relationships
We will focus on these two points.

Expert Tip

Be careful—if the front-to-back flow of the hair is wrong, the sense of three-dimensionality will be lost.

BAD EXAMPLE

2 1 3 4

LOOKS FLAT

Hair the looks flat.

They look like copies of the same part

FRONT-TO-BACK RELATIONSHIP

A simplified uniformity.

4 3 2 1

The lengths are the same and look monotonous

IRREGULAR

By making the sizes of the tufts of hair irregular, they look more realistic.

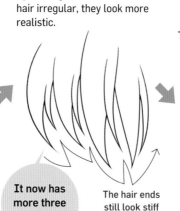

It now has more three dimensionality

The hair ends still look stiff

ADD S CURVES

The hair has been corrected to add smoothness in the form of S-shaped curves.

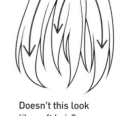

Doesn't this look like soft hair?

◆ Express the Softness of the Hair

Hair hangs down due to the tugs of gravity. If you draw hair while being aware of where gravity is being applied, you can depict differences in softness and stiffness.

For example, hair that has been treated with hair products becomes heavy, so if you draw the curves so that the weight is in the middle of the hair, it looks stiffer.

In contrast, if you want to draw soft, flowing hair, if you draw the curves so that the weight is at the ends of the hair, you can make it look springy and soft.

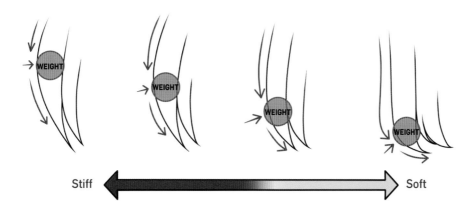

Stiff ←————————————→ Soft

How to Draw Hair Ends

Hair is easier to draw if you draw the outside line of the ends first, and then the inside curve to go along it.

Remember that the main line is the outside line.

Draw the lines so that the inner curve doesn't bend, and that the outer line forms a large curve.

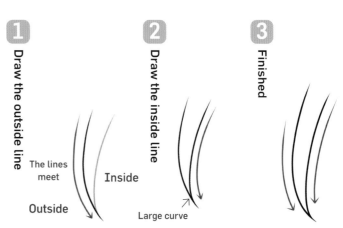

1 Draw the outside line — The lines meet / Outside

2 Draw the inside line — Inside / Large curve

3 Finished

Expert Tips

Make It More Three-Dimensional

When drawing hair, if you make the hair on the outside thinner, you'll achieve a more three-dimensional look.

If you can add a twist to the hair as if you were drawing spiraling noodles, it becomes easier to depict movement.

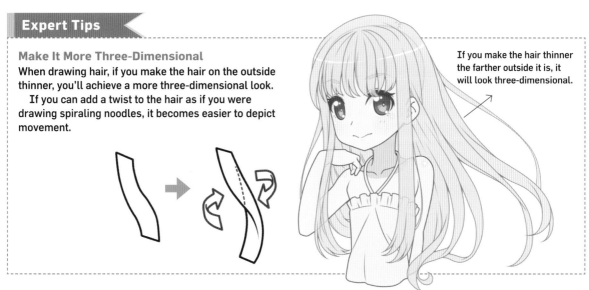

If you make the hair thinner the farther outside it is, it will look three-dimensional.

Make Use of Blocks as You Draw a Full Head of Hair

The areas where hair grows on the head are largely divided into 6 blocks: the front, the sides, the sideburns, the top of the head (in two sections), the back and the nape of the neck. When you think about the actual volume of hair, you can divide it into 4 blocks—front, sides, back and nape.

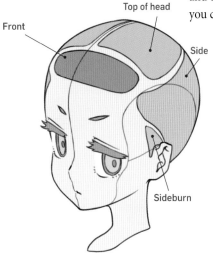

Top of head

Front

Side

Sideburn

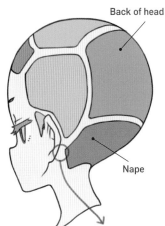

Back of head

Nape

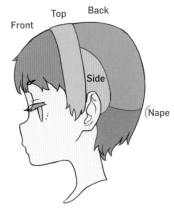

Top

Back

Front

Side

Nape

The Shape of the Fringe

In the left illustration below, the two tufts of hair in the center are the same size and shape, so it's difficult to get a sense of three-dimensionality from them. A fringe is in a semi-circle shape, so contour it around the head.

There is a gap behind the ears where the hair doesn't grow

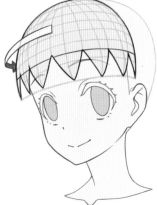

Top

Back

Front

With long hair, since the nape and the back form one whole, you can think of it as 3 blocks.

TAKE A CLOSER LOOK

The Proportions of the Fringe and the Shoulders

In moe-, kawaii- and chibi-type cute illustrations, if you draw the character so that the width of the shoulders is the same as the volume of hair in the front of the face, it looks well-proportioned.

When drawing the figure diagonally, the shoulders look narrower than the width of the head. In that case, it's a good idea to make the shoulder width the same as the line drawn down from the back of the head and the line downv from the front cheek.

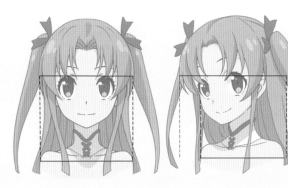

Let's Try Drawing Hair

Let's try actually drawing hair while being aware of the area blocks on the head.

 Visualize the blocks

Top

Front

Side

Sideburn

Be aware of the areas dividing the hair that exist on the head.

 Draw the fringe

Draw a half-sphere-shaped mass from the front hair area block.

Draw the hair on the sides

Add side hair that flows downward from the top of the head behind the fringe.

 Draw the hair on the back of the head

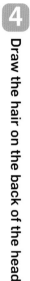

Draw hair that flows toward the back behind the side hair.

 Draw in lines following the guide lines

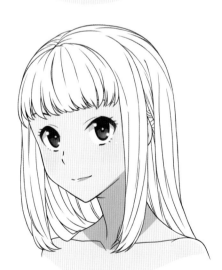

Using the guide lines, divide up the hair into more detailed bundles. Draw in the hair bundles so the lengths and widths are random.

 Clean up the drawing

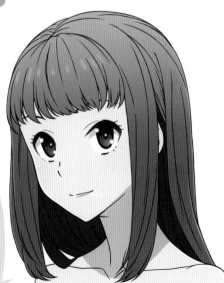

By being aware of the blocks of hair, it's easy to understand the front-to-back relationships between the different sections.

Color it in and you are done.

The Upper and Lower Arms Are the Same Length

Q. Which Arm Looks More Natural?

Which arm on the right looks more natural, A or B? That's right, it's B. So why does A look strange? I'll explain.

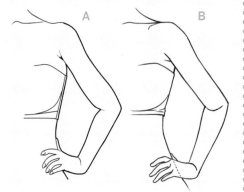

Learn the Proportions of the Arm

◆ The Length of the Arm

Let's see why A in the illustration above looks unnatural. One mistake that is often made is that the width of the upper arm changes drastically.

The lengths of shoulder to the arm and the arm to the wrist are the same.

The collar bone is connected to the shoulder.

Expert Tips

Common Mistakes Made with Arms
Here I will show you some common arm mistakes. The arm does not curve in the same direction, and the same area does not swell to the front and back. If you look at the OK (good) example, one side of the arm is straight, and the other side forms an S-shaped line.

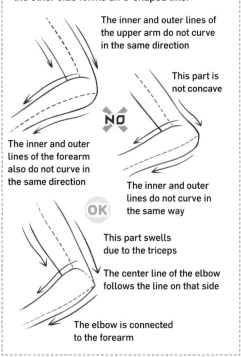

The collarbone is connected to the shoulder

The collarbone and the shoulder are not connected

NO

The thickness of the upper arm is all over the place

OK

½

½ The elbow is connected to the forearm side

The forearm is short

The position of the hand is strange because the forearm is short

The upper arm and the forearm are the same length

The inner and outer lines of the upper arm do not curve in the same direction

This part is not concave

NO

The inner and outer lines of the forearm also do not curve in the same direction

The inner and outer lines do not curve in the same way

OK

This part swells due to the triceps

The center line of the elbow follows the line on that side

The elbow is connected to the forearm

◆Let's Learn the Names of the Muscles and Their Functions

The arm has a range of complicated muscles, but the ones we should be aware of are the ones on the surface, especially the expansion and contraction of the deltoids, the biceps and the triceps.

When the arm is stretched out the S shape of the back part (the triceps) becomes enlarged. When the arm is raised, the S shape of the front part (the biceps) become enlarged.

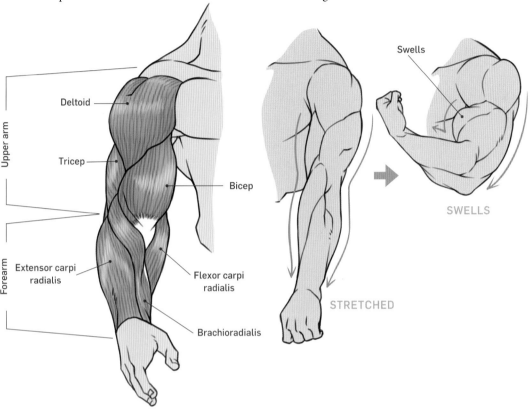

Upper arm

Deltoid

Tricep

Bicep

Forearm

Extensor carpi radialis

Flexor carpi radialis

Brachioradialis

Swells

SWELLS

STRETCHED

How the Arm Looks Different Depending on the Angle

The inside and outside of the arms have different heights. Let's look at those differing heights from various angles.

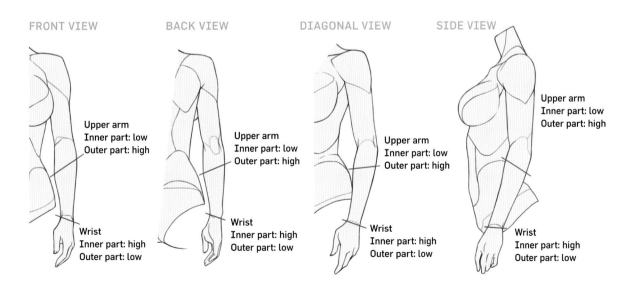

FRONT VIEW

Upper arm
Inner part: low
Outer part: high

Wrist
Inner part: high
Outer part: low

BACK VIEW

Upper arm
Inner part: low
Outer part: high

Wrist
Inner part: high
Outer part: low

DIAGONAL VIEW

Upper arm
Inner part: low
Outer part: high

Wrist
Inner part: high
Outer part: low

SIDE VIEW

Upper arm
Inner part: low
Outer part: high

Wrist
Inner part: high
Outer part: low

The Position of the Elbow When Bent

The lengths of the arm from the shoulder to the elbow and the elbow to the wrist are 1:1. So we can see that the elbow is always at the midpoint between the shoulder and the wrist. The elbow always comes at the center point of a right angle line drawn to connect the shoulder and the wrist.

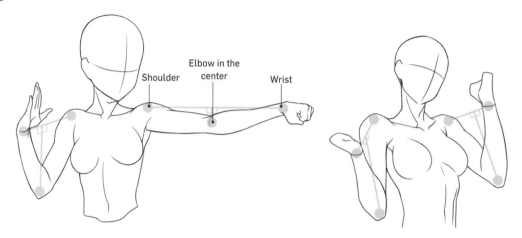

Shoulder

Elbow in the center

Wrist

◆ The Positions of the Elbows and the Arms

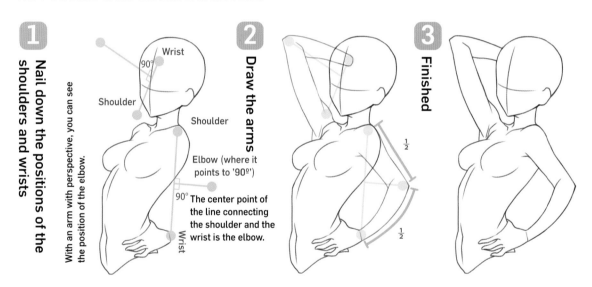

1 Nail down the positions of the shoulders and wrists

With an arm with perspective, you can see the position of the elbow.

Wrist

90°

Shoulder

Wrist

2 Draw the arms

Shoulder

Elbow (where it points to '90º')

90° The center point of the line connecting the shoulder and the wrist is the elbow.

3 Finished

$\frac{1}{2}$

$\frac{1}{2}$

Expert Tips

Angled Arms

When seen directly from the side, the lengths from the shoulder to the elbow and the elbow to the wrist are 1:1; but when the arm is seen from angle, such as when it's held out to the front, that ratio is not 1:1. This is because the forearm from the elbow to the wrist is drawn with perspective.

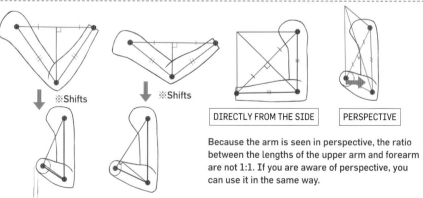

※Shifts

※Shifts

DIRECTLY FROM THE SIDE PERSPECTIVE

Because the arm is seen in perspective, the ratio between the lengths of the upper arm and forearm are not 1:1. If you are aware of perspective, you can use it in the same way.

Let's Try Drawing the Arm

◆ Be Aware of the Shape of the Arm

Now that we understand the shapes of the muscles
and the position of the elbow, let's try drawing the arm.

If we look at the "bone" (the light blue center line), you can see
that neither the arm nor the leg are straight. The thing I want you
to be aware of here is to make the joint areas thin. Create the inner
curves in these areas properly.

In addition, the heights of the inner and outer parts of the forearm
and wrist are different, so be aware of that as you draw them.

◆ Think of the Arm as Simple Shapes

Let's visualize the shape of the arm, and think of it in terms of simple shapes.

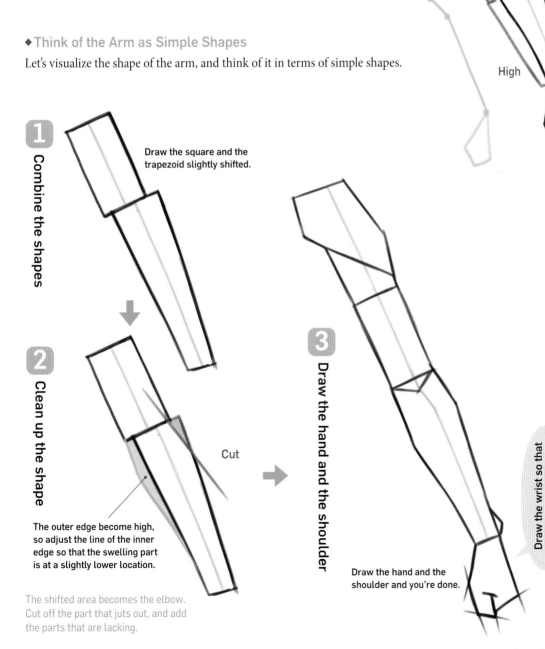

High

High

1 Combine the shapes

Draw the square and the
trapezoid slightly shifted.

2 Clean up the shape

Cut

The outer edge become high,
so adjust the line of the inner
edge so that the swelling part
is at a slightly lower location.

The shifted area becomes the elbow.
Cut off the part that juts out, and add
the parts that are lacking.

3 Draw the hand and the shoulder

Draw the wrist so that
the outer side is higher.

Draw the hand and the
shoulder and you're done.

The Fingers Are Connected in a Fan Pattern

Q. Which Is the Correct Way Fingers Are Attached?

Look at the illustration on the right? Which is the correct way fingers are attached?

The answer is B.

In A, the fingers are attached in parallel and the lengths look about the same. The thumb looks rather long too.

In B, the middle finger is long, and the fingers form a fan shape.

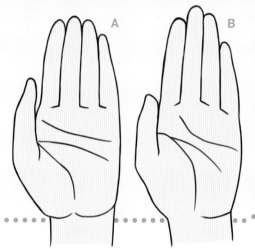

Learn About the Structure of the Hand

The finger joints are not parallel, but are in a fan shape. The ratio of the lengths of the fingers and the palm is 1:1.

The pointer finger, the middle finger and the ring finger are about the same length, but the middle finger looks longer because the fingers are attached in a fan shape.

The thumb is attached a little bit lower than the pointer finger.

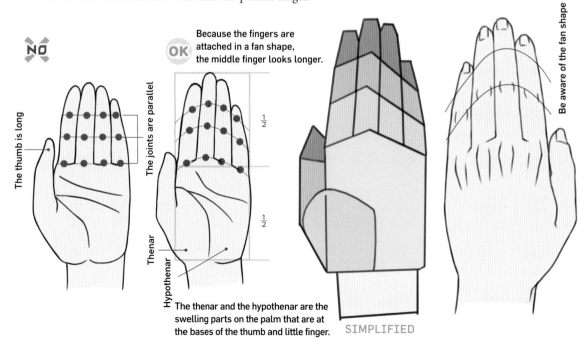

NO

The thumb is long

The joints are parallel

Thenar

Hypothenar

OK Because the fingers are attached in a fan shape, the middle finger looks longer.

$\frac{1}{2}$

$\frac{1}{2}$

The thenar and the hypothenar are the swelling parts on the palm that are at the bases of the thumb and little finger.

SIMPLIFIED

Be aware of the fan shape

Learn the Structure of the Fingers

◆ The Joints of the Fingers

The fingers get thinner toward the ends.
The back side forms a loose S shape,
and the palm side is cushioned.

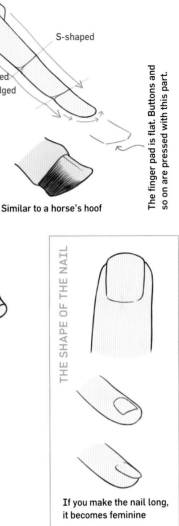

S-shaped

Ridged
Ridged

The finger pad is flat. Buttons and so on are pressed with this part.

Similar to a horse's hoof

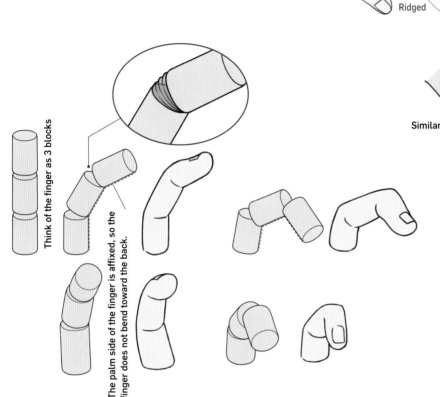

Think of the finger as 3 blocks

The palm side of the finger is affixed, so the finger does not bend toward the back.

THE SHAPE OF THE NAIL

If you make the nail long, it becomes feminine

◆ How the Hand Looks Seen from the Front

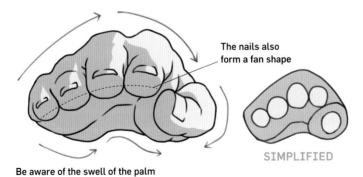

The nails also form a fan shape

SIMPLIFIED

Be aware of the swell of the palm

When seen from the front the fingers are not parallel, but are attached in a fan shape. In addition, the centers are arched, as you can see if you look at the fingernails.

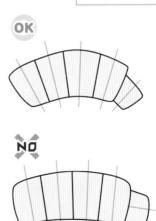

OK

NO

The illustration on the right is a simplified drawing of where the fingers are attached.
Be aware that they are attached in a fan shape, and be careful not to make the fingers straight.

Let's Try Drawing the Hand

1 Let's try drawing the hand

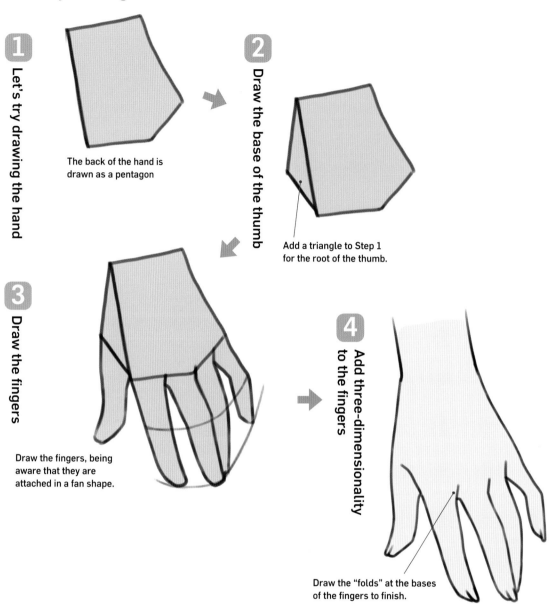

The back of the hand is drawn as a pentagon

2 Draw the base of the thumb

Add a triangle to Step 1 for the root of the thumb.

3 Draw the fingers

Draw the fingers, being aware that they are attached in a fan shape.

4 Add three-dimensionality to the fingers

Draw the "folds" at the bases of the fingers to finish.

※See the tip below

Expert Tip

Three-Dimensionality Can Be Indicated with One Line

By adding just one line to the back side of the hand at the base of the finger, the front-to-back relationship of the fingers becomes easy to understand, and you can depict three-dimensionality.
Here I have called that line the fold.

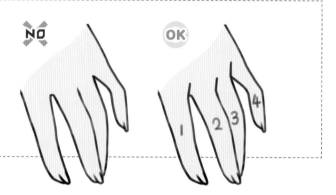

NO OK

1 2 3 4

Different Hand Angles

Let's look at the different angle patterns for the hand.

◆ 360 Degrees

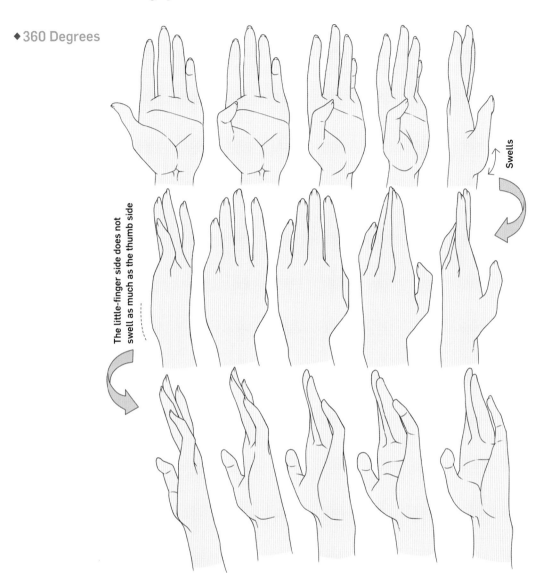

Swells

The little-finger side does not swell as much as the thumb side

◆ Hand Gestures

By putting more or less strength into the clench, pointing the fingers, or adding various gestures to the hand, you can depict fine-tuned emotions.

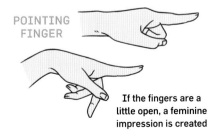

POINTING FINGER

If the fingers are a little open, a feminine impression is created

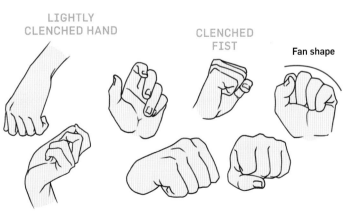

LIGHTLY CLENCHED HAND

CLENCHED FIST

Fan shape

Learn the Structure of the Legs

Q. Which Is the More Natural Leg?

On the right are simplified drawings of legs. Which one looks more natural?

Doesn't A look like it lacks any curves, and is like a stick?

Besides lacking any curves, because the height of each part is the same, it looks clumsy.

From here I will explain how to draw a leg like B with clear definition.

A B

The Keys to Drawing the Leg Are the Heights and the S Shapes

Here I have drawn a leg using the unnatural A version above as a reference. Look at the key points on the leg—the thigh, the knee, the calf, and the ankle.

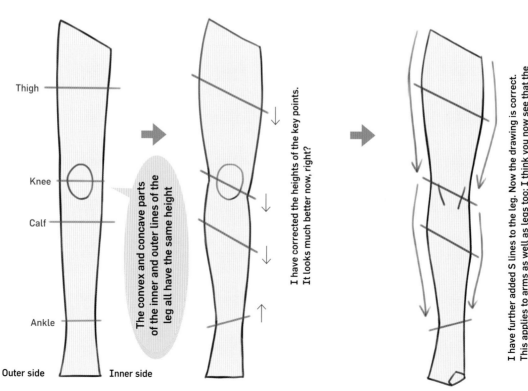

Thigh

Knee

Calf

Ankle

Outer side Inner side

The convex and concave parts of the inner and outer lines of the leg all have the same height

I have corrected the heights of the key points. It looks much better now, right?

I have further added S lines to the leg. Now the drawing is correct. This applies to arms as well as legs too; I think you now see that the keys to drawing them correctly are the heights and the S shapes.

◆ Learn the Muscles of the Leg

The leg has a number of muscles. The shape of the leg has the unique feature of changing easily since there are soft muscles in the thigh such as the biceps femoris muscle and the quadriceps muscle.

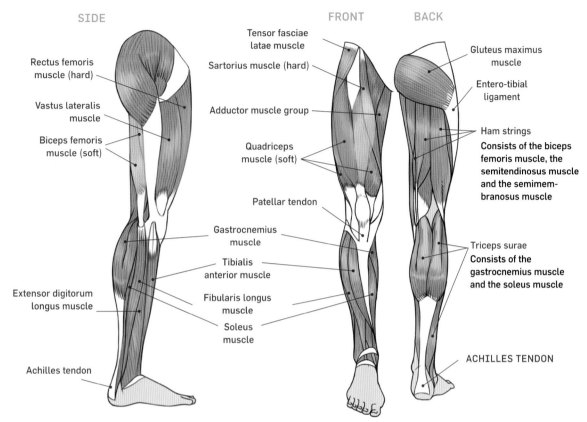

SIDE

Rectus femoris muscle (hard)

Vastus lateralis muscle

Biceps femoris muscle (soft)

Extensor digitorum longus muscle

Achilles tendon

FRONT

Tensor fasciae latae muscle

Sartorius muscle (hard)

Adductor muscle group

Quadriceps muscle (soft)

Patellar tendon

Gastrocnemius muscle

Tibialis anterior muscle

Fibularis longus muscle

Soleus muscle

BACK

Gluteus maximus muscle

Entero-tibial ligament

Ham strings
Consists of the biceps femoris muscle, the semitendinosus muscle and the semimembranosus muscle

Triceps surae
Consists of the gastrocnemius muscle and the soleus muscle

ACHILLES TENDON

How the Leg Looks Different Depending on the Angle

The inside and outside parts of the leg have different heights. Let's look at the differing heights by the viewing angle.

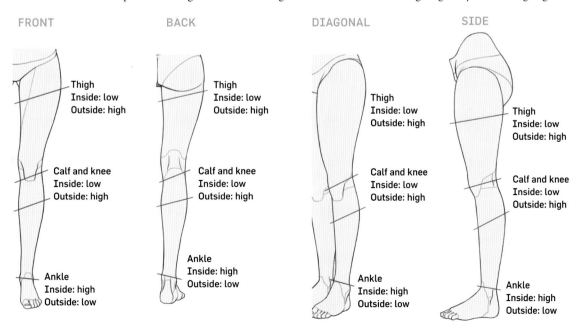

FRONT

Thigh
Inside: low
Outside: high

Calf and knee
Inside: low
Outside: high

Ankle
Inside: high
Outside: low

BACK

Thigh
Inside: low
Outside: high

Calf and knee
Inside: low
Outside: high

Ankle
Inside: high
Outside: low

DIAGONAL

Thigh
Inside: low
Outside: high

Calf and knee
Inside: low
Outside: high

Ankle
Inside: high
Outside: low

SIDE

Thigh
Inside: low
Outside: high

Calf and knee
Inside: low
Outside: high

Ankle
Inside: high
Outside: low

The Volume of the Leg

Next, let's look at the differences between male and female legs.

◆ Female

The leg in the middle is a standard leg. The leg to the right of it is thinner, and the legs to the left of it are more muscular. The key point is that on female legs, the thigh and the calf form gentle curves.

Thicker Slimmer

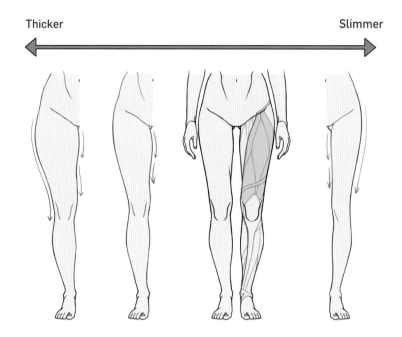

◆ Male

The male legs here are drawn to be thinner toward the right side and more muscular to the left. The key point here is that if you draw the leg so that it looks like the edges are bulging, you can differentiate between masculine and feminine legs.

Muscular Streamlined

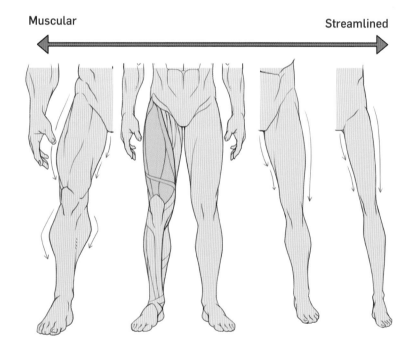

Expert Tip

The Thigh and the Calf Are Key to the Volume of the Leg

When you want to create a thicker or thinner body, you put on more flesh or shave it off. In order to do that, adjust the areas that are marked with arrows.

As I explained in the section on inward curves (page 26), the key is not to change the widths of the inward curving knees and ankles very much.

Let's Try Drawing the Leg

◆ Be Aware of the Shape of the Leg

We now understand the shapes of the muscles and the location of the knee, so let's try drawing a leg.

If we look at the bone (the light blue center line), you can clearly see that as with the arm, the leg is not straight. The thing I want you to be aware of here is to make the joint areas thin. Create the inner curves in these areas properly.

In addition, the heights of the insides and outsides of the thigh, calf and ankle are different, so be aware of that as you draw them.

◆ Think of the Leg as Simple Shapes

Let's visualize the shape of the leg, and think of it in terms of simple shapes.

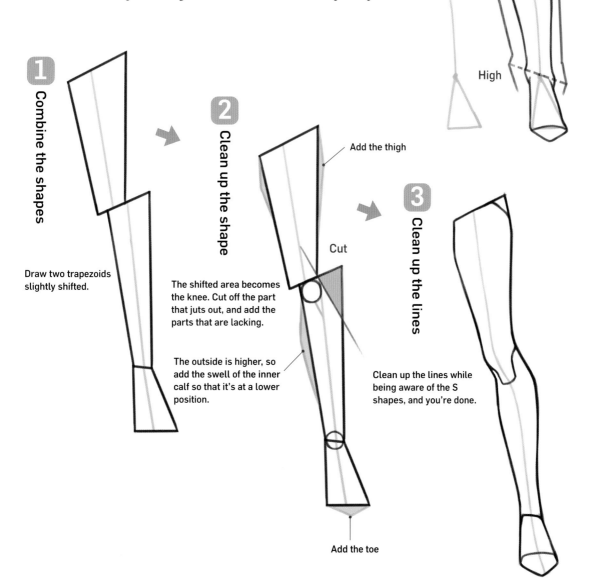

1 Combine the shapes

Draw two trapezoids slightly shifted.

2 Clean up the shape

Add the thigh

Cut

The shifted area becomes the knee. Cut off the part that juts out, and add the parts that are lacking.

The outside is higher, so add the swell of the inner calf so that it's at a lower position.

Add the toe

3 Clean up the lines

Clean up the lines while being aware of the S shapes, and you're done.

High

High

High

Changes in the Shape of the Leg

Let's look at how the shape of the leg changes when it is bent or when sitting.

◆ Sitting

When the leg is sitting or raised, the thigh looks like a triangle.

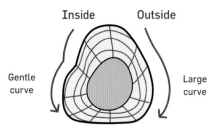

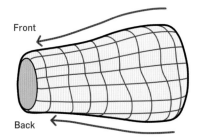

The inside curves gently, and the outside swells out in a large curve.

The back of the thigh forms a gentle curve when sitting in order to make it easier to sit.

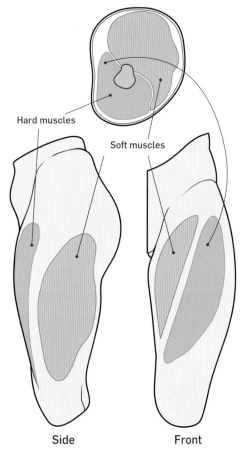

The thich has soft and hard muscles.

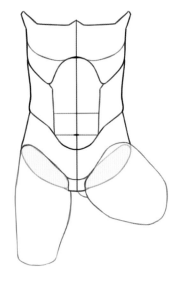

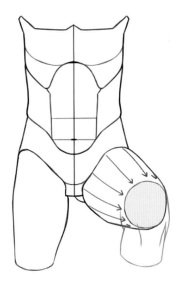

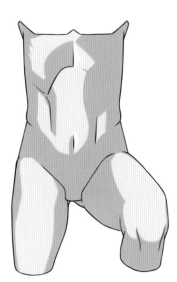

Since the inside and back of the thigh are made up of soft muscles, depict the differences in volume when you draw them.

◆ Kneeling

When kneeling, the thigh and the calf are pushed together and look like they're somewhat fused.

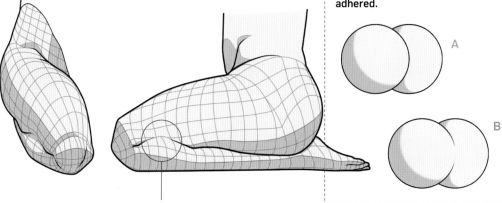

The thigh and the calf stick together

Expert Tip

How Coherent Parts Are Depicted

If you compare A and B here, doesn't it look like B is more coherent? By cutting off part of the line that is stuck together, you can give the impression that the parts are more closely adhered.

A

B

TAKE A CLOSER LOOK

Think of the Shape of the Leg as Cylinders

First, look at the illustration on the right. It's a drawing of a figure wearing kneesocks, but which one looks natural?

Both may look natural, but if you look closely at the tops of the socks, doesn't B look rather strange?

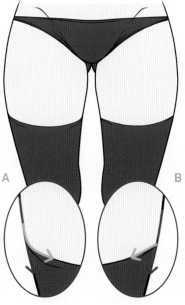

A B

OK

A shape like a small "r"

Round

NO

A shape like a capital "T"

Angled

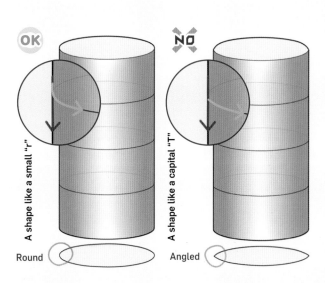

Now let's look at the legs as simplified illustrations. The sock top on B rounds around the thigh in a "T" shape. This is not a circle, but a depiction of an angle.

The human body is entirely made up of ovoid (oval-shaped) spheres. By being aware of the way lines flow and intersect, you an increase the sense of three-dimensionality.

Thickness Is Important for the Feet

Q. Which Foot Is Correctly Drawn?

Which is the correct foot on the right, A or B? The answer is A. B is an example of the way feet are often drawn incorrectly.

Because the top of the foot is too short, the whole foot looks like it's too flat.

Here I'll explain some tips for how to draw feet.

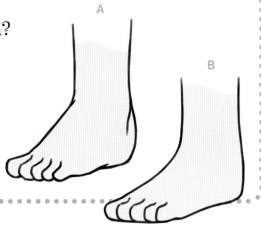

Be Aware of the Top of the Foot

Be very aware that the instep or the top of the foot has thickness when you draw the foot.

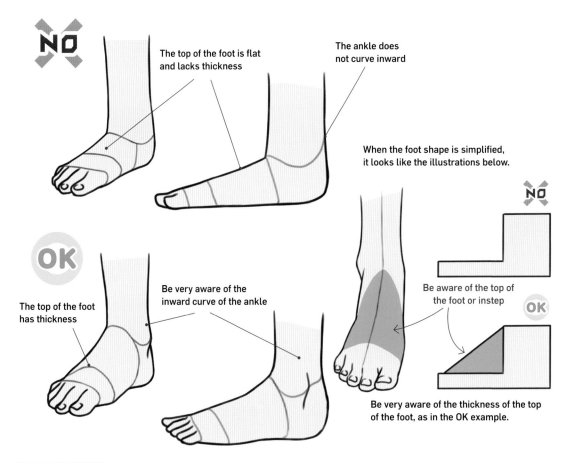

The top of the foot is flat and lacks thickness

The ankle does not curve inward

When the foot shape is simplified, it looks like the illustrations below.

The top of the foot has thickness

Be very aware of the inward curve of the ankle

Be aware of the top of the foot or instep

Be very aware of the thickness of the top of the foot, as in the OK example.

Let's Learn About the Shape of the Foot

The foot can be largely divided into 3 blocks.

It becomes easier to envision when you remember that the toes (1) are a triangle, the instep or top of the food is a trapozoid (2), and the heel (3) is a square.

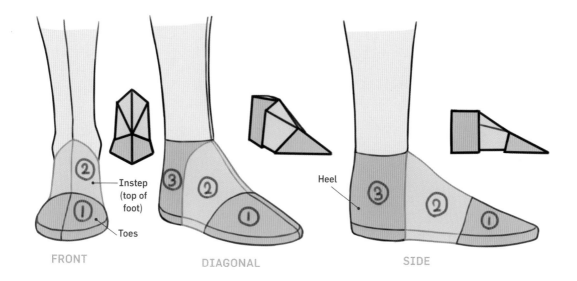

Instep (top of foot)

Toes

Heel

FRONT

DIAGONAL

SIDE

How to Differentiate Inward-Facing and Outward-Facing Feet

It is very easy to differentiate outward and inward-facing feet.
With outward-facing feet draw the inside line straight; do the opposite for inward-facing feet, to differentiate between the two.

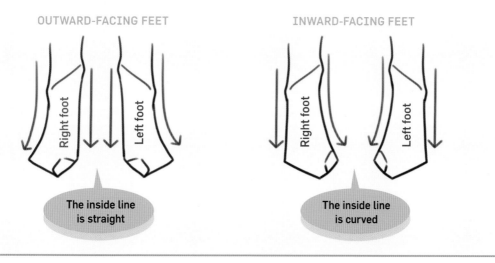

OUTWARD-FACING FEET

INWARD-FACING FEET

Right foot

Left foot

Right foot

Left foot

The inside line is straight

The inside line is curved

How to Draw the Foot

Let's look at simple ways to draw the foot.

◆ Bare Foot (Left)

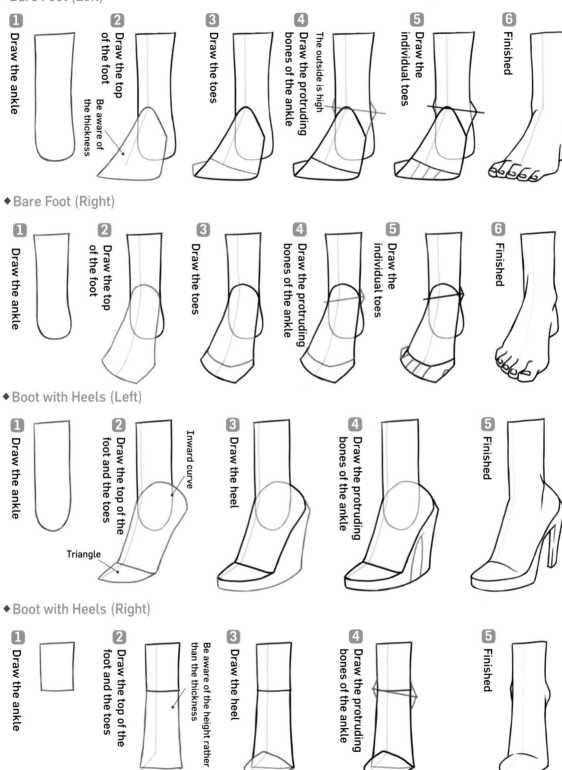

1. Draw the ankle
2. Draw the top of the foot — Be aware of the thickness
3. Draw the toes
4. Draw the protruding bones of the ankle — The outside is high
5. Draw the individual toes
6. Finished

◆ Bare Foot (Right)

1. Draw the ankle
2. Draw the top of the foot
3. Draw the toes
4. Draw the protruding bones of the ankle
5. Draw the individual toes
6. Finished

◆ Boot with Heels (Left)

1. Draw the ankle
2. Draw the top of the foot and the toes — Inward curve — Triangle
3. Draw the heel
4. Draw the protruding bones of the ankle
5. Finished

◆ Boot with Heels (Right)

1. Draw the ankle
2. Draw the top of the foot and the toes — Be aware of the height rather than the thickness
3. Draw the heel
4. Draw the protruding bones of the ankle
5. Finished

Various Angles of the Foot

I have drawn the foot at various angles. Draw the arch of the foot properly. When the foot is flat it looks awkward, so be careful of that.

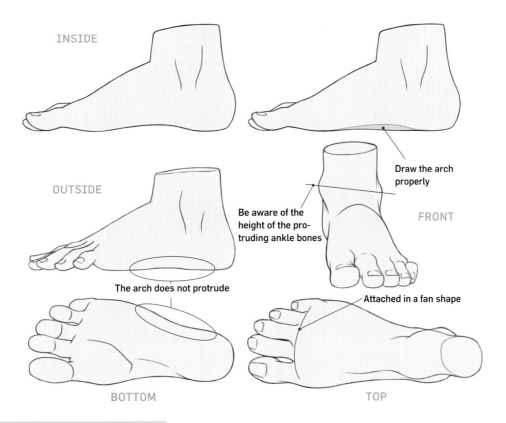

INSIDE

OUTSIDE

Draw the arch properly

Be aware of the height of the protruding ankle bones

FRONT

The arch does not protrude

Attached in a fan shape

BOTTOM

TOP

TAKE A CLOSER LOOK

Comparing the Sizes of the Hands and Feet

Compared to realistic illustrations, in two-dimensional illustrations the head is drawn bigger, so if you make the hands and feet the same size as on a real human being, they'll look overly large and unnatural. The hand is about the same size as the face (from the forehead to the chin). It's a good idea to visualize the foot as being a little bit smaller than the head.

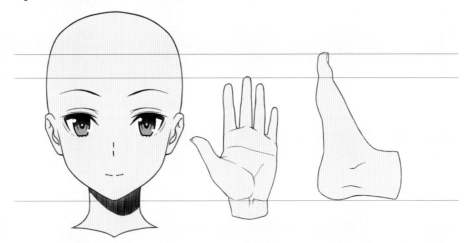

The Only Part of the Torso that Moves Is the Midsection

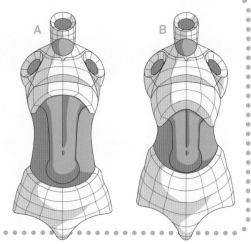

Q. Which Torso Is Rendered Right?

Which is the natural length of the torso, A or B? The answer is B. The sternum and the pelvis of a human being are actually about this big.

The sternum and the pelvis are rigid. The only part of the torso that can move is the midsection or the stomach area.

The Movable Area of the Torso

Here I show what surfaces exist on a female torso in a simplified form. The blue sections are the mobile areas.

Since the chest and the hip area are mostly made of bone, they basically do not change much.

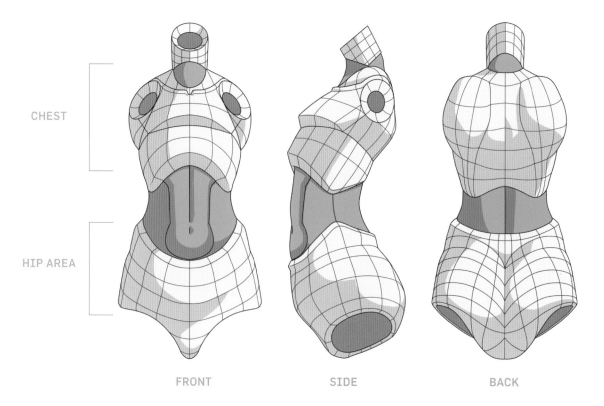

CHEST

HIP AREA

FRONT　　　　　SIDE　　　　　BACK

Simplify the Torso

Let's start by dividing the torso into 3 parts—the chest, the midsection, and the hip area—and simplifying them. By making the parts into simplified shapes, you can see how perspective works and understand how each part overlaps the others. It becomes a guide to how to draw the torso from underneath or from above.

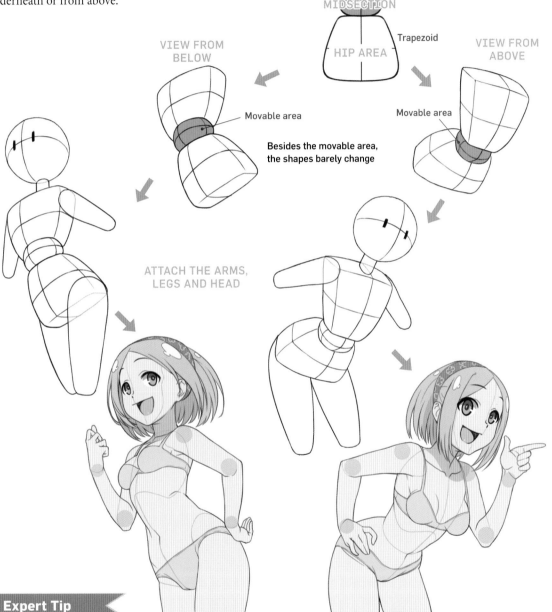

EYE LEVEL VIEW

CHEST — Trapezoid

STOMACH / MIDSECTION — Circle

HIP AREA — Trapezoid

VIEW FROM BELOW

VIEW FROM ABOVE

Movable area

Movable area

Besides the movable area, the shapes barely change

ATTACH THE ARMS, LEGS AND HEAD

Expert Tip

Think About Posable Figures

You have probably seen posable mannequins and figures, right? The figures are made of a hard plastic, with rigid unbending parts. But they still don't look wholly unnatural. Why is that?

This is because the forms skillfully divide the parts with bones and moveable joints, recreate the parts of the body that move on a human figure. In other words, by memorizing the moving parts and the nonmoving parts on the human form, you'll be able to draw poses from whatever angle without it looking wrong.

For the Breasts, Visualize a Water Balloon

To draw the breasts, it's a good idea to visualize a water balloon hanging on a diagonally leaning board. Changes in the shape of the breast according to its size occur due to its weight and the force of gravity. By adjusting the amount of water in the water balloon, you can visualize the differences in the size of a breast.

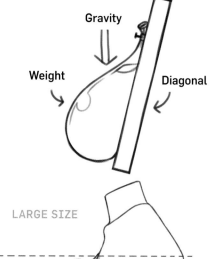

◆ Differences in Shapes Depending on the Size

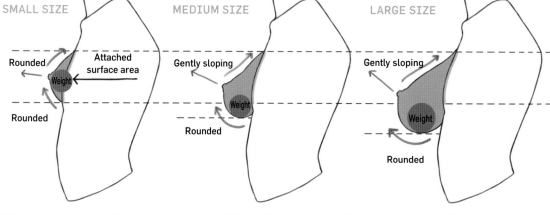

SMALL SIZE

Rounded

Attached surface area

Weight

Rounded

MEDIUM SIZE

Gently sloping

Weight

Rounded

LARGE SIZE

Gently sloping

Weight

Rounded

With small breasts, since the weight is contained inside the attached surface area, the top and bottom sides are both rounded and do not change much.

With medium or large-sized breasts, the weight shifts from the attached surface area down to the ground, so the lower side rounds out into a shape that is close to a circle. The upper side becomes a gentle slope pulled down by the weight. Because the nipple is pulled down also from its original position by the weight, it faces upward.

◆ How the Breasts Swell

The breast swells with the nipple at its center.

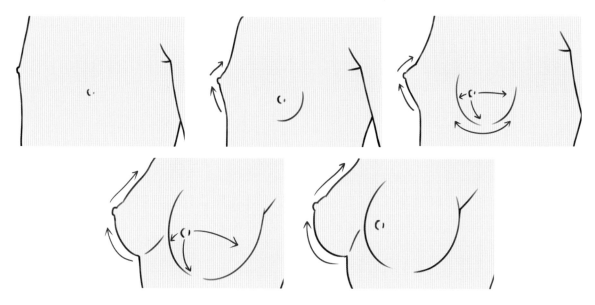

How the Breasts Are Attached

The sternum is shaped like an oval, so the breasts area attaches diagonally as shown in the illustration. When drawing them from the front, it's a good idea to place the nipples on the outside of the centers of the breasts.

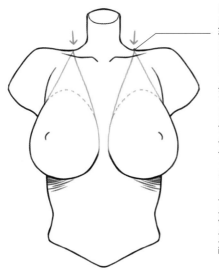

Think of the breasts as being hung at the same position as the straps of a swimsuit. Be aware of forming a teardrop shape with the base of the neck as its top point.

Conventional bras have straps that are a little more widely placed than those of a swimsuit.

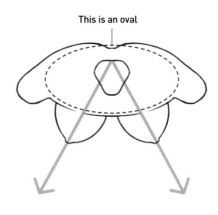

This is an oval

TAKE A CLOSER LOOK

The Chest Area Is Surprisingly Thick

The chest area is thicker than you may imagine. If you draw it too thin because the character is thin, the S shape will become weak, and the character will look emaciated with a narrow body.

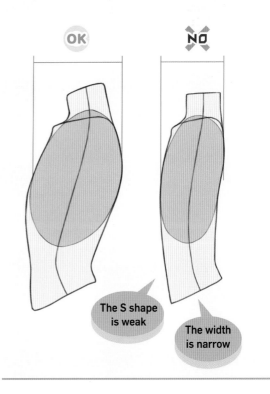

The S shape is weak

The width is narrow

Expert Tip

How the Breasts Are Attached

There is a significant area between the area where the breasts are attached and the collarbone.

If you draw in the NO (bad) way the area from the bottom of the breasts down to the abdomen becomes long, and the torso looks too long, so be careful of that.

Although it's possible to correct errors by changing the proportions, while you're still improving, it's best to follow the basics.

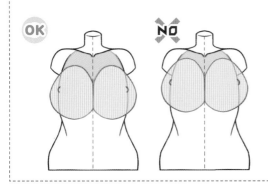

How the Shoulders, Legs and Neck Are Attached

Q. Which Arm Is Connected Correctly?

Which arm is connected correctly? The answer here is B.

The shoulder is attached straight in A, and the side is flat too.

Up until now I have explained how to draw various parts of the body, so here I will explain how to connect the shoulders, the legs and the neck.

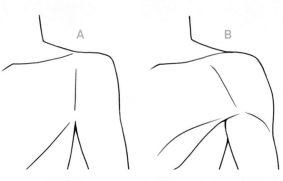

The Structure of the Shoulder

◆ How the Shoulder Is Attached

The structure of the shoulder is attached to the upper arm as if to surround it.

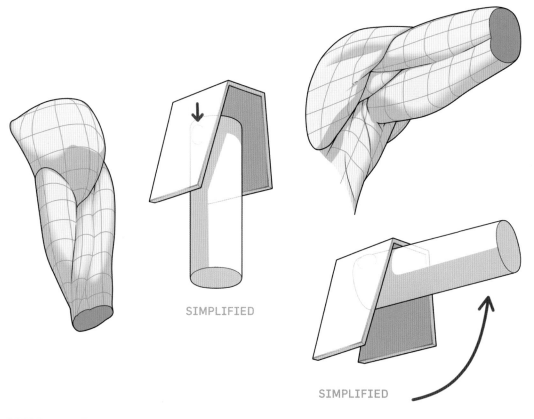

SIMPLIFIED

SIMPLIFIED

◆ The Movable Area of the Shoulder

The shape of the shoulder changes when the upper arm moves.

◆ The Shape of the Shoulder

The shoulder does not swell into a rounded sphere, but bulges while bending at various angles. If you draw the shoulder rounded, it will look too big, especially on female figures.

In the case of muscular figures, these angles are well defined, so it's a good idea to exaggerate them.

If this is drawn rounded, it looks muscular.

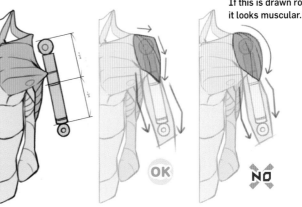

Expert Tips

The Rotation of the Wrist

The wrist itself doesn't actually rotate; when the arm rotates, the wrist looks like it's twisting too.

Try to turn your hand while holding onto your wrist. Your hand doesn't turn independently, right?

The forearm is made up of two bones, and it rotates by crossing these two bones.

When the palm of the hand is facing the front, these two bones are separated. By turning the arm to the inside, these two bones cross and rotate. The shape of the forearm changes too at this time, so be aware of that when you're drawing.

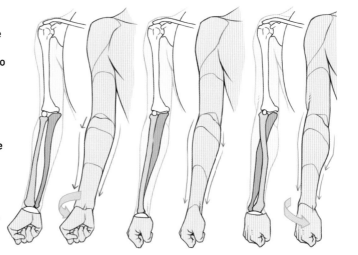

The Structure of the Groin

◆ How the Leg Is Attached

The femur or the thigh bone is connected to the hip bone in an L shape. This is why the legs can be spread wide to the sides.

◆ The Motion Range of the Leg

The leg moves to the side and back and forth.

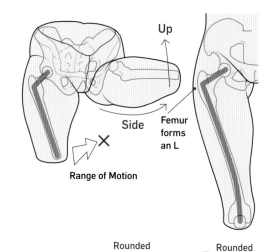

Up

Side

Femur forms an L

×

Range of Motion

The Shape of the Knee

◆ The Shape of the Knee and How It Moves

Be aware that when the knee is bent, the cap moves down toward the calf.

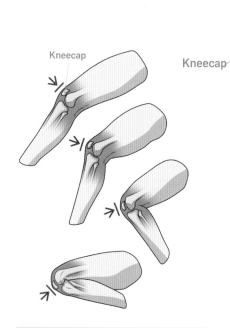

Kneecap

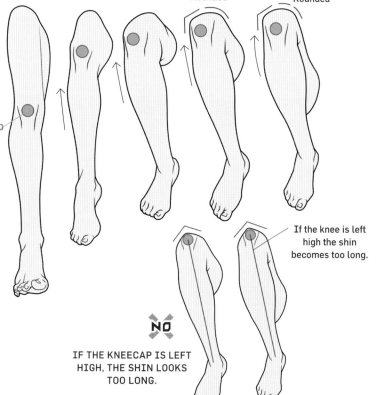

Rounded

Rounded

Kneecap

If the knee is left high the shin becomes too long.

NO

IF THE KNEECAP IS LEFT HIGH, THE SHIN LOOKS TOO LONG.

TAKE A CLOSER LOOK

The Motion Range of the Ankle

Although you can move the ankle to the back, the toes don't rise that much. When moving the foot from the left to the right, it can't move much to the inside, but it rotate significantly to the outside.

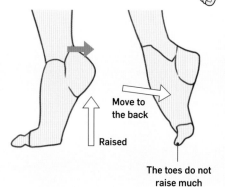

Raised

Move to the back

The toes do not raise much

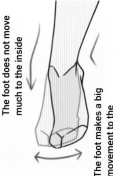

The foot does not move much to the inside

The foot makes a big movement to the outside

The Structure of the Neck

◆ How the Neck Is Attached

If you draw the lines of the sternocleidomastoid muscles as the outlines of the neck, you can modify the thickness of the neck.

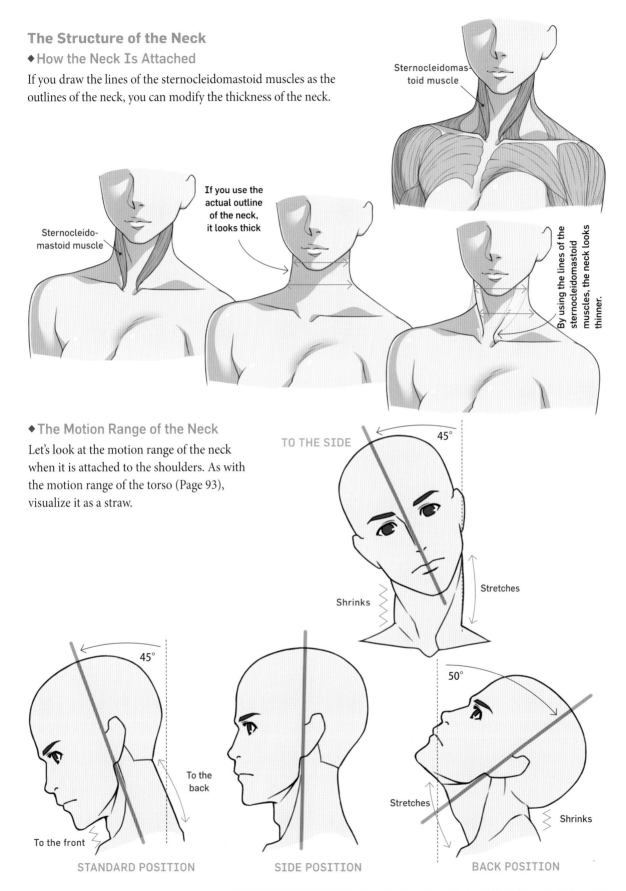

Sternocleidomastoid muscle

Sternocleido-mastoid muscle

If you use the actual outline of the neck, it looks thick

By using the lines of the sternocleidomastoid muscles, the neck looks thinner.

◆ The Motion Range of the Neck

Let's look at the motion range of the neck when it is attached to the shoulders. As with the motion range of the torso (Page 93), visualize it as a straw.

TO THE SIDE

45°

Shrinks

Stretches

45°

To the back

To the front

STANDARD POSITION

SIDE POSITION

50°

Stretches

Shrinks

BACK POSITION

The Various Movements of the Shoulders

I've tried drawing various shoulder movements. The thing to be careful of here is not to draw flat surfaces.

Be aware that the upper arms are in front of the back, and the pectoralis major (the breast muscle) is attached in front of the upper arms.

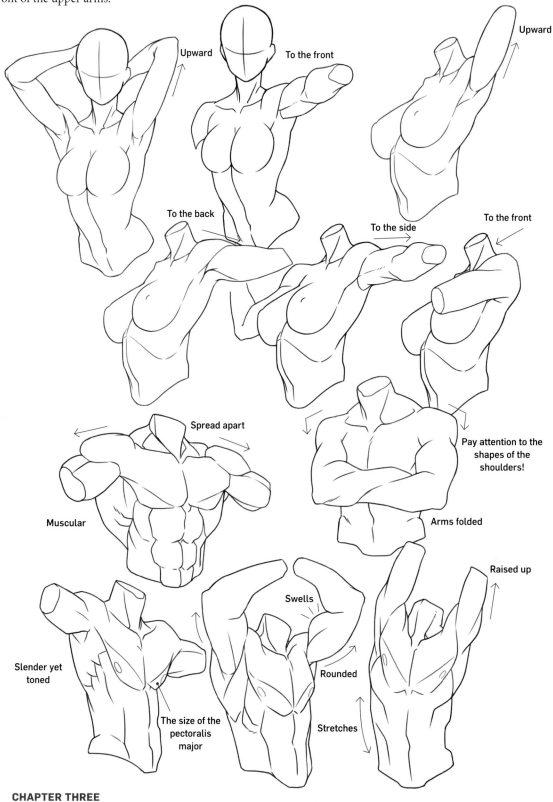

Upward

To the front

Upward

To the back

To the side

To the front

Spread apart

Muscular

Pay attention to the shapes of the shoulders!

Arms folded

Slender yet toned

Swells

Raised up

Rounded

The size of the pectoralis major

Stretches

The Muscles of the Upper Body

When you start out drawing, basically there is no need to learn the structure of the muscles. It's enough to start with simple shapes.

It's enough to remember the shapes of the surface muscles only, but here I'll offer a detailed visual breakdown for your reference.

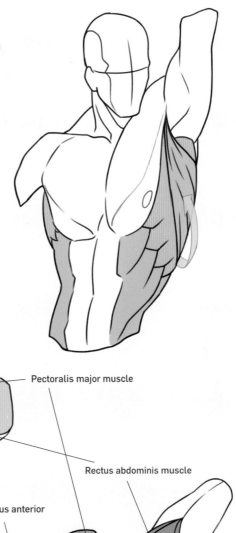

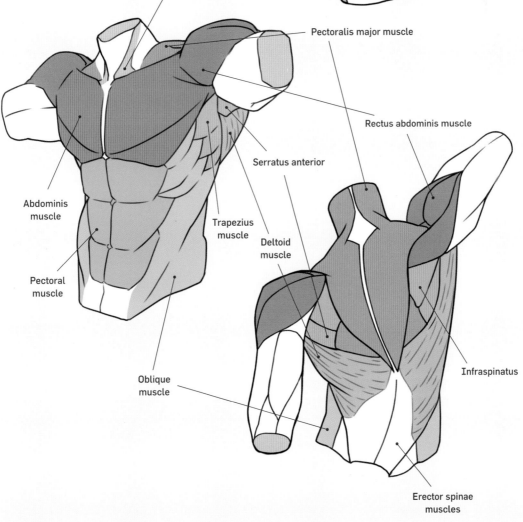

Sternocleidomastoid muscle

Pectoralis major muscle

Rectus abdominis muscle

Serratus anterior

Abdominis muscle

Trapezius muscle

Deltoid muscle

Pectoral muscle

Oblique muscle

Infraspinatus

Erector spinae muscles

When Posing Your Figure, Be Aware of Contrapposto

Q. Which Pose Looks More Appealing?

Which pose looks more appealing, A or B? I think most people would answer A. These both depict the same person with the same proportions, but A looks much more natural.

This pose where the figure stands with its weight on one leg is called contrapposto in the visual arts.

By being aware of this compositional concept, you can draw a range of dynamically lively and realistic poses.

A

B

About Contrapposto

Contrapposto, to simplify its meaning, refers to a standing pose where the weight is on one leg. Because the shoulders and arms are shifted over from the axis of the buttocks and legs, it's a pose with more dynamism and complexity.

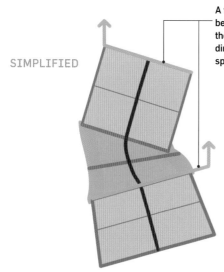

SIMPLIFIED

A feature of this pose is that because the shoulders and the hips tilt in opposite directions, the line of the spine forms an S shape.

REALISTIC

The collarbones and the chest tilt in the same way

The pelvis and the groin tilt in the same way

Let's apply contrapposto to sample illustrations.

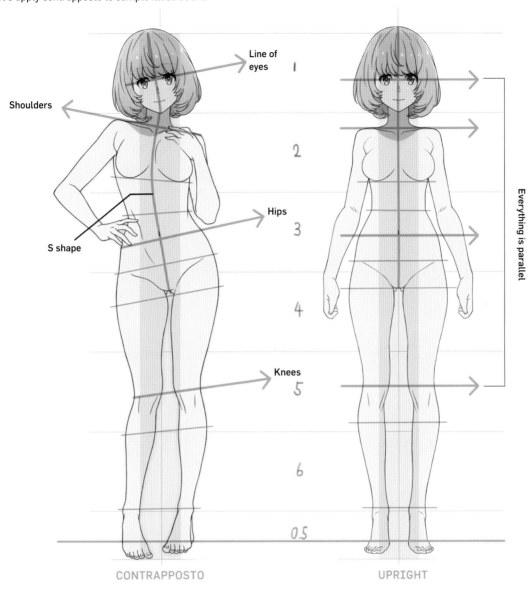

Line of eyes

Shoulders

S shape

Hips

Knees

Everything is parallel

1

2

3

4

5

6

0.5

CONTRAPPOSTO

UPRIGHT

TAKE A CLOSER LOOK

For the Stomach's Range of Motion, Visualize a Bending Straw

The motion range of the torso is similar to that of a bendy straw. The straw can bend because the inner side shrinks and the outer side stretches.

In the same way, the opposite side of the torso that is bent stretches, be aware of this when you draw it (see Page 83).

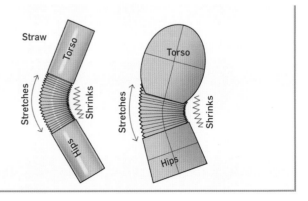

Straw

Torso

Stretches

Shrinks

Hips

Torso

Stretches

Shrinks

Hips

Add a Twist

When I described contrapposto, I noted that the tilt of the shoulders and the tilt of the hips go in opposite directions. But another method is to add a twist to the upper and lower bodies. By doing this, the pose becomes more natural, so give it a try.

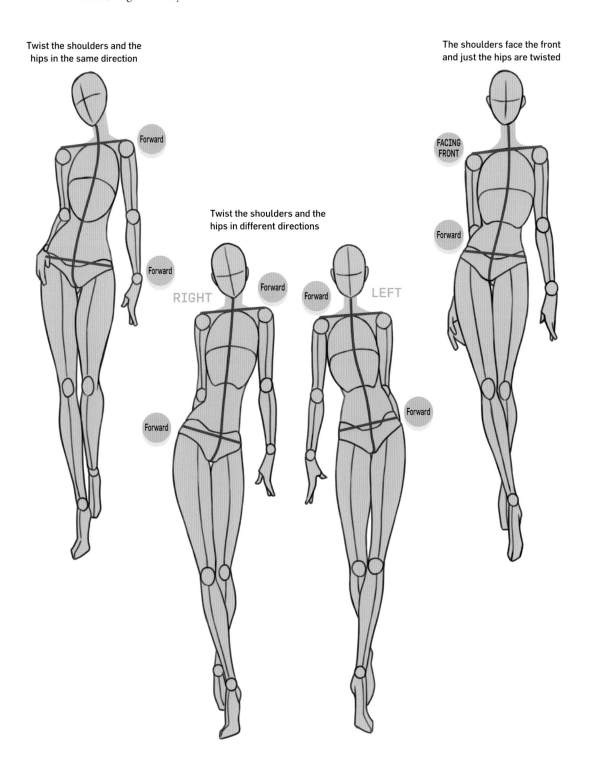

Twist the shoulders and the hips in the same direction

Forward

Forward

Forward

The shoulders face the front and just the hips are twisted

FACING FRONT

Forward

Twist the shoulders and the hips in different directions

RIGHT

Forward

Forward

LEFT

Forward

Attractive Poses Without Using Contrapposto

When you are drawing standing figures, do your pictures sometimes turn out flat? This is because everything is drawn at eye level, so the three-dimensionality is lost.

One way to make the figure look better is to draw the upper body from the waist up as seen from below, and the lower body from the waist down seen from above. In this way, you can draw a three-dimensional character with perspective.

View from below

View from above

◆ Make the Drawing Look Three-Dimensional

One method for making a drawing look three-dimensional is to indicate the front-to-back relationships between each part skillfully.

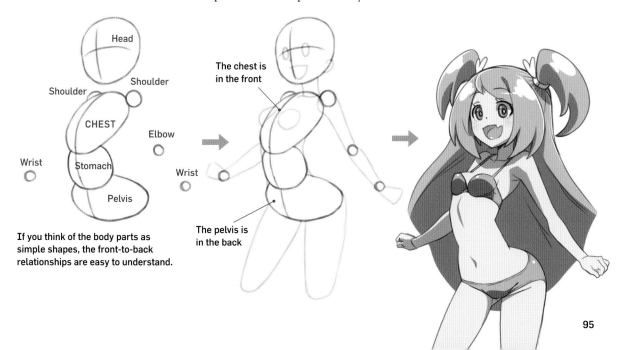

Head

Shoulder

Shoulder

CHEST

Elbow

Wrist

Stomach

Wrist

Pelvis

If you think of the body parts as simple shapes, the front-to-back relationships are easy to understand.

The chest is in the front

The pelvis is in the back

The Keys to the Wrinkles on Clothing Are Gravity and Contact Points

Q. Which One Looks More Natural?

There's no doubt that A is more natural. Although the B shirt has wrinkles, they look very monotonous. This is because they all have the same pattern.

As with drawing hair (Page 60), when the same pattern is lined up, it looks repetitive and unnatural.

Tips for Wrinkles

If you draw wrinkles in the same way repeatedly at the same distance, the drawing will look amateurish.

If you add too many wrinkles in one section, the parts without any wrinkles will look empty and create too stark a contrast.

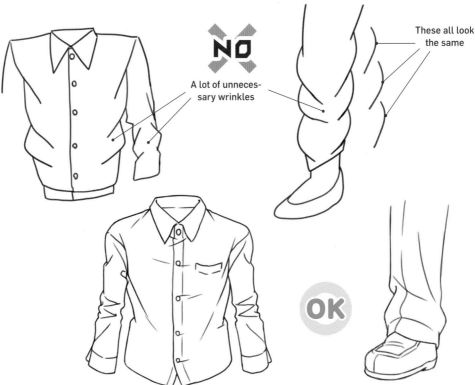

NO

A lot of unnecessary wrinkles

These all look the same

OK

The Key Points for Adding Wrinkles

Wrinkles are formed at the shoulders, hips and in the case of females above the breasts (wherever the body and the clothes meet contact points) and the fabric is pulled to form wrinkles.

The main wrinkle points are:

1. Wrinkles that form due to the downward pull of gravity

2. The wrinkles that form by being pulled between contact points

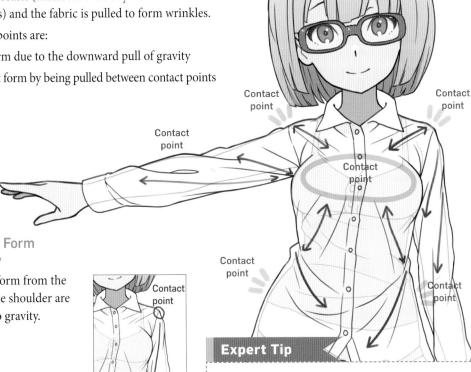

◆ Wrinkles That Form Due to Gravity

The wrinkles that form from the contact point on the shoulder are pulled down due to gravity.

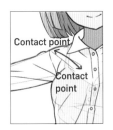

◆ Wrinkles Formed by Being Pulled Between Contact Points

The wrinkles that form from the shoulder to the chest are created by being pulled between contact points.

Since gravity pulls on wrinkles between contact points too, they curve somewhat downward.

Expert Tip

Observe the Wrinkles on Clothing
The shapes of wrinkles on clothing change depending on the thickness of the fabric or the material, so it's important to observe the clothing you usually wear as well as the clothes other people wear in everyday life, and to learn the characteristics of various types of textiles.

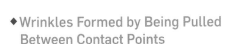

The contact points for wrinkles change when the body moves.

Put on some clothes and observe where there are contact points by moving your own body.

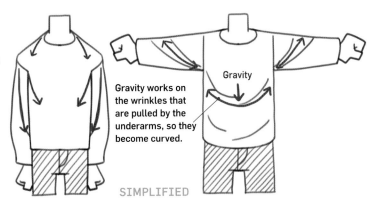

Gravity works on the wrinkles that are pulled by the underarms, so they become curved.

SIMPLIFIED

How Wrinkles Are Formed

◆ Lower the Arms

When the arms are raised, the wrinkles on the arm gather at the underarm.

When the arms are lowered, the distance between each wrinkle becomes wider, and the contact point moves from the arm to the shoulder.

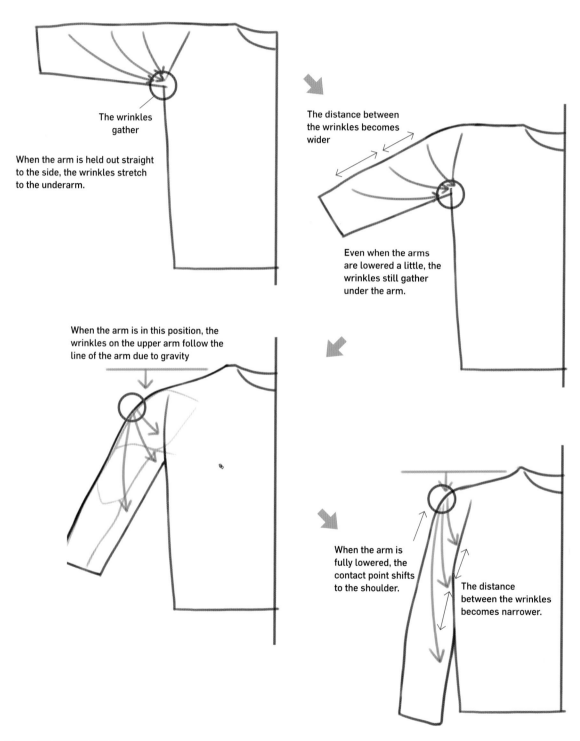

The wrinkles gather

When the arm is held out straight to the side, the wrinkles stretch to the underarm.

The distance between the wrinkles becomes wider

Even when the arms are lowered a little, the wrinkles still gather under the arm.

When the arm is in this position, the wrinkles on the upper arm follow the line of the arm due to gravity

When the arm is fully lowered, the contact point shifts to the shoulder.

The distance between the wrinkles becomes narrower.

◆ How Wrinkles Bend ● The Shape of the Cuff

Let's focus on how wrinkles on clothing bend.

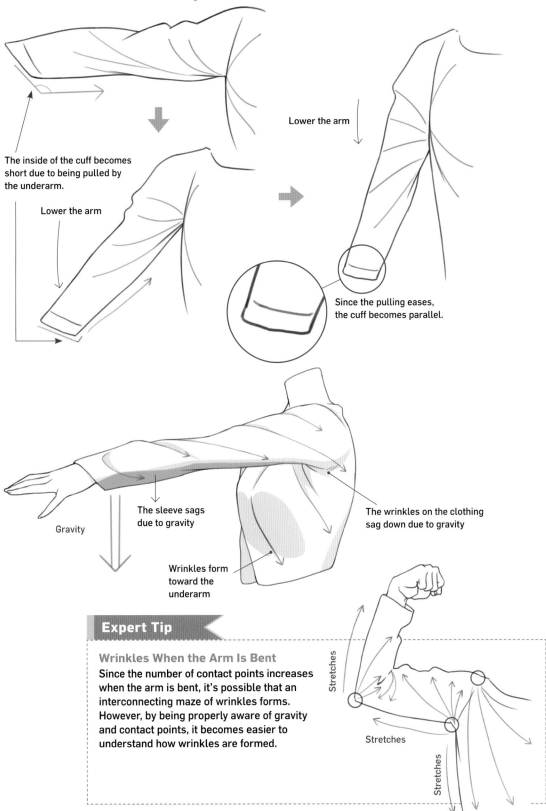

The inside of the cuff becomes short due to being pulled by the underarm.

Lower the arm

Lower the arm

Since the pulling eases, the cuff becomes parallel.

Gravity

The sleeve sags due to gravity

Wrinkles form toward the underarm

The wrinkles on the clothing sag down due to gravity

Expert Tip

Wrinkles When the Arm Is Bent
Since the number of contact points increases when the arm is bent, it's possible that an interconnecting maze of wrinkles forms. However, by being properly aware of gravity and contact points, it becomes easier to understand how wrinkles are formed.

Stretches

Stretches

Stretches

Wrinkle Patterns

Let's examine some wrinkle patterns on actual illustrations. If you look at contact points such as the underarm and the effects of gravity on them as you look at the drawings, I think they will be easier to understand.

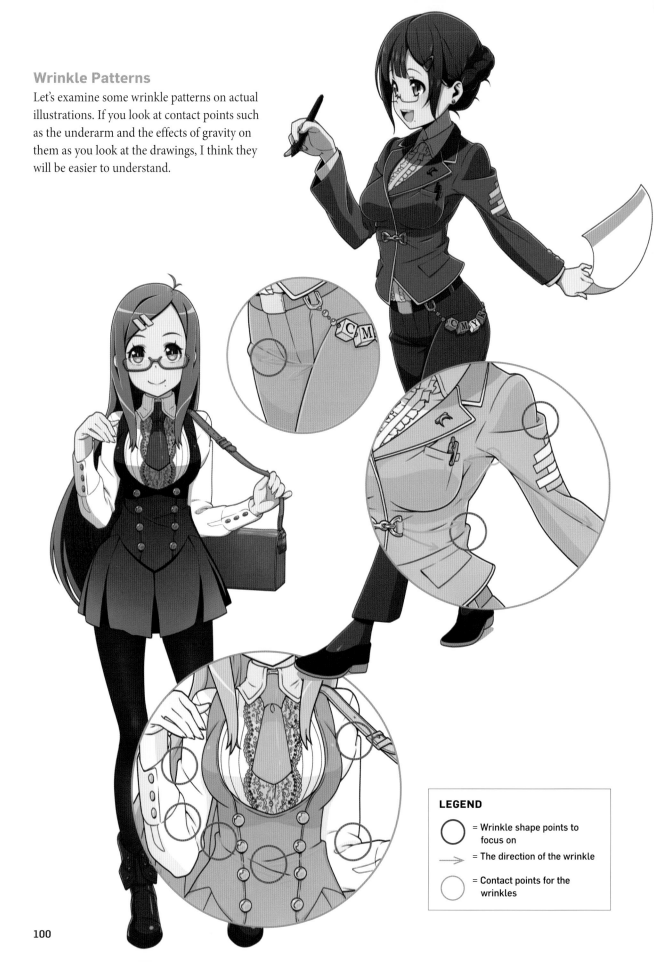

LEGEND

⬤ = Wrinkle shape points to focus on

→ = The direction of the wrinkle

◯ = Contact points for the wrinkles

Common Wrinkle Patterns
The same pattern of wrinkles is often used.
The key is to be properly aware of how the wrinkle rounds back to places where you cannot see them and what the folds on the fabric are like.

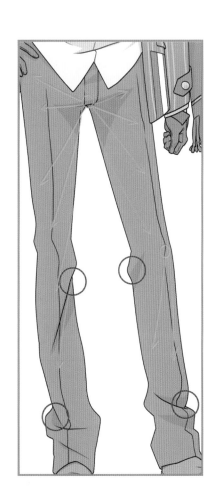

How Different Fabrics Form Wrinkles

The key to drawing different fabrics is the amount of wrinkles and their size. Another key is the way the fabric puffs out at the sleeves and the bottom hem.

◆ Thick Knit

Thick, heavy knits do not form many wrinkles.

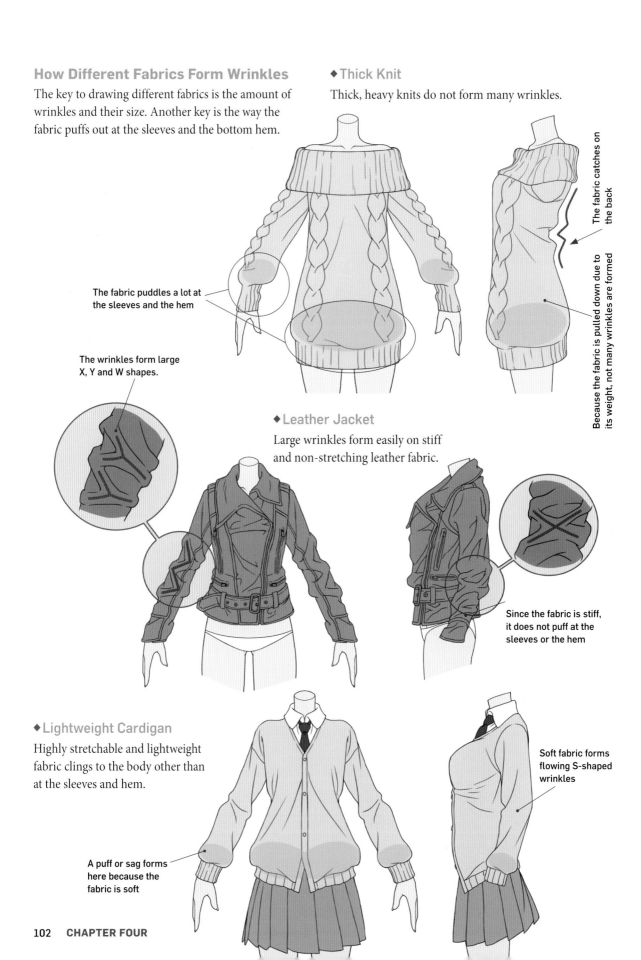

The fabric catches on the back

Because the fabric is pulled down due to its weight, not many wrinkles are formed

The fabric puddles a lot at the sleeves and the hem

The wrinkles form large X, Y and W shapes.

◆ Leather Jacket

Large wrinkles form easily on stiff and non-stretching leather fabric.

Since the fabric is stiff, it does not puff at the sleeves or the hem

◆ Lightweight Cardigan

Highly stretchable and lightweight fabric clings to the body other than at the sleeves and hem.

Soft fabric forms flowing S-shaped wrinkles

A puff or sag forms here because the fabric is soft

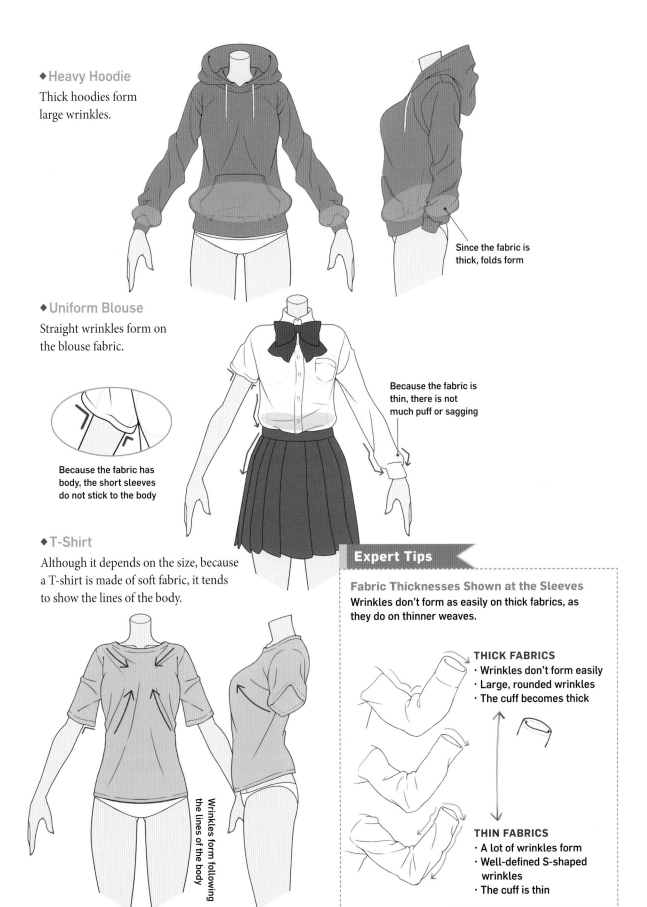

◆ Heavy Hoodie

Thick hoodies form large wrinkles.

Since the fabric is thick, folds form

◆ Uniform Blouse

Straight wrinkles form on the blouse fabric.

Because the fabric has body, the short sleeves do not stick to the body

Because the fabric is thin, there is not much puff or sagging

◆ T-Shirt

Although it depends on the size, because a T-shirt is made of soft fabric, it tends to show the lines of the body.

Wrinkles form following the lines of the body

Expert Tips

Fabric Thicknesses Shown at the Sleeves
Wrinkles don't form as easily on thick fabrics, as they do on thinner weaves.

THICK FABRICS
· Wrinkles don't form easily
· Large, rounded wrinkles
· The cuff becomes thick

THIN FABRICS
· A lot of wrinkles form
· Well-defined S-shaped wrinkles
· The cuff is thin

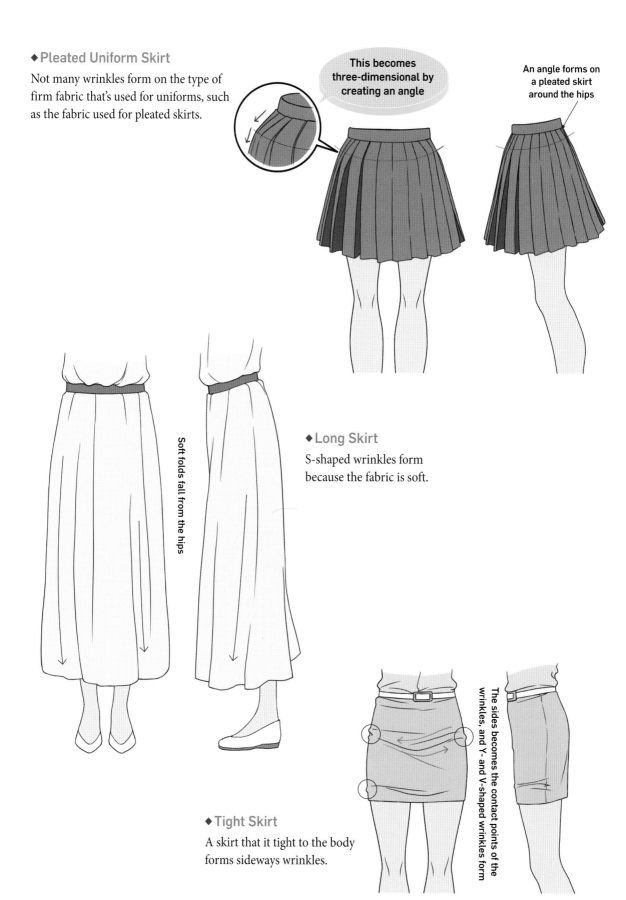

◆Pleated Uniform Skirt

Not many wrinkles form on the type of firm fabric that's used for uniforms, such as the fabric used for pleated skirts.

This becomes three-dimensional by creating an angle

An angle forms on a pleated skirt around the hips

Soft folds fall from the hips

◆Long Skirt

S-shaped wrinkles form because the fabric is soft.

The sides becomes the contact points of the wrinkles, and Y- and V-shaped wrinkles form

◆Tight Skirt

A skirt that it tight to the body forms sideways wrinkles.

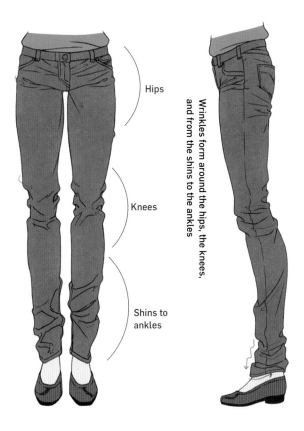

Hips

Knees

Shins to ankles

Wrinkles form around the hips, the knees, and from the shins to the ankles

◆ Jeans and Denim

Large wrinkles form because the fabric is stiff.

◆ Leather Pants

Since the fabric is stiff and has no stretch, large wrinkles form.

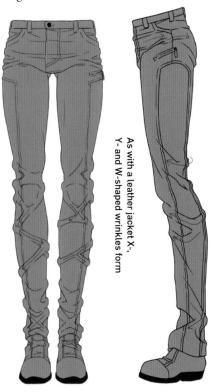

As with a leather jacket X-, Y- and W-shaped wrinkles form

◆ Tight Pants

Since these types of pants are fitted to the body, hardly any wrinkles are formed.

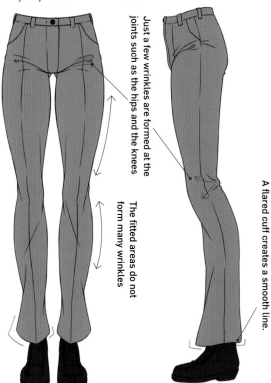

Just a few wrinkles are formed at the joints such as the hips and the knees

The fitted areas do not form many wrinkles

A flared cuff creates a smooth line.

Let's Try Drawing Skirts with Movement

1 Draw the hemline of the skirt

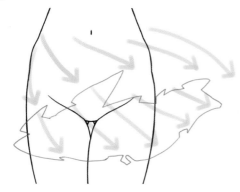

The shape can be random, but if you are conscious of the flow of the fabric as you draw, it will be cohesive.

2 Draw the outline

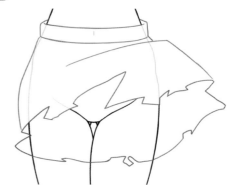

Be aware of the flow and movement of the wrinkles as they follow the hemline as you draw just the outline.

3 Draw the lines of the pleats of the skirt

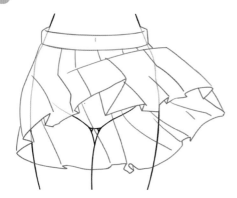

Be aware of the surfaces that you cannot see as you draw.

4 Finished

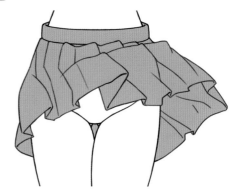

Make fine adjustments to the area around the hips to finish.

Various Skirt Shapes

These are just a few examples of skirts with movement.

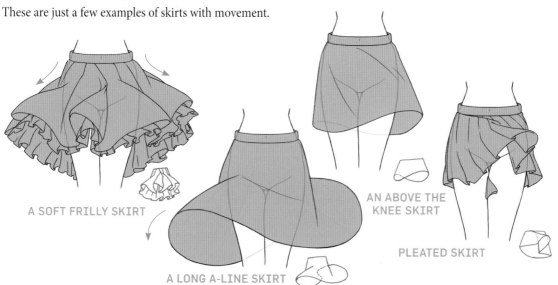

A SOFT FRILLY SKIRT

A LONG A-LINE SKIRT

AN ABOVE THE KNEE SKIRT

PLEATED SKIRT

Figure Drawing

When you try to draw a figure or a character, you may think that you have to draw it cleanly. However, it's O.K. not to draw it in a finished style from the start. Begin by picking up the information you need from the photograph, then clean it up gradually. Here I'll introduce you to how I usually draw a figure.

Expert Tip

Zoom Out from the Canvas When You Draw surself away from the canvas so that the entire picture is in your view. It's useful to draw guide lines on the original subject you are drawing to verify the positions too.

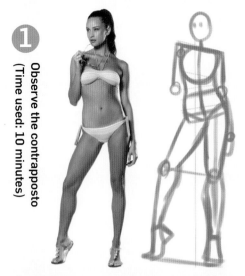

① Observe the contrapposto (Time used: 10 minutes)

Start by observing the contrapposto of the original subject well, and draw in the position and relationships of each part.

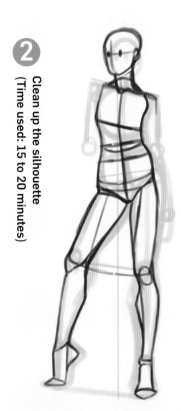

② Clean up the silhouette (Time used: 15 to 20 minutes)

Next, clean up the silhouette. Start by drawing the head and the torso. Once you have the shape of the torso down, you'll be able to see the position relationships of the arms and legs. The key is to ignore the small details and to be aware of the silhouette.

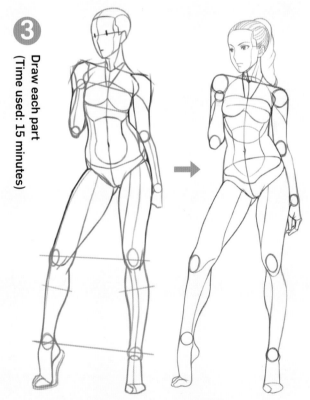

③ Draw each part (Time used: 15 minutes)

Finally you are allowed to zoom in and enlarge the canvas. The silhouette should already be done, so now you will draw in each part.

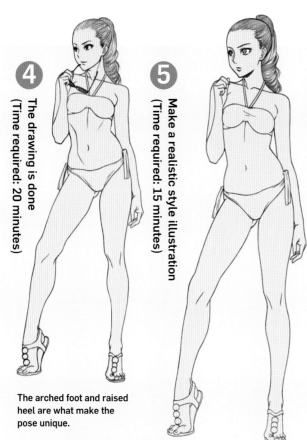

④ The drawing is done
(Time required: 20 minutes)

The arched foot and raised heel are what make the pose unique.

⑤ Make a realistic style illustration
(Time required: 15 minutes)

From this point on, let's make the drawing more two-dimensional.

Since this figure is 6.5 heads tall, we won't be changing the vertical proportions. Instead, we will use what we learned about the balance of the human figure (Page 20) and only adjust the widths.

By shaving off just a little bit from the original drawing, the result is sure to change.

⑥ Try distorting the figure further

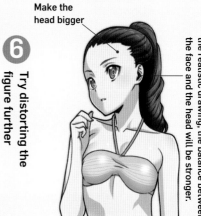

Make the head bigger

By moving the ear closer to the face than in the realistic drawing, the balance between the face and the head will be stronger.

Narrow the width to make the figure slim.

Last, try distorting the figure further. When you want to draw a slim figure with a relatively small head you usually elongate the area below the knees. But this time we have made this area a bit short to make the character look younger.

TAKE A CLOSER LOOK

The Guide Lines for the Human Figure Are Easy with "Bones"

There is an even easier way to decide on the proportions of the human body than making a figure drawing.

If you utilize what you have learned so far about the differences between male and female bone structures, you can create quick guide lines for the figure using just the head, collarbones, the width of the hips and the lines of the arms and legs (the "bones").

By using what you have learned about how to bring the human body's proportions to life, you'll be able to create rough drawings in no time.

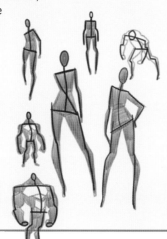

Guide lines made by adding red volume to blue bones

Composition Section

Composition and posing will make illustrations more attractive, more dynamic. They draw in viewers and give your work the Wow Factor you're looking for!

BY KIYOSHI NITOU

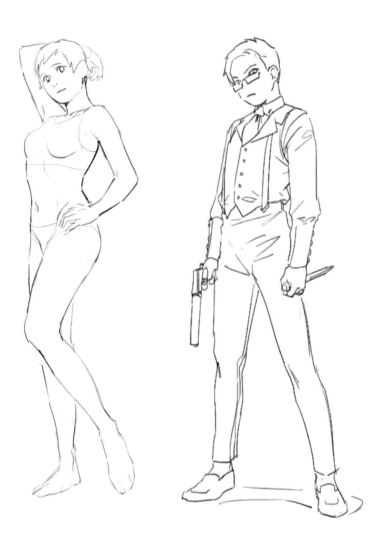

The Key to a Dynamic Pose Is the Expanded Posture

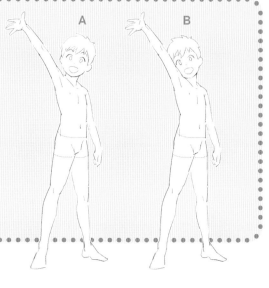

Q. Which One Looks More Dynamic?

Of A and B, which one looks more dynamic?

Don't both of them look energetic? Here we will break down the elements of a pose that make it look more lively and full of energy.

The Key Elements to Poses

Let's look at the four elements that make a figure's pose look lively and energetic.

The joints (the arms and legs) and the posture are straightened or fully extended to give the figure an expansive and commanding presence.

Emphasizing the facial expression through the angles of the face and the neck finishes off the illustration, giving a dynamic immediacy to your characters and a fluidity to the poses they strike.

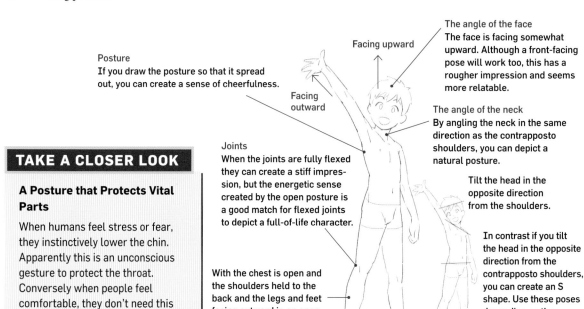

Posture
If you draw the posture so that it spread out, you can create a sense of cheerfulness.

Facing upward

Facing outward

The angle of the face
The face is facing somewhat upward. Although a front-facing pose will work too, this has a rougher impression and seems more relatable.

The angle of the neck
By angling the neck in the same direction as the contrapposto shoulders, you can depict a natural posture.

Tilt the head in the opposite direction from the shoulders.

Joints
When the joints are fully flexed they can create a stiff impression, but the energetic sense created by the open posture is a good match for flexed joints to depict a full-of-life character.

In contrast if you tilt the head in the opposite direction from the contrapposto shoulders, you can create an S shape. Use these poses depending on the direction you want to take.

With the chest is open and the shoulders held to the back and the legs and feet facing outward in an open stance, a pose with a sense of stability is created.

TAKE A CLOSER LOOK

A Posture that Protects Vital Parts

When humans feel stress or fear, they instinctively lower the chin. Apparently this is an unconscious gesture to protect the throat. Conversely when people feel comfortable, they don't need this form of self-protection, so the chin and head are raised.

Let's Look at Pose Patterns

Certain gestures or elements can greatly change how a pose is perceived.

◆ Round the Posture

The character becomes more graceful and cute

When a person turns his or her knees inward on purpose, it looks as if they're forcing it. It's not a natural-looking position. But in illustrations and photographs, it doesn't look as awkward or as wrong, don't you think? Why is that?

Round the posture

Turn the elbow inward

Turn the knees inward

It is often said that the pose becomes more graceful when the arms are held close to the sides, but by closing the knees together the delicate impression is increased.

Graceful

Energetic impression

Close up the shoulders and sides and bend the elbows

Do not close up the sides (stick out the elbows)

◆ Bend the Joints

Because the joints such as the elbows and knees have been bent gently, a feeling of softness, maturity and composure is created.

They may seem like small matters, but the joints add to a character's sense of dynamism and help round out the curvature of a pose.

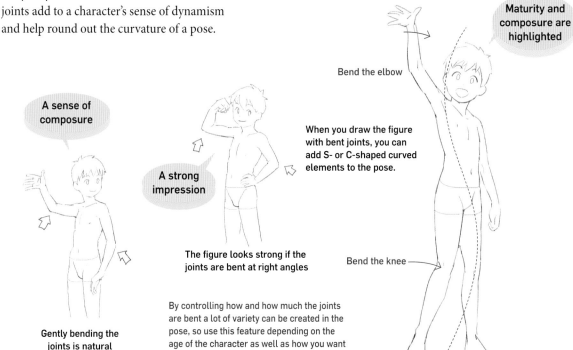

A sense of composure

A strong impression

Bend the elbow

Maturity and composure are highlighted

When you draw the figure with bent joints, you can add S- or C-shaped curved elements to the pose.

The figure looks strong if the joints are bent at right angles

Bend the knee

By controlling how and how much the joints are bent a lot of variety can be created in the pose, so use this feature depending on the age of the character as well as how you want to stage them for that moment.

Gently bending the joints is natural

◆ Make the Face Look Down

Even if the pose is the same, by making the face look down, the pose is transformed.

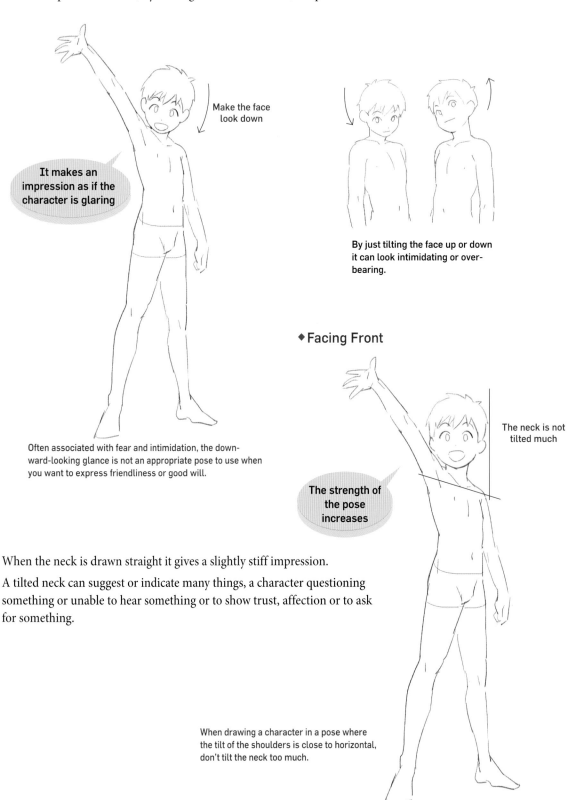

Make the face look down

It makes an impression as if the character is glaring

By just tilting the face up or down it can look intimidating or over-bearing.

◆ Facing Front

The neck is not tilted much

The strength of the pose increases

Often associated with fear and intimidation, the down-ward-looking glance is not an appropriate pose to use when you want to express friendliness or good will.

When the neck is drawn straight it gives a slightly stiff impression.

A tilted neck can suggest or indicate many things, a character questioning something or unable to hear something or to show trust, affection or to ask for something.

When drawing a character in a pose where the tilt of the shoulders is close to horizontal, don't tilt the neck too much.

Various Energetic Poses

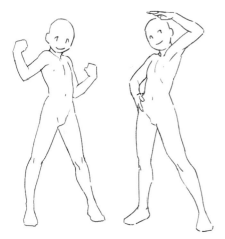

If the figure is standing with legs spread apart and firmly planted and the elbows held out, it becomes a fighter's pose.

By emphasizing the contrapposto and exaggerating the twisted posture, it becomes an idol singer type of pose. The legs are slightly spread.

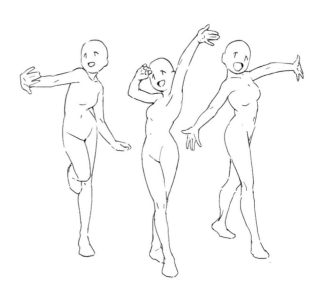

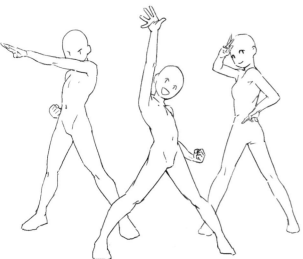

This is an exaggerated upright pose with the legs spread apart that is often seen from heroes that transform themselves or from battle heroines.

By strengthening the angle of view or creating an aerial pose, the figure looks even more dynamic.

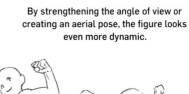

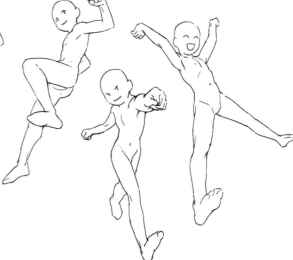

Express Reserve with Defensive Poses

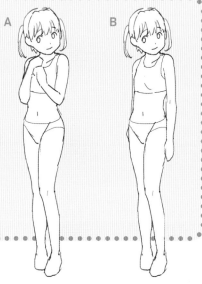

Q. Which Girl Looks More Reserved?

A and B both give an impression of shyness or introversion, but doesn't A give a stronger impression of this?

From here I will explain the key points to poses that look quiet and retiring.

Keys to the Pose

Reverse the elements of an extrovert's pose to summon and suggest introspective qualities.

Another thing to consider is the importance of hand gestures (see Page 71). A lot of the gestures of an introverted person, such as ones where they are touching their faces or protecting vulnerable spots like their throat or chest, come from a feeling of nervousness or wariness toward the others.

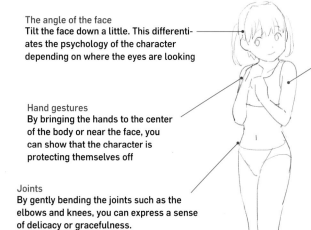

The angle of the face
Tilt the face down a little. This differentiates the psychology of the character depending on where the eyes are looking

Posture
To depict a shrinking, retiring character, hold the elbows close to the sides, drawn in the chin, and have her stand with her legs spread slightly.

Hand gestures
By bringing the hands to the center of the body or near the face, you can show that the character is protecting themselves off

Joints
By gently bending the joints such as the elbows and knees, you can express a sense of delicacy or gracefulness.

Expert Tip

Expansive and Shrinking
While an energetic character makes large gestures with an expansive posture, an introverted character takes a shrinking posture and is limited to small gestures.

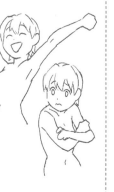

Let's Look at Pose Patterns

An introverted character can display certain pose patterns worth considering.

◆ Stretch out the Arms and Legs

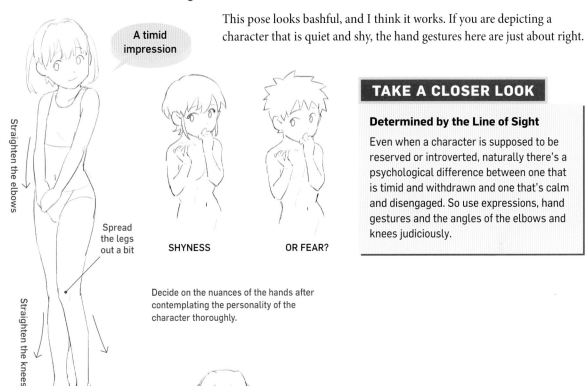

A timid impression

Straighten the elbows

Straighten the knees

Spread the legs out a bit

SHYNESS

OR FEAR?

Decide on the nuances of the hands after contemplating the personality of the character thoroughly.

This pose looks bashful, and I think it works. If you are depicting a character that is quiet and shy, the hand gestures here are just about right.

TAKE A CLOSER LOOK

Determined by the Line of Sight

Even when a character is supposed to be reserved or introverted, naturally there's a psychological difference between one that is timid and withdrawn and one that's calm and disengaged. So use expressions, hand gestures and the angles of the elbows and knees judiciously.

◆ Face the Neck to the Front

This is a pose where the face isn't turned to the side, up or down but is looking forward. The line of sight looks unbalanced as a result. Even with a dynamically posed character, the line of sight looks too strong if the face is turned straight forward.

If you want to depict timidity, it's easier to recognize if you turn the face a little downwards. You want to avoid this straight-on pose unless you want to purposefully express the strength of the eyes or unless you are using it for a three-angle view.

Expert Tip

Elevate a Simple Silhouette with Accessories

When you are creating a quiet pose, the silhouette can become too simple, so it's necessary to add hand gestures where the hands are held close to the face or to add the waves of the hair or the flapping of the clothing.

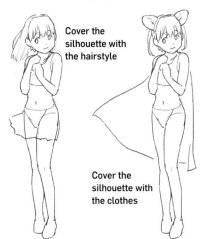

Cover the silhouette with the hairstyle

Cover the silhouette with the clothes

Unsuccessful Examples

◆ Make the Posture Straight

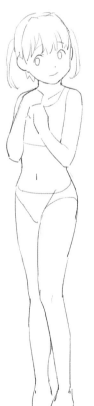

Not so good

Compared to the original drawing, the figure's back is straight and her shoulders are drawn back, giving her a dignified posture that is at odds with her passive hand gestures.

Make the posture straight

Retracting one's neck and holding the hands near the chest or neck are gestures that protect vulnerable points.

If you want to draw a timid character, give them a proper protective stance.

◆ Lower the Hands Roughly

Not so good

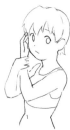

In this version the figure isn't employing protective gestures, and her hands hang at her sides. With her feet turned inward, it's become more difficult to gauge what kind of character this is.

Lower the hands

Hands are the most useful body parts for expressing the character's emotions after the face. If you do not stage the arms and hands accordingly the figure becomes less expressive, and the pose becomes boring.

Put another way, by simply adding hand gestures it's possible to instantly add emotion, so hand gestures are an indispensable element for showing a character's emotions.

Delicate-looking hand gestures

Hand gesture that looks like the character is troubled

Various Quiet Poses

By placing the hands near the mouth, neck or chest, you can give the character a weak impression.

Crossing the arms or the legs also shows that the character is psychologically in a defensive posture.

Placing the hands on vulnerable areas is a type of defensive pose. This is a gesture one is likely to make when one is nervous.

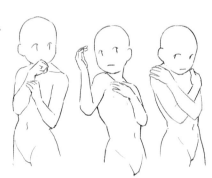

Bending the neck or drawing in the shoulders are also effective in showing weakness.

COOL QUIETNESS

Even if the pose is subdued, by straightening the posture, it won't give an impression of weakness.

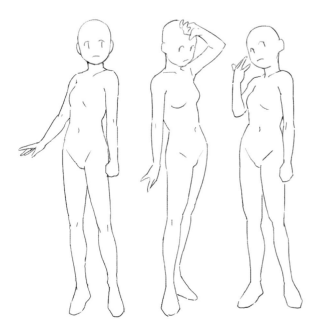

CALM QUIETNESS

By drawing in the shoulders meekness and kindness are brought out, as is a degree of coyness or charm.

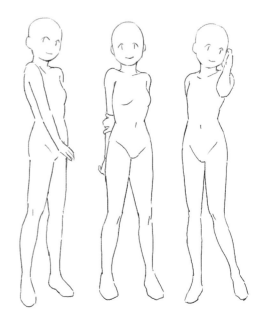

DARK QUIETNESS

By simply rounding the back, the vibe of the character becomes rather negative.

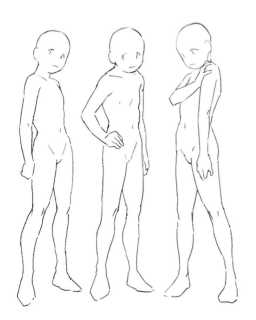

MYSTERIOUS QUIETNESS

If you twist the neck so that it's facing opposite the upper torso, a delicate model-like pose is created.

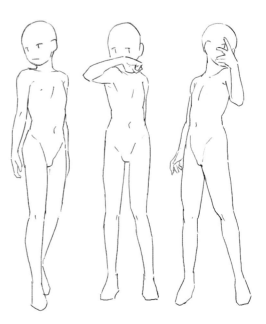

For Powerful Poses, Be Aware of Straight Lines

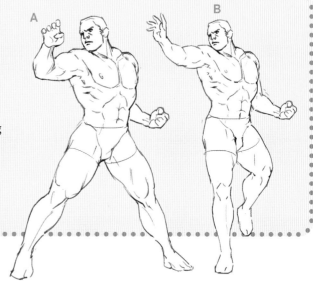

Q. ### Which Pose Looks More Powerful?

Which pose looks the most powerful, A or B? Both depict muscular characters, but doesn't A look stronger?

Here I will explain the key points for making characters look powerful.

A

B

The Key Elements to the Pose

A powerful pose is created by suggesting energy and dynamism. Well-known methods for emphasizing strength include viewing the character from below or with a wide-angle perspective.

If it's a simple standing pose, put the weight of the character on both feet to give a sense of stability by posing it with strong angles. When bending joints such as the elbows, knees, wrists, and fingers, drawing them at right angles will create a pose with power.

Expanded Posture
Humans look more powerful the larger their silhouettes are, so an expanded posture is most suitable for giving an impression of strength.

Straight Lines
By drawing the pose with straight lines, you can emphasize hardness and tension.

Center of Gravity
Give stability and balance to poses. In this example, the weight is evenly distributed on both feet.

Hand Gestures
When the hand is formed into a fist, it looks as if the figure is straining.

By making parts of the body such as the wrists and ankles, variety is created and the brawny body is highlighted.

Making the wrists and ankles thinner emphasizes the figure's solidity.

Let's Look at Pose Patterns

Balance and angularity are two keys to striking the proper pose.

◆ Change the Center of Gravity and the Angles of the Joints

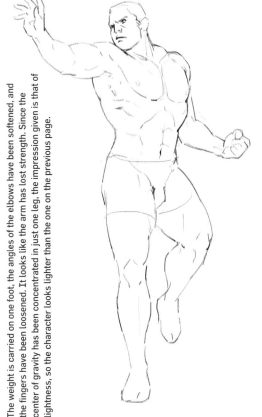

The weight is carried on one foot, the angles of the elbows have been softened, and the fingers have been loosened. It looks like the arm has lost strength. Since the center of gravity has been concentrated in just one leg, the impression given is that of lightness, so the character looks lighter than the one on the previous page.

Children or chibi-style characters can have rather thick wrists and ankles

In contrast, in the case of childish characters, if you draw them in a rounded way without a lot of variation, the form becomes cuter.

The pose is made more graceful, the figure more lithe.

Power has been removed from the fingers so the tension is gone, and a lightweight impression is made.

Expert Tips

Powerful Hand Poses

In a situation such as when an object is being grasped firmly, basically the fingers are fused together. Alternatively, they can be bent at right angles.
If the fingers are bent gently, they lack strength and precision.

Bent gently

Clearly straightened

Clearly bent

Bent at an angle close to right angles

Various Powerful Poses

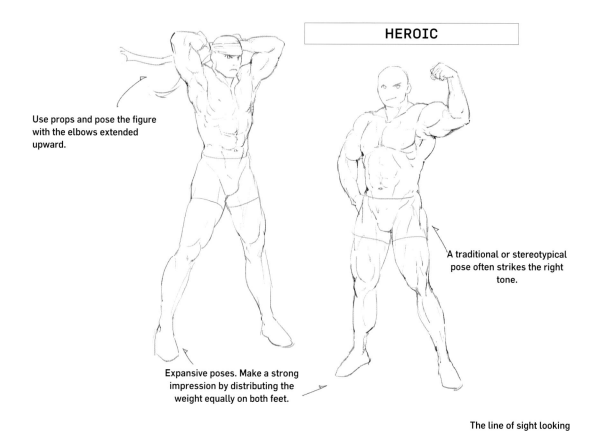

HEROIC

Use props and pose the figure with the elbows extended upward.

A traditional or stereotypical pose often strikes the right tone.

Expansive poses. Make a strong impression by distributing the weight equally on both feet.

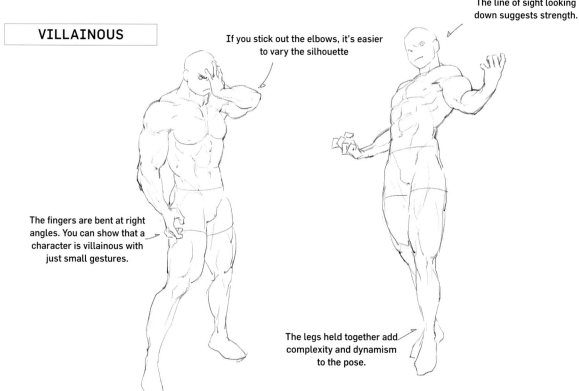

VILLAINOUS

If you stick out the elbows, it's easier to vary the silhouette

The line of sight looking down suggests strength.

The fingers are bent at right angles. You can show that a character is villainous with just small gestures.

The legs held together add complexity and dynamism to the pose.

Lines Are Important for Provocative Poses

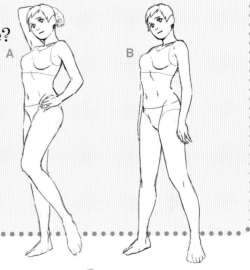

Q. Which Pose Looks Provocative?

Which female character looks most appealing, A or B?

Both have the same shape and figure, but doesn't A look more provocatively posed? Here I'll explain the key points in highlighting a character's physical appeal.

Keys to the Pose

In order to make a character look provocative, it's useful to emphasize their gracefulness. By using an S-shaped curve, the softness of the body is expressed.

The eye is drawn to curves more than it is to straight lines. In order to incorporate the elements of the S curve effectively, make the body or the face diagonal instead of facing to the front or give it a twist and bend the elbows or knees. Combine elements of the expansive energetic pose with the subtle gestures of the quiet pose.

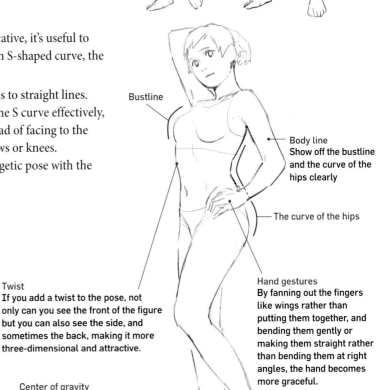

Bustline

Body line
Show off the bustline and the curve of the hips clearly

The curve of the hips

Hand gestures
By fanning out the fingers like wings rather than putting them together, and bending them gently or making them straight rather than bending them at right angles, the hand becomes more graceful.

Twist
If you add a twist to the pose, not only can you see the front of the figure but you can also see the side, and sometimes the back, making it more three-dimensional and attractive.

Center of gravity
Strengthen the contrapposto; by putting the weight of the body on one foot, the other foot becomes playful and you can stage it freely.

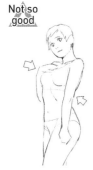

Not so good

The bust and hip lines (see Page 122) are hidden, so the figure looks more shy.

Let's Look at Pose Patterns

Curves, contours and gestures bring a pose to life.

◆ Change the Center of Gravity and the Hand Gestures

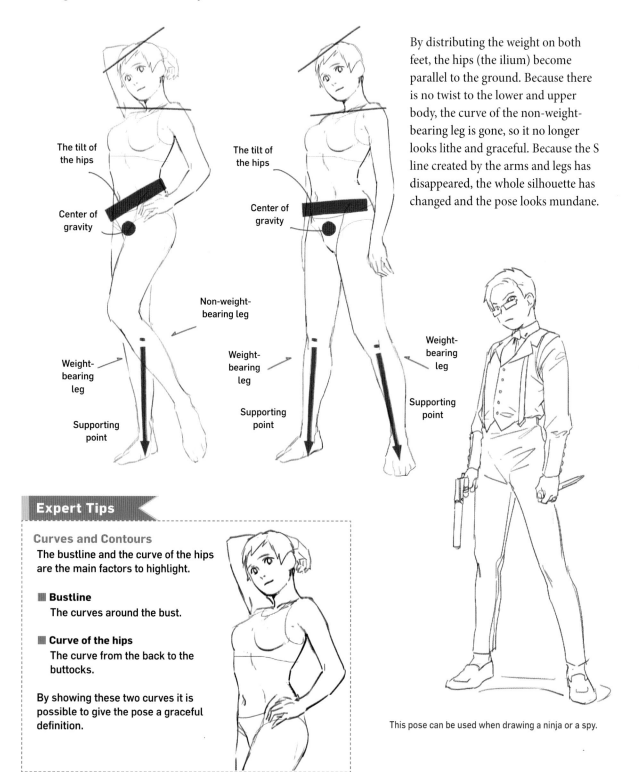

The tilt of
the hips

Center of
gravity

Weight-
bearing
leg

Supporting
point

The tilt of
the hips

Center of
gravity

Non-weight-
bearing leg

Weight-
bearing
leg

Supporting
point

Weight-
bearing
leg

Supporting
point

By distributing the weight on both feet, the hips (the ilium) become parallel to the ground. Because there is no twist to the lower and upper body, the curve of the non-weight-bearing leg is gone, so it no longer looks lithe and graceful. Because the S line created by the arms and legs has disappeared, the whole silhouette has changed and the pose looks mundane.

Expert Tips

Curves and Contours
The bustline and the curve of the hips are the main factors to highlight.

▦ **Bustline**
The curves around the bust.

▦ **Curve of the hips**
The curve from the back to the buttocks.

By showing these two curves it is possible to give the pose a graceful definition.

This pose can be used when drawing a ninja or a spy.

Various Poses

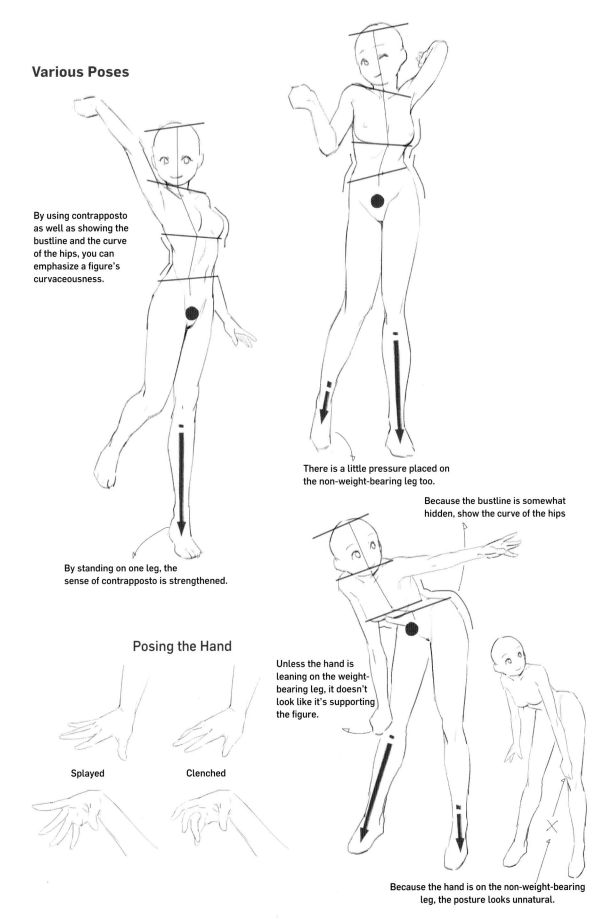

By using contrapposto as well as showing the bustline and the curve of the hips, you can emphasize a figure's curvaceousness.

By standing on one leg, the sense of contrapposto is strengthened.

There is a little pressure placed on the non-weight-bearing leg too.

Because the bustline is somewhat hidden, show the curve of the hips

Unless the hand is leaning on the weight-bearing leg, it doesn't look like it's supporting the figure.

Because the hand is on the non-weight-bearing leg, the posture looks unnatural.

Posing the Hand

Splayed

Clenched

How to Bring Out the Force in Your Character

Q. Which One Looks More Forceful?

Which, of A and B, looks more forceful? It's B of course.

So why does B look more forceful?

Here I will explain the methods and points for bringing out the power and strength in a character.

A

B

The Key Elements to Bringing Out Forcefulness

The 3 points below are key to a composition that brings out the forcefulness of the character.

1. Make it look dominant

2. Make it look large

3. Give it vigor

Before The character is taking a fighting pose, but somehow the composition lacks force.

After

By not changing the pose but by looking up at the character and using perspective and putting the powerful fist in the foreground, we've changed the composition.

Composition Tips

Let's look at some key points for bringing out the force in a character.

◆ Make the Figure Look Dominant

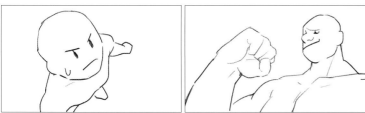

A way of showing superiority and inferiority that is seen often in anime. These are cutouts showing the weaker character looking upward and to the right, and the strong character looking downward and to the left.

Use Stage Left and Stage Right

The basic rules for stage left and stage right (see the sidebar) are used for fight scenes in manga; often the weak character is positioned to the left and is turned to the right, while the powerful opponent is positioned to the right and is turning to the left.

In this instance we want the character to look strong and forceful, so we will position it on the right turned to the left. We want the eye of the viewer to look upward so we adjust this as in the next section on zoom and angle.

TAKE A CLOSER LOOK

Directing the Action

In Japanese theater as well as in movies and TV dramas, the left side of the stage or screen when the actor is facing the audience (stage left in English) is called the "kamite" or "upper stage," and the right side of the stage (stage right) is called the "shimote" or "lower stage."

Usually, actors come onto the stage from the kamite (stage left) and exit toward the shimote (stage right). The basic rule of kamite and shimote is that the character in shimote (stage right) is weak, and the character in kamite (stage left) is strong. By being aware of the action that flows from left to right, you can use it to enrich and strengthen your illustrations.

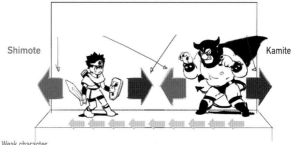

The direction or the direction of the movement are facing "shimote" (stage right).

The direction or the direction of the movement facing "kamite" (stage left).

Shimote

Kamite

· Weak character
· Small character
· Disadvantaged character
· Character in peril

· Strong character
· Large character
· Advantaged character
· Safe character

Audience

◆ Make the Character Look Large

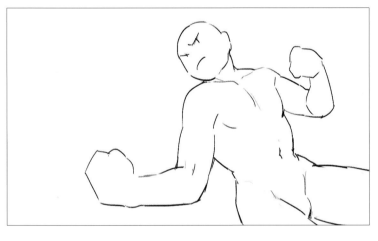

Exaggerate the Size by Zooming in and Viewing from a Low Angle

In a picture where you are zooming in on the character, by using a low angle the size of the main character is emphasized in the illustration. In addition, by drawing the character from below your strokes are naturally concentrated to the top, which creates an effect similar to the one created by triangular compositions. It adds a sense of stability and a feeling of power.

Front angle

Low angle

◆ Show Momentum

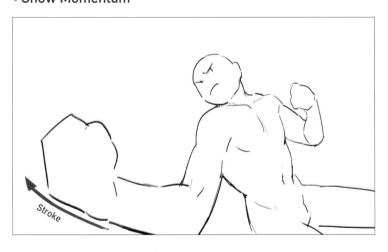

Exaggerate Momentum with Long Strokes

Momentum resides in long strokes. Apply the speed lines and concentration lines when drawing manga, and position parts of the body or motifs that use long strokes in the direction you want to show momentum. In this instance the body is positioned so that the eye goes toward the bottom left. Long strokes are also used in other ways for guiding the eye of the viewer to the main character or for diagonal compositions.

The whale has been enlarged, and long strokes have been added.

By positioning long strokes toward the direction or a point where you want to show momentum, you can add movement to the main character or dynamism to the drawing.

◆Other Things to Consider

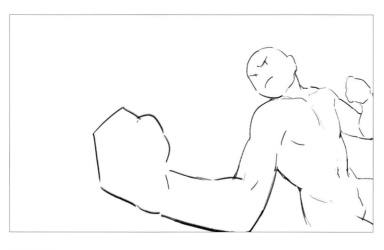

Add Liveliness with Blank Space

It's possible to add a sense of calm or busy-ness to a picture by the way you create blank space. Ordinarily, by including a lot of blank space the picture becomes refined, and by allowing little blank space, you can create the impression that the main character is coming toward the viewer.

Express a sense of refinement with a lot of blank space

Express power by reducing the blank space

Overhanging Composition

By cutting off the motif so that elements hang outside the frame, the objects look bigger than if they were all fitted into the frame. As with blank space, since the cut-off overhanging parts cannot be seen, the deletion potentially stirs the imaginations of the viewers.

Make the motif overhang the frame to give scope to the imagination

Various Forceful Compositions

A lot of blank space is left, and the figure overflows the frame. Momentum is created with long strokes.

The blank space is limited. Momentum is created with an overhanging composition and long strokes.

Momentum is created with an overhanging composition and long strokes, and the size of the figure is exaggerated with the low angle of view.

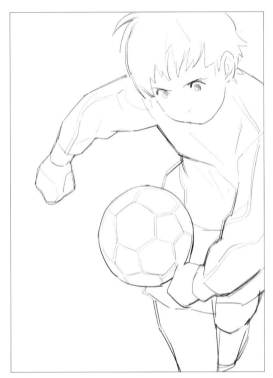

Plenty of blank space plus an overhanging composition is used. By positioning the ball skillfully, the strength of the character is expressed.

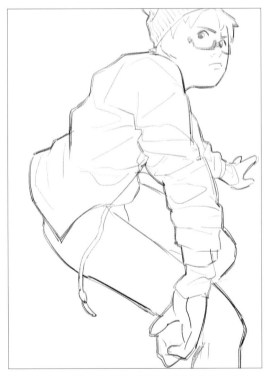

By using an overhanging composition and zooming out from the character, there are a lot of blank spaces. Power is evoked with the low angle, and momentum is suggested by using long strokes.

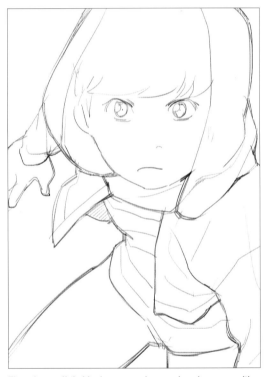

There is very little blank space and an overhanging composition is used. A high angle with the character looking down at us suggests strength and force.

How to Create an Atmosphere of Unease

Q. Which Drawing Has an Atmosphere of Unease?

Which illustration suggests an uneasy atmosphere, A or B?
Isn't B the more effective rendering?
I'll explain why that's so.

A

B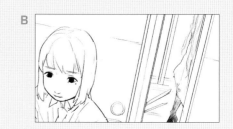

The Key Elements to Evoking a Sense of Unease

The two points below are key to a composition that expresses a sense of unease.

1. Show a feeling of oppression

2. Upend the sense of stability

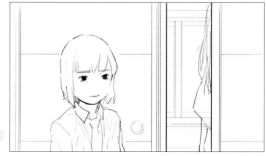

Before Since the main character is facing in the direction of the element that causes unease, the sense of discomfort is lessened.

By breaking down the positions of the motifs and the balance of the space on purpose, a sense of discomfort is created, and unease and fear are conjured.

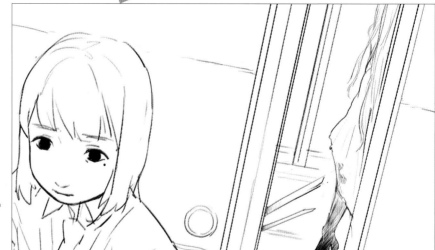

After

Being aware of the element that causes unease expresses fear.

Composition Tips

Let's look at some key points for stirring up unease.

◆ Express a Feeling of Oppression

Use the Dutch Angle

Tilting the horizon line drastically is called the Dutch angle. It's a technique that challenges the viewer's sense of balance and summons unease, and is used often in horror and mystery movies and videos. By tilting the horizon line, an inverted triangle shape is created naturally, so when you use the Dutch angle, the elements of an inverted triangle composition come into play.

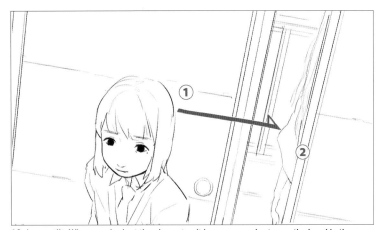

10 degree tilt. When you look at the character, it becomes easier to see the hand in the shadow.

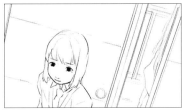

15 degree tilt. The impression of the tilt becomes a little stronger.

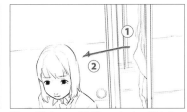

Minus 10 degree tilt. The order in which the eye of the viewer is lead changes, so this time one sees the hand in the dark first.

Confined Spaces

If you want to express weakness and unease, controlling the space so that the main character looks confined is effective. Position the main character in the frame so that they're isolated, and include large blank spaces.

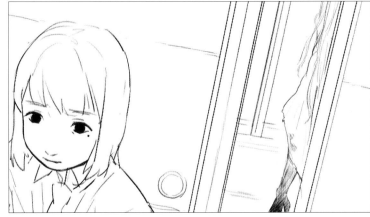

Zoom in and shift the person to the corner. The uneasy expression as well as the hand in the dark have been emphasized.

If the zoom is partial, the sense of unease is diminished.

The viewing angle has been adjusted to further strengthen the feeling of oppressiveness.

◆Express Negative Psychology

The Relationship Between the Direction of the Line of Sight and the Space
If you create space in the direction of the line of sight, the illustration achieves a sense of cohesion and purposefulness. In contrast, if you show space in the opposite direction to the line of sight, tensions are established or unresolved. In the After example on Page 130, we've made the person look toward the past and expressed a negation of hope.

By putting the direction of the line of sight and the blank space on opposite sides, the character is clearly unaware of the presence of the hand.

If there's space in the same direction as the line of sight, it's hard to suggest a sense of fear.

Because of the direction of the line of sight, the positioning of the character is not fully utilized.

TAKE A CLOSER LOOK

Suggest the Past and Future with the Direction of the Line of Sight

In an illustration where the person is turning or looking straight at the viewer, which side is the future and which side is the past? When the person is turning, the direction in which they're looking becomes the future side; when they're looking straight at the viewer, the opposite side becomes aligned the future. If you create a space in the direction in which the main character is trying to move, you can create a picture that captures a hopeful sense of the future.

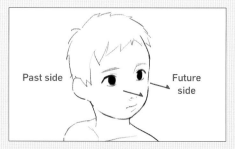

Since the character is gazing to the right of the viewer, the right-side space is the future side.

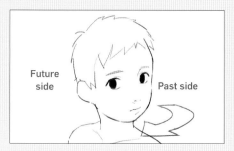

Since the character is in the process of turning back his neck that he's moved to the left, the left space is the future side.

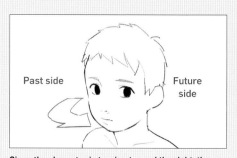

Since the character is turning toward the right, the right space is the future side.

◆ Compromised Stability

Use an Inverted Triangle Composition

If a triangle composition has a sense of stability, an inverted triangle composition creates a sense of instability. Even though we sense its instability, because the triangular composition is present, it also contributes a sense of order and balance just the same.

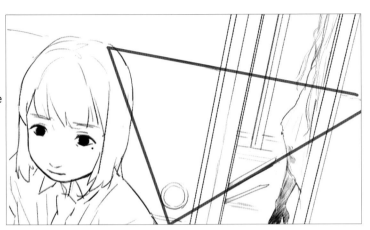

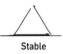

Stable

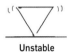

Unstable

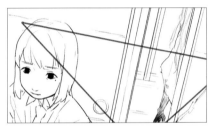

Another pattern. A large inverted triangle composition that juts out of the frame.

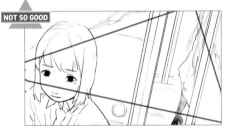

NOT SO GOOD

If you arrange the elements into a triangle composition, the feeling of instability is compromised.

Expert Tips

Switch Between Stage Left and Stage Right

We can use the rules for stage left and stage right that we introduced on page 125 here too.
In this example, we've positioned the main character to the left to suggest weakness and had her face left to show despair.

Positioned to the right and turning right
Since the eye goes first to whatever is in the back, this composition isn't very effective.

Positioned to the left and turning left.
The main character is on the side where the weak character is traditionally placed in this composition.

Various Compositions That Stir Up Unease

An example that uses the Dutch angle and an inverted triangle composition. It is scarier not to reveal the source of the fear.

The tension has been heightened by using a Dutch angle, an inverted triangle composition, and the oppressive feeling of the walls.

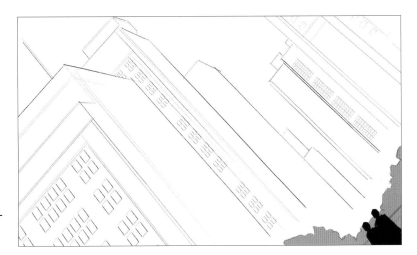

An example that uses the Dutch angle and an inverted triangle composition to strongly express an atmosphere of instability.

An example that uses the Dutch angle and an inverted triangle composition to strongly express an atmosphere of instability.

An example that oppresses the character with the space in addition to using the Dutch angle and an inverted triangle composition.

How to Show Charm and Appeal

Q. Which Picture Makes the Girl Look More Appealing?

A

Which girl on the right looks more appealing or interesting, A or B? I think that A is by far the strongest.

Because B is facing to the front, even though she's smiling, the picture suggests an ID photo.

The pose in A is better of course, but because the composition is diagonal, it has three-dimensionality and looks even more appealing.

In this section, I'll explain the charm factor and how to get it.

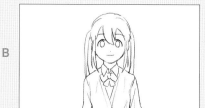

B

Points for Making the Character Look Cute

A character's charm and appeal can be intensified a couple of key ways:

1. By evoking the immediacy of three-dimensionality

2. The emotional appeal of the facial expression and the pose

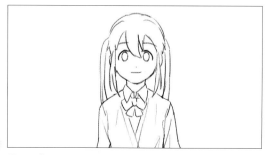

Before Seen from the front, this picture looks like a passport or license photo.

What types of compositions strengthen the three-dimensionality or emotional appeal?

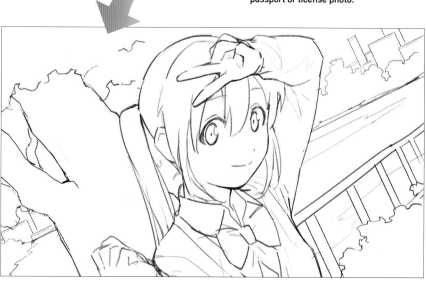

By changing the angle and adding the hand, the three dimensionality of the figure is emphasized.

Composition Tips

Let's look at some key points for making the character look more appealing and magnetic.

◆Bringing Out Three-Dimensionality

Objects, like people's faces, are said to look more attractive when seen diagonally rather than from the front. Even when the main character is framed in a closeup as in the example here, add a twist to the pose and position it so that a number of sides can be seen.

Even by adding a subtle twist, there will be a difference in the sense of three-dimensionality. If you draw the character from a slight angle or have them face down a little, not only can you make their eyes look bigger as they look up to the viewer, the face forms an angle where the line of the chin is distinct, yielding an attractive expression.

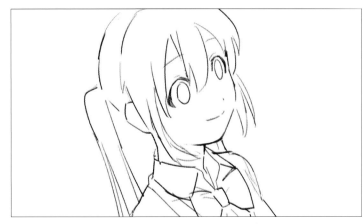

By creating a composition that looks down onto the character from diagonally above, three dimensionality is created.

If you look up at the face, the line of the jaw is indistinct

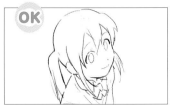

When you look down at the face from above, the line of the jaw is seen distinctly

Superimposed Perspective

When motifs are layered in an illustration, a sense of depth is created. This is called superimposed perspective, and is one of the basic rules of perspective. It's more difficult to position motifs within an illustration so that they don't overlap, so you might say that superimposed perspective is used unconsciously more often than not.

In this example, we've created a composition where one motif (the person) fills the whole frame, so in order to make it not look so two-dimensional, we've positioned the hand in front in a way that it overlaps the figure to provide depth.

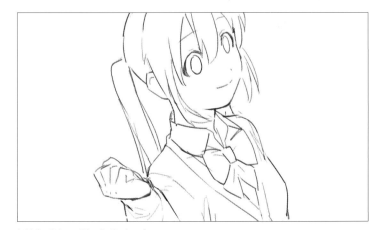

Add depth by putting in the hand

If the motifs do not overlap, it's difficult to sense distance

By overlapping the motifs, it's easy to see the front-to-back relationships

◆ Appealing to the Emotions

The Way the Body Is Facing and the Line of Sight

When the body and the line of sight are facing the same way, it becomes a composition that potentially expresses the character's honesty, purity and intellect.

When we're trying to emphasize the character's beauty as is the theme here, by shifting the line of sight in opposition to the way the body is facing, the emotions expressed by the character become more complex than one where they are looking straight ahead. Many famous paintings, including Hishikawa Moronobu's "Beauty Looking Back" and Johannes Vermeer's "Girl With a Pearl Earring," fit this mode.

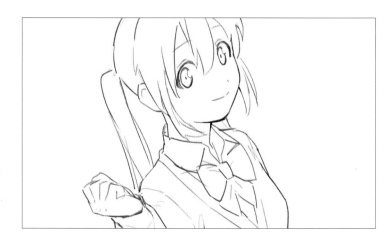

The way the girl is looking back in "Girl With a Pearl Earring."

The backward-facing pose of "Beauty Looking Back."

Add the Hand

This was introduced in the Poses section, but the hands, next to the face, are well suited to expressing emotions. You can match the expression of the hands to the face to emphasize the character's appeal, or change the position of the hands to create a different impression. You can suggest a range of things just by using the face and the hands.

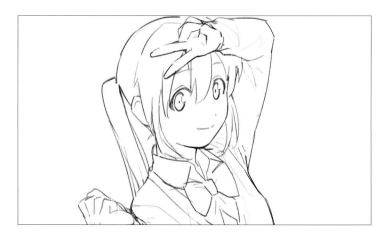

A supple image

By using the whole arm, the impression changes again

Position One Eye at the Center Line

Eyes turned toward us draw us in, but positioning one of the eyes at the center line of the composition intensifies that effect all the more.

This method is used often in portrait photos. This results in an image with a stronger gaze from the subject and captures and holds the viewer's attention.

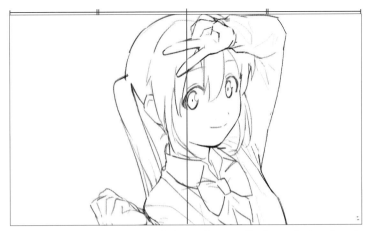

By bringing one eye to the center line, the impression created by the eyes is strengthened.

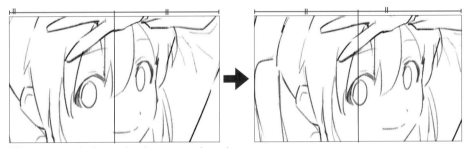

When you zoom, the impression changes conspicuously.

Hide the Expression

By hiding parts of a character's expression, the atmosphere becomes suggestive. Photographer Leslie Kee, who is famous for his "SUPER" series, often features subjects where one eye is hidden.

By hiding one eye the viewer is lead to the subject's other visible eye. If you want to maximize the strength of the appeal of parts of the face, one method you can use is creating interesting compositions hiding or occluding parts of it.

The Elements to Put in the Four Corners

If the elements that are put in the four corners of the picture are not well-considered, they won't highlight the main character but instead create a scattered impression. If the main motif has a complicated shape, keep the elements in the four corners to a minimum.

If you make the four corner elements all the same, the background becomes limited. By organizing the four corner elements, they serve to enhance the main character. If you make the upper two corner elements the same and the lower two corner elements the same, the motifs drawn on the horizontal center line become emphasized. In order to conjure a sense of liveliness while stabilizing the composition, put different elements in the four corners. The configuration of the picture becomes more complex as a result.

If the elements in the four corners are all different, the line of the viewer's sight is scattered

If the top two and the bottom two corner elements are unified, the line of sight is concentrated on the center line

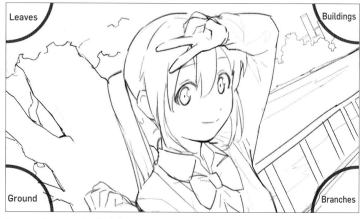

Because there are detailed disparate elements in the four corners, the center figure does not stand out

This is an example of using the same elements for the top and bottom corners. Although it looks organized, it gives a rather static impression.

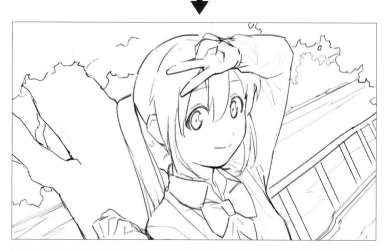

This is an example of using the same elements in opposing corners. The line of sight is now directed toward the center.

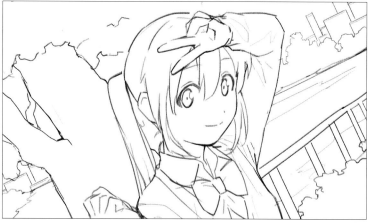

Various Compositions

An example where one eye is positioned in the center, a diagonal pose is used and the arm is positioned over the face for a superimposed perspective

One eye is positioned in the center, a diagonal pose is used and empty space is left in the upper corners to balance the drawing

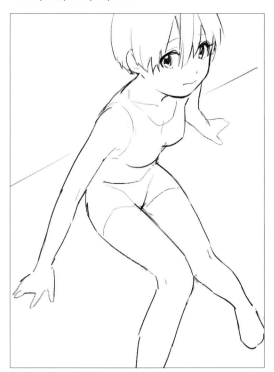

A diagonal pose and a composition where space is left in the four corners leads the eye to the character

One eye is positioned in the center and the strength of the eyes is emphasized by hiding one of them. The hand gestures and bustline are emphasized to show the character's allure

How to Suggest Towering Buildings

Q. In Which Picture Do the Buildings Look Bigger?

In which picture do the buildings look bigger, A or B?

Don't they look bigger in B?

Because more contrasting elements are drawn in B compared to A, the buildings are made to look larger.

In this section I will explain what elements make buildings loom larger in your illustrations.

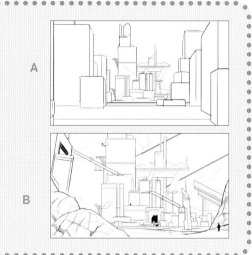

A

B

Points for Making Buildings Look Large

There are various methods for emphasizing size:

• Contrast with other objects

• Create a sense of distance

• Use supporting elements

These are the three main methods.

You can effectively show size just by using one of these methods. By combining them, you can indicate size even more effectively.

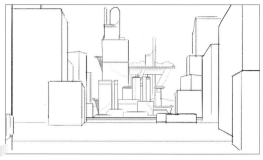

Before It's hard to see get a sense of the size of the buildings because there are no contrasting elements in this composition.

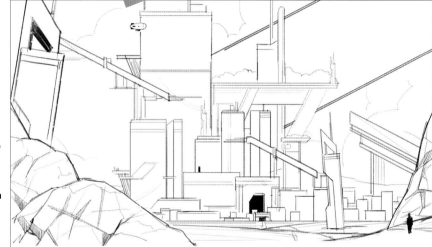

After

By placing people in the composition as well as rocks in the foreground, the size of the buildings as well as a sense of distance are more easily communicated.

Composition Tips

Let's look at each of the points for making buildings look large.

◆ Contrast With Objects

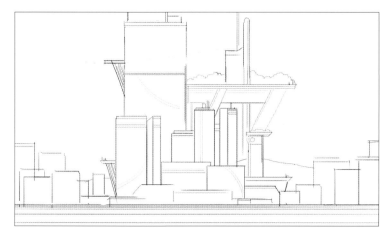

When you want to emphasize the large size of the main element when seen from afar, it's useful to contrast it with other objects to show its scale.

To think of this in terms of camera angles, zoom out as much as you can for an extreme telescopic setting, and make the size of the buildings clear with this effect.

If you compare a telescopic view and a wide-angle-lens view, while the scale of the former doesn't change much, because the perspective is compressed, the objects farther away should look closer.

If you frame the illustration close to the figure, the figure looks bigger.

If you zoom out, the building looks bigger.

When you want to show far-away objects as being large, try drawing them as if you are shooting them with an extreme telephoto lens with the objects pushed to the front.

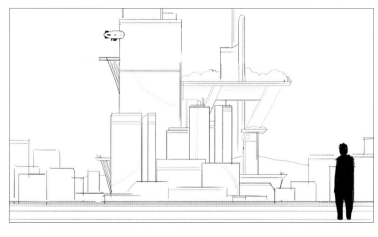

Staffage

Staffage are the small humans or animals as well as small objects (houses, cars and so on) that are included in a picture. One of the merits of including staffage is that they help to show the scale of the overall picture quite easily. A human is usually around 5 to 6 feet (1.5 to 2 meters) tall, so you can extrapolate the approximate size of trees and buildings from there.

The second merit is that they add more story to the picture. By adding staffage such as simply including a single flower in a scene that is packed with human-made objects, or by showing a car in a nature scene, you can create sight lines that draw the viewer toward the main character and make the illustration look more dramatic.

 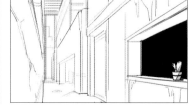

By adding a motif that becomes a focal point, you can heighten the narrative quality of the scene.

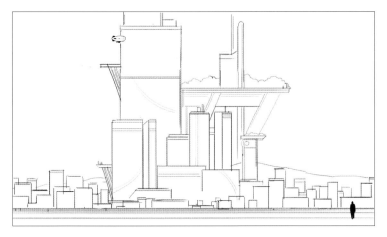

Utilize the Jump Rate

In this example we want to emphasize the size of the buildings, so we've used a telescopic view and made the human figure in the foreground look small compared to those buildings. In other words, we raised the jump rate—the size ratio difference between the objects. Because the jump rate has increased, the eye goes toward the towering building, which is the main character of this scene. By being aware of the compression of the image due to the telescopic view, the objects in the picture come close to their actual sizes. Nearby humans are small, and far-away buildings are large.

TAKE A CLOSER LOOK

What Is the "Jump Rate"?

Jump rate is a term that is used to describe pictorial or text layouts, and is used to show or emphasize movement due to the size ratio differences between elements. In the second example below, we've made it easier to imagine the sizes of the motifs.

When the jump rate is low (the object sizes are similar), a calmer, more balanced impression is created.

In a layout where the jump rate is high (the object sizes are very different), the impact is emphasized.

◆ Create a Sense of Distance

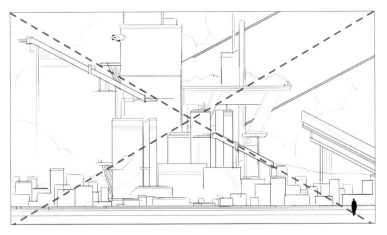

Diagonal Composition

Use an X-shaped composition to draw the viewer's eye to the central point of the picture. An X-shaped composition is an effective way of suggesting depth while adding dynamism, so it is well suited to landscapes. In this example we want the viewer to look past the figure in the foreground to focus on the building in the back, so the X shape shifts the viewer's gaze to the center of the composition.

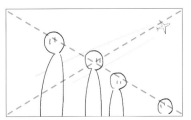

Even by aligning the objects approximately along the X lines, movement is suggested.

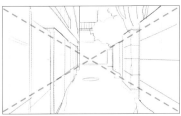

If you draw a road using single point perspective, an X-shaped composition is naturally created.

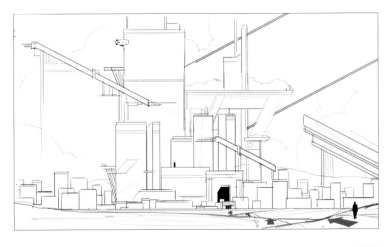

Zig-Zag Perspective

The zig-zag perspective method exists as a way of indicating depth in a landscape picture. Not only can you show the size of the space by combining alternatively slanted elements, the zig zag draws the viewer's eye toward far-away buildings and has the effect of emphasizing the main character of the drawing. The zig-zag perspective method is especially suited to situations where far-away landscapes are viewed close to the horizon line.

This time we have shifted the zig zag over a bit to unbalance a too symmetrical and stable composition. When you're using a symmetrical composition, you can avoid monotony by shifting it, depending on what you are trying to emphasize.

A zig-zagging road looks as if it's stretching farther into the distance than a straight road.

◆Use Supporting Elements

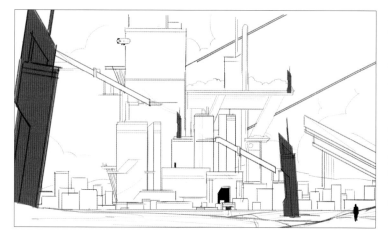

Size Perspective

With size perspective, there is no need to create a vanishing point; the basic rule is that the farther away an object is, the smaller it's drawn. This method can be used in a landscape with a lot of natural objects such as mountains, or a land-scape drawn with the telescopic view where the perspective is compressed. If you add multiple objects where the size is fixed such as humans or animals, you'll have to add three-dimensional perspective in any case.

Even if the same motif is used, by changing the size you can indicate perspective.

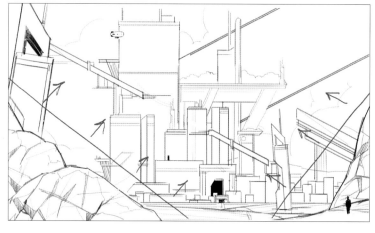

V-Shaped Composition

This is a variation of the inverted triangle composition. Here I've sandwiched the main building in the middle with the hills on either side, so that the viewer's eye flows to the center.

In addition, since the objects inside the V shape look as if they're even more in the distance due to the superimposed perspective effect (see page 137), you can create a sense of depth.

V-shaped symmetry is perfect for sacred or mystical images.

Guiding the viewer's eye toward the center works for dramatic scenes too.

Various Compositions That Make Buildings Look Large

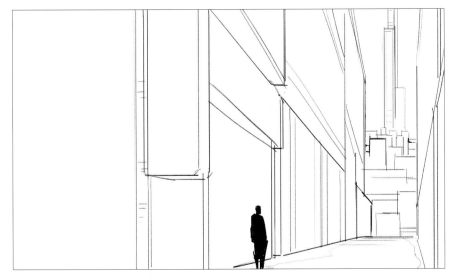

Utilize an X-shaped composition that is not made up of diagonal lines coming from opposing corners

Frame out the building on a large scale and contrast it with the tiny human in the foreground.

Here a V-shaped composition and a zig-zag perspective are utilized with foregrounding figures.

How to Draw Interiors with Depth

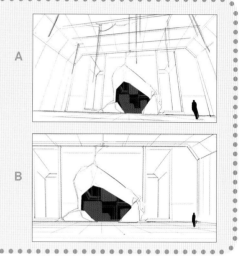

Q. Which Interior Looks Large?

In which picture on the right does the room look large, A or B?

Doesn't A look larger?

Both pictures are of the same room, but you can show depth through the use of angles and composition.

Let's look at the elements that make an interior loom large.

A

B

Points for Showing a Sense of Depth

If you want to give a dramatic impression even in the limited space of an interior, devise the framing and angle to show dynamism and depth, while using composition and placed elements to create a sense of rhythm and to smoothly guide the viewer's eye.

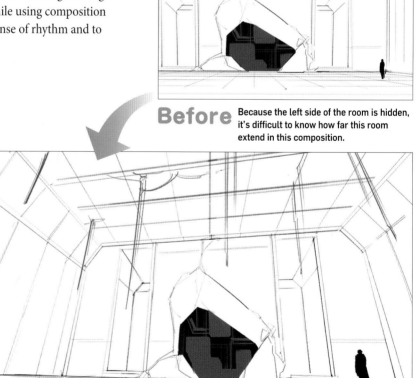

Before Because the left side of the room is hidden, it's difficult to know how far this room extend in this composition.

After

By changing the angle and creating a composition where the whole room can be seen, height and depth can be expressed.

Composition Tips

Let's look at the key points for showing depth.

◆ Indicate Power and the Depth of the Space

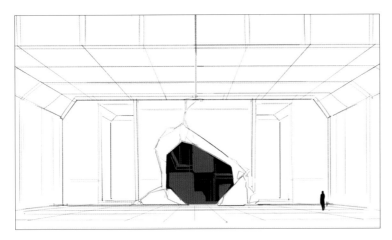

Include the Corners

When drawing an interior, by including the corners of the room in the picture, you'll be drawing at least two walls, so the viewer can more easily recognize the space through the perspective lines of the walls. When you want to make the scale of the room clear, try to include at least two corners of the room.

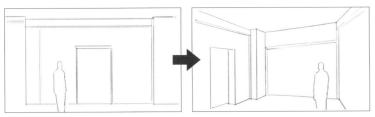

A room looks bigger when you can see the corners compared to when you can't.

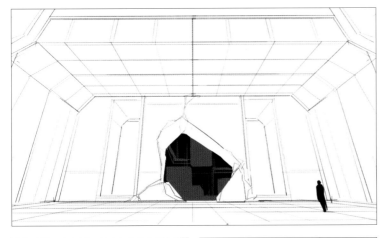

Low Angle

When you view a room from a low angle (from below), not only can you increase the three-dimensionality of placed motifs and exaggerate their sizes, you can create a feeling as if the viewer is in the space as well.

A low angle increases the feeling of subjectivity.

A high angle increases the feeling of objectivity.

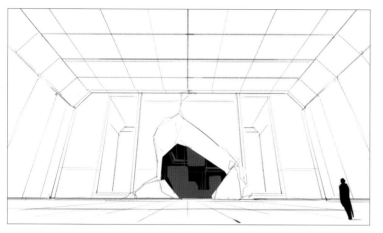

Dynamically with a Wide Angle Setting

When you want to show depth and space in an interior, draw it at a wide angle and use perspective. If you make it a wide angle, the three-dimensionality of nearby objects increases, and a visual difference is created between those objects and faraway ones. Due to this effect, a sense of distance is created, and even small spaces can look bigger and more dynamic than they actually are. If you look at photographs of real estate listings or accommodations online, you'll notice that most of them are taken at a wide angle to make the rooms look bigger.

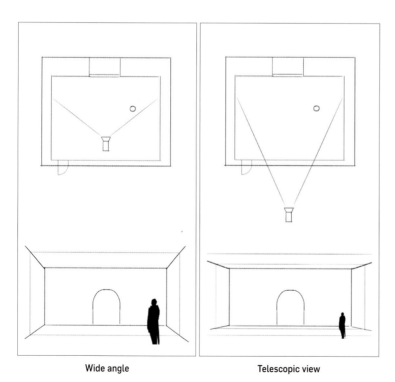

Wide angle Telescopic view

Distance Is Necessary in Order to Shoot at a Telephoto Angle

When shooting a small interior using a camera, because the camera is so close to the subject, it becomes difficult to shoot with a telephoto or telescopic view. If you want to create a natural-looking image, when drawing a small space, I recommend assuming a regular angle or wider perspective.

◆ Emphasize Height with Vertical Perspective

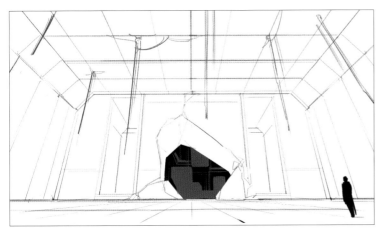

If you add vertical perspective with three-point perspective, the composition will be even more powerful. What becomes useful to emphasize the sense of three-point perspective are vertical elements that stretch from the floor to the ceiling. Use vertical motifs such as columns placed at regular intervals or electrical wires hanging from the ceiling to add detail and complexity to the drawing.

Emphasizing the vertical perspective can work in outdoor settings too. For example, make it rain or use plants and flowers to add vertical perspective.

◆ Guide the Line of Sight Smoothly

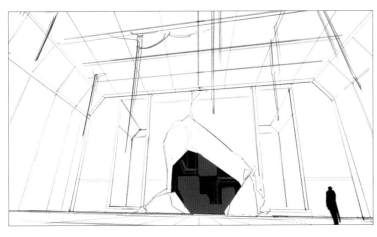

Diagonal Composition

Here we've compromised the sense of symmetry. It becomes easier to get a sense of the space by adding perspective, and the more diagonal lines there are in the picture the more movement is created. By reducing the number of horizontal lines in the picture, the impression given is less stiff.

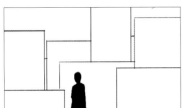

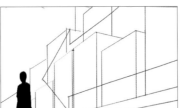

When you want to emphasize the kinetic qualities of the scene, break up the horizontal and vertical perspective lines.

Diagonal lines are created easily in urban street scenes and interiors, so these two settings are ideally suited to that compositional model.

If the lines are all horizontal and vertical the picture seems static

When there are diagonal elements, a flow is created. If you place the main character at the end points of the diagonal lines, they'll effectively guide the viewer's line of sight.

The Use of One-Point Perspective in the Works of Stanley Kubrick

In the works of the master filmmaker Stanley Kubrick, you often see interiors taken with the one-point perspective view. By combining the impression given by the one-point perspective with the mysterious feeling of symmetrical compositions, they have a beauty like those of religious paintings. In addition, since the scenes are shot so that the vanishing point of the one-point perspective is always located in the dead center of the picture, the perspective lines converge at that center, so that the line of sight is definitively guided towards the people or objects there.

Although this type of composition is difficult since it's liable to look flat when drawn, it can be utilized when you want to add impact to the center of the picture while keeping a sense of stability and balance.

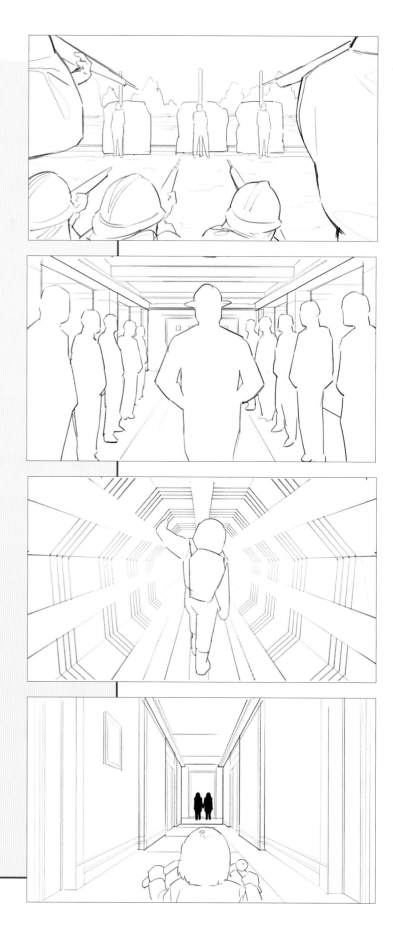

Various Compositions That Show Depth in Interiors

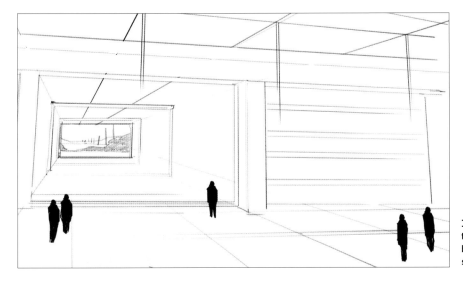

If you add tile-shaped objects that show the perspective, it becomes easier to express a sense of space.

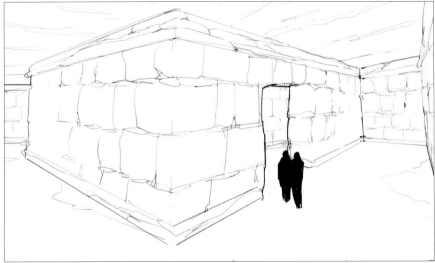

Depth is emphasized with a wide angle. The blocks make it easier to establish the perspective.

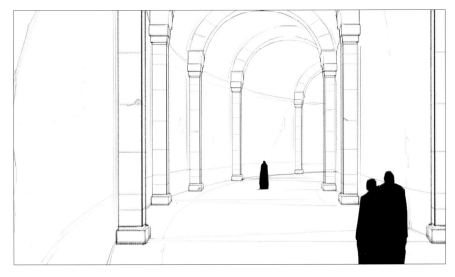

If you layer the same motif, you can create a sense of distance.

How to Draw Lively Urban Landscapes from Above

Q. In Which Picture Is the Landscape the Main Feature?

A

Of A and B, which composition features the urban landscape as the main character? Although the position of the person has not changed, in B, by using more of a bird's eye view, the landscape has been drawn wider.

In contrast, A has a composition where the eye is drawn to the person. In this way, you can change what you want to feature in the picture even when the subject matter is the same. In this section, I'll show you the fine points for doing this.

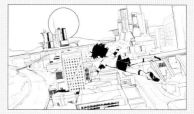

B

How to Create Attractive Urban Landscapes

In order to show landscapes in an attractive way, it's important to be aware of these 3 points:

1. Angle of view

2. Sense of distance

3. Framing

Use these judiciously depending on what you want to feature in your drawing.

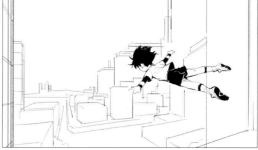

Before The sense of distance is weak, and it looks like the character is buried in the buildings of the town.

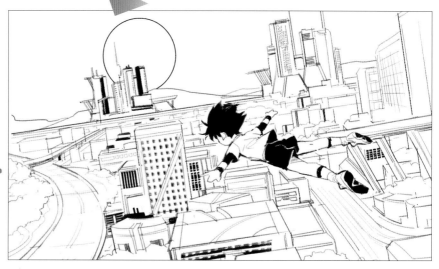

After

By being firmly aware of the sense of distance and creating a bird's eye view composition, the picture now gives the impression that the person is flying above the town.

Composition Tips

Let's look at the key points for urban landscapes attractively

◆ Adjust the Sense of Speed With the Angle of View

In a composition where the viewer is looking down on the landscape, the sense of scope changes depending on whether you use a wide-angle view or a telescopic view.

In a wide-angle view, since closer objects look bigger and far-away ones look smaller, it becomes easier to sense the distance between near and far objects. Since we're assuming a wide-angle view in the Before composition, it looks as if the person is shooting zipping in between the buildings.

When you use a telescopic view, by compressing the sense of distance, it looks as if the person in the foreground is moving slowly or floating in the air. If you want to make the person in the foreground the star and make it seem as if he's moving rapidly through the cityscape, use a wide-angle view; if you want to put the focus on the cityscape use a telescopic view to make this clearer.

Wide-angle and telescopic views are explained on Page 160.

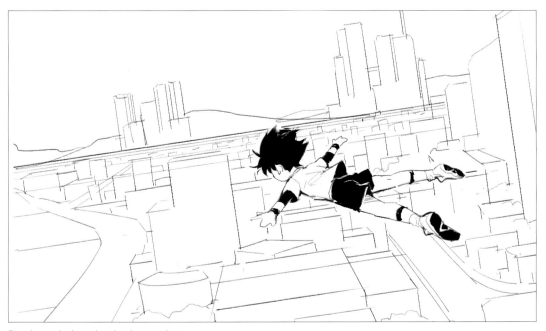

By using a telephoto view,the cityscape has
become the main feature of this composition

◆Creating a Sense of Distance

By dividing the landscape within the picture largely into the near view, middle view and distant views, you can definitely produce depth.

With normal vision, it's natural to see the close-up view most clearly, with the landscape becoming more blurry the farther away it is. It's not always necessary to have the focal point in the close-up view; it's more usual to have the focal point on the main character and the landscape closest to it, and to reduce the amount of details added to objects farther away to bring out the sense of blurriness.

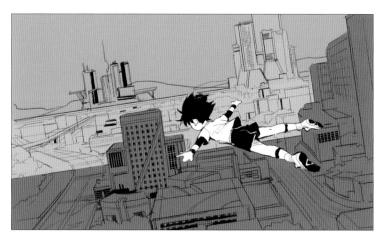

If you roughly decide on the distant, middle and close-up views before you start drawing, it becomes easier to evoke a sense of distance.

By deciding on the distant, middle and close-up views, a sense of distance is created.

A Sense of Distance Through Repetition

By drawing similarly shaped objects repeatedly, you can guide the viewer's eye and bring cohesiveness to the picture.

In the After picture on page 154, we've added several buildings with unique silhouettes, and positioned them using size differences following perspective rules to guide the eye from the larger buildings to the smaller ones.

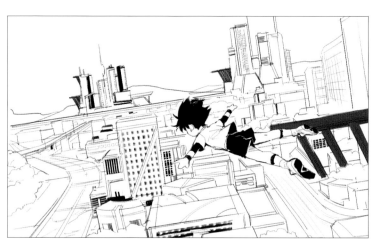

By positioning similarly shaped objects, a sense of distance is created.

You can guide the viewer's eye by how the objects are positioned.

C-Shaped Perspective

In the After example, a C-shaped perspective where the eye of the view is drawn from the front to the back by drawing a gentle view has been used. Since the landscape becomes smaller from the front the back following the flow of the lines, it becomes easier for the viewer to get a handle on the perspective.

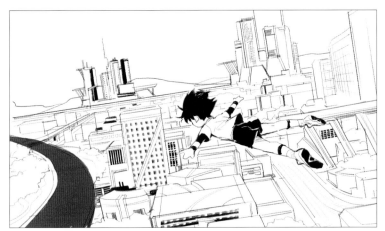

With an S-shaped composition even more perspective can be shown.

A Z-shaped (zig-zag) composition has the same effect.

The Power of the Circle

People are naturally drawn to round objects, so by just adding a C curve to the picture, you can create a soft accent in the squared and blocky building group.

In addition, a picture loses dynamism when a whole circle is included in it, so when you're including circular objects, I recommend making them jut out of the frame.

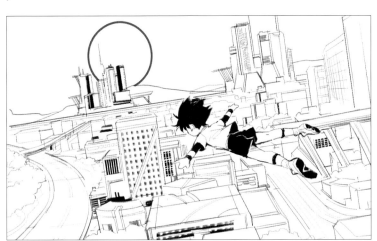

A composition where the whole circle is included gives a balanced impression.

A circular composition that juts out of the frame gives a more suggestive impression.

◆ How Views Change Depending on How They're Framed

Use Portrait Mode For a Dynamic Feeling

What happens when you use portrait mode for the picture? You sense more depth and movement than in landscape mode. Since people's eyes are positioned horizontally and side by side, their field of view is horizontally elongated too. For this reason, we find it intuitively easier to view landscape-oriented images. Portrait-mode images are well suited to showing movement and height.

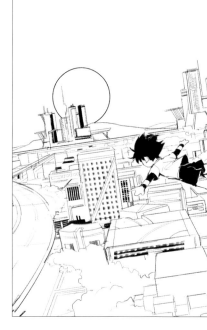

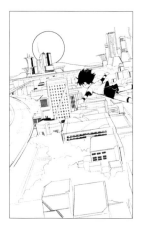

Because one's field of view is narrow vertically, in a portrait mode picture a sense of movement, incongruity and depth are strongly felt it seems.

Framing Using a Partitioning Method

When you aren't sure how to position your main character or the horizon, try to apply various partitioning methods.

Of all the various partitioning methods, the easiest to apply is the rule of thirds. The picture is divided equally into thirds vertically and horizontally, and positioning motifs at the intersections of the lines creates a sense of stability and balance.

The reason why the rule of thirds brings a sense of stability to a picture is because the ratio of the rule of thirds (1:2) is close to the golden ratio (1:1.618).

The golden ratio is a ratio that is seen often in nature. It is held to be the ratio that is sensed to be the most beautiful by the biggest majority of people.

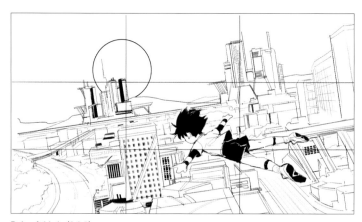

Rule of thirds (1:1:1)

Bisection method (1:1)

Vertical: Golden ratio (1:1.618), horizontal: rule of thirds (1:1:1)

Various Compositions That Show Lively Urban Landscapes

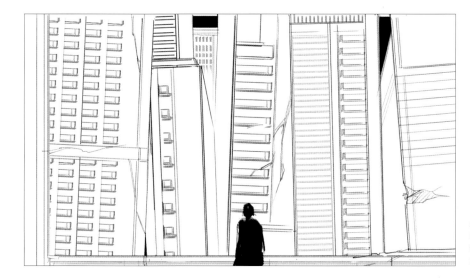

A telescopic view has been used. The depth of the forest of buildings has been compressed

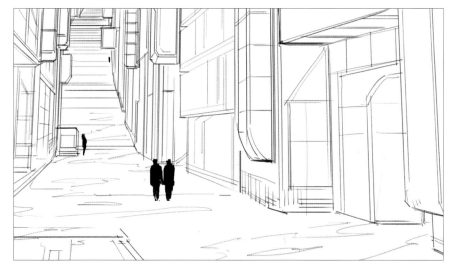

Repeated motifs are utilized to express a sense of distance and movement.

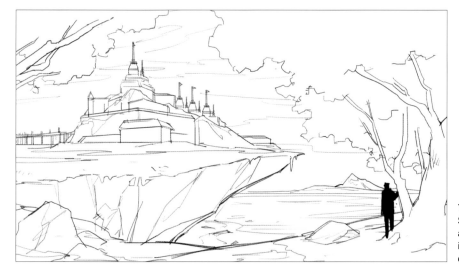

This image uses an S-shaped composition, and also divides the view into distant, middle and close-up views.

TAKE A CLOSER LOOK

Wide Angle and Telescopic/Telephoto

I'll explain how the perspective changes depending on the difference in camera lenses.
Let's start by exploring how they look different, so that you can better understand perspective.

Expert Tip

Choose the Right Lens for Your Picture
By assuming the use of a lens that fits the objective of your picture, not only will the picture become more natural, by increasing your lens options such as standard, wide angle and telescopic, the sense of variety and dynamism will be enhanced as well.

WHAT'S THE DIFFERENCE BETWEEN WIDE ANGLE AND TELESCOPIC (TELEPHOTO)?

If you're taking a photo from the same position, it has the same perspective whether you are using a wide-angle or telephoto lens. Although they may seem different at first glance, if you cut out the center of a photo that is taken with a wide-angle lens, it matches one taken with a telephoto lens.

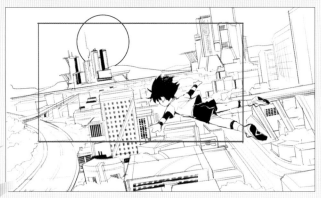

The area that can be covered differs

To take a picture with a telephoto lens without changing the position of the camera is the same as zooming in.

If it's a photo that is taken from the same position, the only thing that differs is the way it's cut off or cropped.

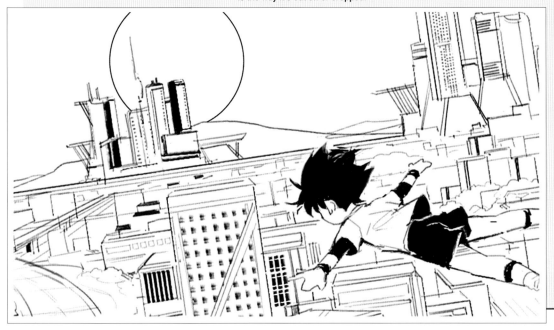

WHY WIDE ANGLE AND TELEPHOTO LOOK DIFFERENT

The only reason why there is a difference between wide angle and telephoto look different is the whether the distance between the camera and the subject is "close"or "far"—that is all.
A picture that is captured with a telephoto lens means that the camera is located far away from the subject.

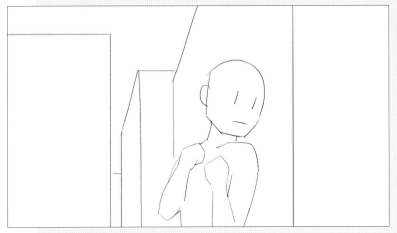

The Key to Drawing at a Wide Angle
A wide angle has the characteristic of capturing near objects over a wide range. Since the closer the object is the more the perspective's emphasized, when creating an illustration that takes advantage of the wide angle, it's similar to taking a photo at a close distance.

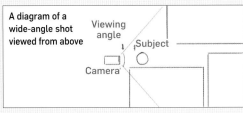

A diagram of a wide-angle shot viewed from above

Viewing angle

Subject

Camera

The distance between the camera and the subject is different

When capturing the subject at the same size, at a wide angle the distance between the camera and the subject is minimal.

The Key to Drawing a Telephoto Scene
When capturing a photo with a telephoto lens, if you try to take it at the same position as you would a wide-angle shot at the same distance from the subject, the focus will be off and it will be blurry. When drawing a telephoto (telescopic) scene, always remember that it's impossible in reality if you're not at a distance from the subject.

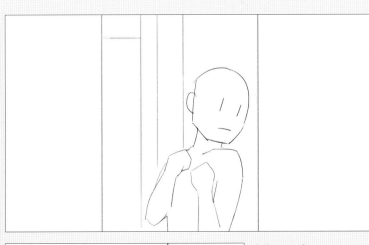

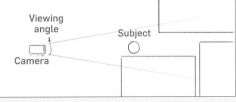

Viewing angle

Subject

Camera

A diagram of a telephoto shot viewed from above

In a telephoto shot, the camera is at a distance from the subject

MAKE USE OF THE WIDE-ANGLE LENS

Wide-angle shots are characterized by a sense of speed, presence, movement, force, breadth, depth, subjectivity and/or incongruity. They're generally used to depict movement and are well suited for use in scenes where you want to show action and impact rather than subtle emotions.

Expert Tip

Verify Telephoto Views with Your Eyes

People's eyes work in a similar way to wide-angle lenses. Even if we want to see things at a telephoto angle, our eyes don't have a zoom function. So you may wonder if it's possible to see objects with a telephoto (telescopic) view. There's actually a way to emulate a telephoto view. This is something that movie directors often do, where they make a cylinder with their hand and look through it with one eye.

Although the center of a wide-angle lens view is the same as the view captured with a telephoto lens, if you only look at the center of the field of view with one eye, that becomes the view that is captured with a telephoto lens.

Utilize Distortion

By dramatically distorting the perspective utilizing the fish-eye effect (where perspective converges in the center and the motif becomes distorted the closer it gets to the edges of the frame), a sense of strangeness and dislocation are evoked.

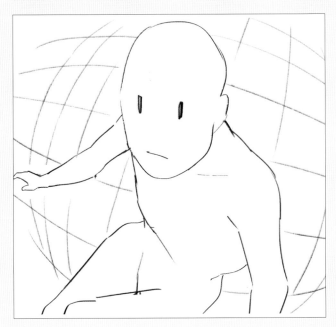

Capture a Wide Area

If you use a wide-angle lens to capture a scene, it's well suited for emphasizing size and clarifying the setting. For example, you can use it to dynamically capture landscapes or any scene that needs to be portrayed on a large scale.

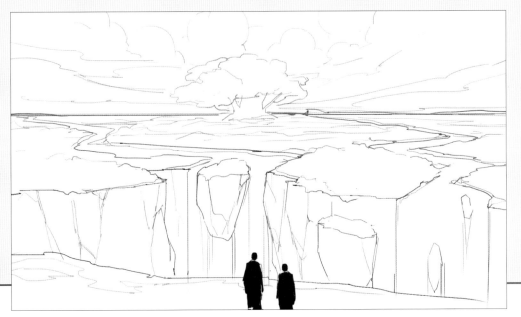

MAKE USE OF THE TELEPHOTO LENS

Telephoto shots are characterized by a sense of balance, familiarity and objectivity. They're used to express stability, order and clarity and are suited to situations where you need to explain the scenario or a dramatic situation.

Layer with Emotion

In pictorial expression, because high-impact scenery draws the viewer's attention, for a scenario where you want to engage the viewer's emotions, use a telephoto view.

When drawing a scene with a wide-angle view as in the illustration to the left, the viewer's attention is drawn more to the scenery itself rather than to the emotions of the people in it. This is because a lot of information is included in the landscape.

Highlight the Size with the Compression Effect

Since the sense of distance is weakened, you can express objects at close to their actual scale ratio. This is effective when there is a large object in the far distance, and you want to imbue it with a sense of power and definition.

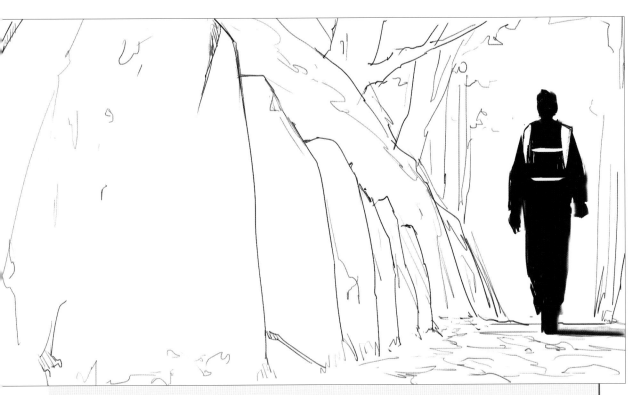

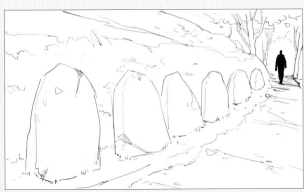

Make the Scene Cohesive with the Compression Effect

You can use the compression effect to make the motifs within the drawing cohesive too. If you match the sense of scale and put the silhouettes together, you can effectively unify several motifs.

Summary

Keep the following two points in mind:

- The closer the object, the more the perspective is emphasized
- Wide-angle shots capture a wide landscape, and telephoto (telescopic) shots only capture far-away objects

For this reason:
Since a wide-angle lens captures nearby objects too, the perspective is emphasized.
Since a telephoto lens only captures far-away objects, the perspective is compressed.

When You Want to Show a Close Relationship

Q. What Kind of Relationship Do these Characters Have?

A

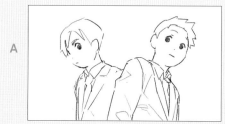

Even though the illustrations show the same two characters, doesn't A have an atmosphere as though the two trust each other more?

You can show relationships by changing the way characters are positioned.

So let's explain the key points for doing that.

B

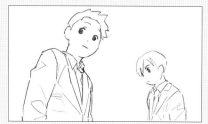

Even if the two people are far apart, you can make them look more connected by using an angle that unifies their positions or trajectories, or by overlapping the silhouettes as an indication of their relationship and proximity.

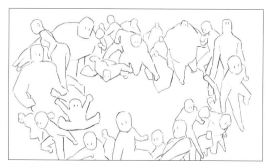

Even if there are a lot of motifs, by combining them, they become one visual unit.

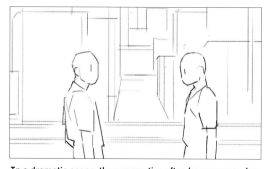

In a dramatic scene, the perspective often becomes weaker.

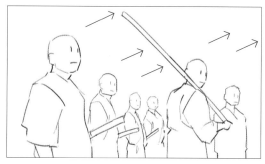

By making the people face the same direction, you can make them look like a group.

Composition Tips

Let's look at the various key points.

◆ Compress the Perspective by Using a Telephoto View Rather Than a Wide-angle View

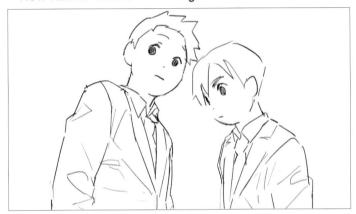

If you use a telephoto lens view the sense of distance is weakened, so objects far away look as though they are closer. Even if the objects are far away, if you change the viewing angle, you can adjust the sense of distance.

◆ Stack the Silhouettes

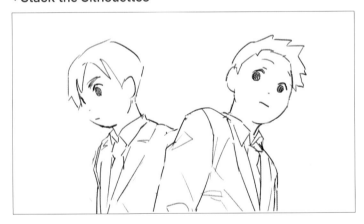

When the silhouettes of objects are stacked or overlapped, multiple motifs becomes a group and are seen as one. Not only can you achieve this effect by bringing silhouettes closer, you can also do this by adding new objects to the picture.

◆ Make the Directions or the Heights of the Lines of Sight Match

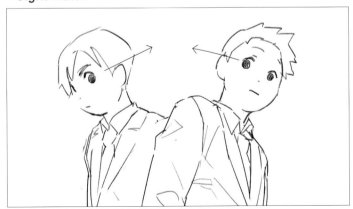

The person who is looking at another and the person who is being looked at seem as they have a relationship, so even if their silhouettes are apart you can make them look as if they in harmony.



When You Want to Show Antagonistic Relationships

Q. In Which Picture Does It Look Like the Two Have an Antagonistic Relationship?

A
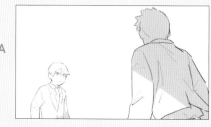

In which picture do the two characters look as if they are being antagonistic, A or B?

Although both A and B show the characters as being hostile to each other, doesn't A generate a greater sense of tension?

Let's explain the key points for showing antagonistic relationships.

B
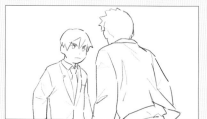

If you want to show two sides that are hostile to each other, use methods that are opposite to the ones used on the previous two pages.

Use a wide-angle view, separate the silhouettes, make the lines of sight collide as they glare at each other, and express the discord between the characters.

In addition, if you use a diagonal composition or a symmetrical composition, you can show the conflict clearly.

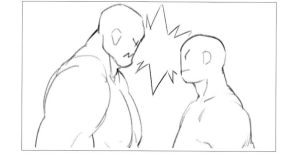

How to Show Antagonistic Relationships

Let's look at each of the key points.

◆ Separate the Silhouettes

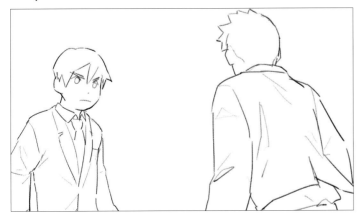

If you totally separate the silhouettes of the characters, their unifying relationship is cut off entirely, and a sense of tension is expressed by the separation. The more you separate the secondary character from the main character, the more that tension increases.

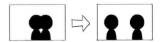

◆ Express Distance with a Wide Angle

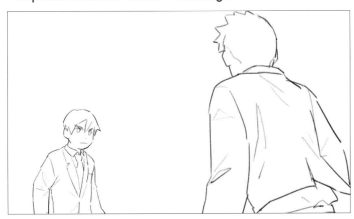

If you assume a wide-angle-lens view of your illustration, you can make the distance between two objects look bigger. Since it's easier to detect conflict between two characters that are positioned far apart, the key to showing antagonism is to position the characters visually at a distance from each other.

◆ Change the Colors, Shapes and Textures of the Motifs

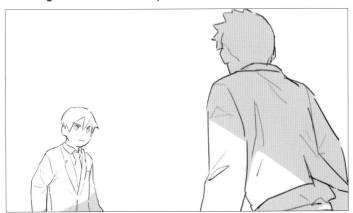

If you want to erase this sense of harmony and show conflict, differentiate the colors and shapes (silhouettes) or textures of the two to add variety to the illustration.

Showing Relationships Through Contrast

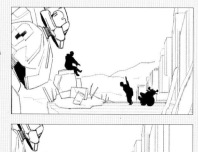
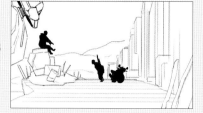

A

B

Q. What's the Relationship Between These Two?

Both A and B are the same picture framed in two different ways. What kind of relationships can you discern from the two?

In B, because the person on the right is in the center of the picture, doesn't it give the impression that they are the main character?

In A, since the two characters are positioned to the left and right of the center point, it looks as though they're in conflict.

You can show relationships just by the way a scene is framed. In this section, I'll explain the key points for showing relationships through contrast.

Opponent and ally, main character and side character, the sea and the sky, the city and the countryside: you can emphasize the characteristics of both by using contrast in your compositions. If there are two motifs that differ in terms of color, shape or brightness, you can show contrast by capturing their similarities.

If there are two motifs that share similar characteristics,

emphasize the differences. Bisectional compositions are where the picture is divided equally in halves horizontally or vertically. This type of composition is often used to contrast similar objects that are different, or to express two different worlds in each section, to heighten the contrasting nature of the two divisions. arise in your drawing.

When deciding on your composition, it may inadvertently fit into a pattern that you did not intend. When this happens, try shifting your motifs or backgrounds, changing colors, moving the position of the horizon line and adjusting things as much as you can. Composition is just one element that creates a picture, so you should not be too caught up in the details. At times, you should just forge ahead and see how you resolve it.

Contrast a large and a small triangle to express conflict.

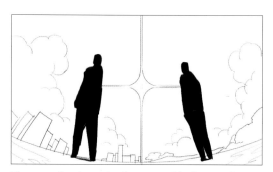

The symmetry of a contrasting composition in a popular movie poster.

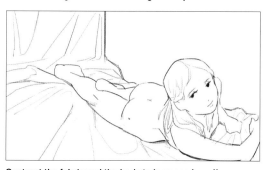

Contrast the fabric and the body to increase her allure.

How to Show Relationships

◆ Contrast Through Bisectional Composition

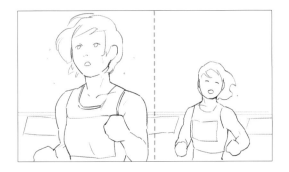

Bisectional compositions are where the picture is divided in halves horizontally or vertically. This composition is often used to contrast two similar yet disparate elements, or two show two different worlds in each section, to heighten the contrasting nature of the two divisions. The division does not always have to be in equal halves; it is possible to differentiate between the main and side character or create space by the way the picture is divided.

Showing space with a bisectional composition.

◆ Contrast Through Symmetrical Composition

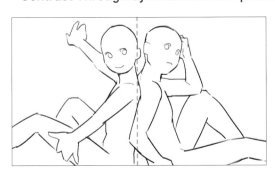

A composition that is divided into equal halves is called a symmetrical composition. Since the separation between the two divided areas becomes distinct, the contrasting effect becomes strong and the drama is increased. But if you divide your layout into a symmetrical composition without reason, the illustration will have an unnatural or an artificial feeling to it.

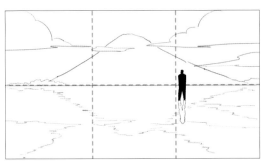

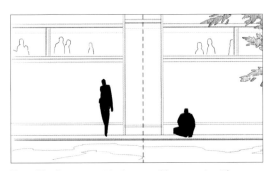

By making it a symmetrical composition, a contrast is created in the relationship between the two people.

Backgrounds that Cross the Figure

Compositions that Intersect the Neck or Eyes

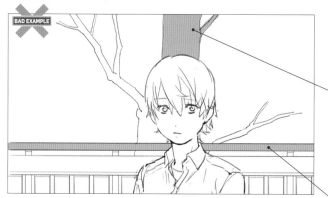

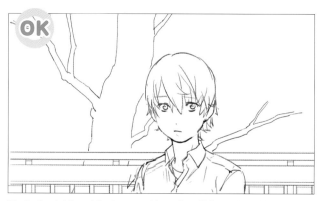

The horizontal line of the fence avoids cutting off the neck, and the vertical tree has been prevented from skewering the head by shifting it to the side.

When background lines divide the neck or head of the figure, besides looking unnatural and ominous, they prevent the viewer's eye from being directed toward the face.

◆ Skewered Composition

Arranging motifs so that there are vertical lines that look as though they are stuck into the head look awkward and should be avoided.

◆ Transept Composition

Here there's a line that seems to cut across the neck of the character. Unless it's intentionally meant to suggest dread or impending danger, avoid this imbalance.

◆ Eye-Skewering Composition

Avoid having motifs overlap a figure in profile so that it looks like they're intersecting or entering the eyes.

As you grow and develop as an illustrator, you'll notice compositional missteps right away and avoid them instinctively.

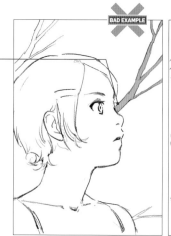

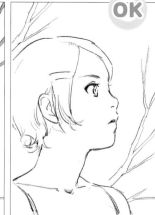

Compositions that Cut Off the Joints

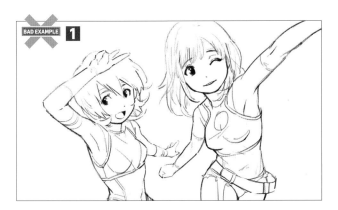

BAD EXAMPLE **1**

As with compositions that skewer, intersect or bisect the head or the neck, if you frame the picture so that it cuts off moving parts of the body, it becomes hard to understand what's going on.

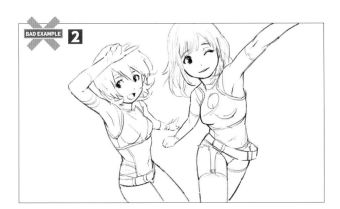

BAD EXAMPLE **2**

TAKE A CLOSER LOOK

How to Fit a Triangle in a Frame

When fitting a triangle in a frame, in the top illustration it's impossible to know how large it is, or even if it is a triangle at all.

By including two angles as in the bottom illustration, the viewer can imagine roughly where the third angle will be.

In the first bad example, the right figure is cut off around the wrists, so it looks unnatural. In the second bad example, although the wrist isn't cut off this time the knees are cut off, and the composition looks poorly placed. In the example to the right, the angle and position have been adjusted to avoid cutting off the joints, while leaving a strong impression of the characters.

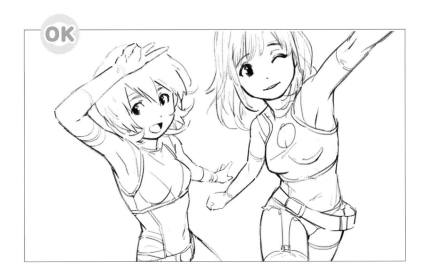

OK

Compositions that Compromise the Character's Uniqueness

This is a basic manga technique or rule: the features that make a character unique should be included as much as possible in one frame, to make that character readily and easily identifiable.

A cowlicks, a large sword, a tail, a ribbon, whatever visual identifiers define your character and set her or him apart need to be present in every frame.

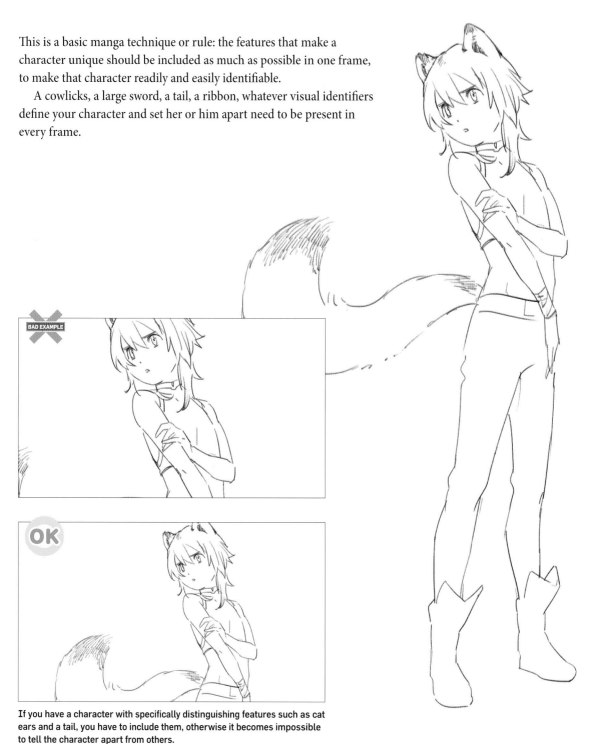

If you have a character with specifically distinguishing features such as cat ears and a tail, you have to include them, otherwise it becomes impossible to tell the character apart from others.

If you have a character whose weapons are two swords, always show both of them to emphasize his uniqueness.

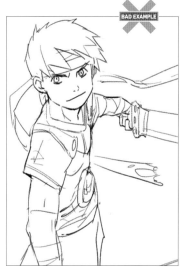

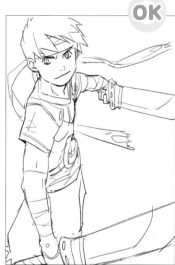

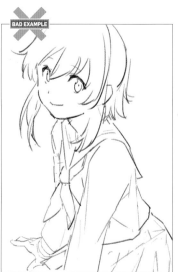

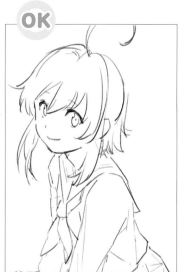

The personality of the character seems different based on whether or not the cowlick is showing. The one on the right looks like a more comical character, doesn't she?

If the heart-shaped motif on the front of the outfit isn't visible as in the left illustration, the appeal and power of the pose and the character are diminished.

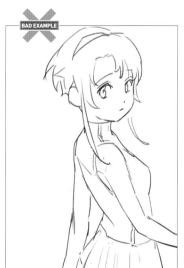

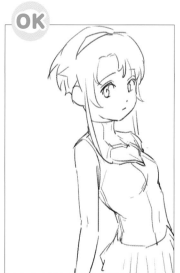

"Books to Span the East and West"

Tuttle Publishing was founded in 1832 in the small New England town of Rutland, Vermont [USA]. Our core values remain as strong today as they were then—to publish best-in-class books which bring people together one page at a time. In 1948, we established a publishing outpost in Japan—and Tuttle is now a leader in publishing English-language books about the arts, languages and cultures of Asia. The world has become a much smaller place today and Asia's economic and cultural influence has grown. Yet the need for meaningful dialogue and information about this diverse region has never been greater. Over the past seven decades, Tuttle has published thousands of books on subjects ranging from martial arts and paper crafts to language learning and literature— and our talented authors, illustrators, designers and photographers have won many prestigious awards. We welcome you to explore the wealth of information available on Asia at **www.tuttlepublishing.com.**

Published by Tuttle Publishing, an imprint of Periplus Editions (HK) Ltd.

www.tuttlepublishing.com

ILLUST KAITAI SHINSHO
© 2018 Naoto Date, Kiyoshi Nitou, Remi-Q
English translation rights arranged with Mynavi Publishing Corportion through Japan UNI Agency, Inc., Tokyo

English Translation © 2023 by Periplus Editions (HK) Ltd

ISBN 978-4-8053-1726-6

Library of Congress Cataloging-in-Publication Data in process

Distributed by

North America, Latin America & Europe
Tuttle Publishing
364 Innovation Drive
North Clarendon, VT 05759-9436 U.S.A.
Tel: 1 (802) 773-8930; Fax: 1 (802) 773-6993
info@tuttlepublishing.com; www.tuttlepublishing.com

Japan
Tuttle Publishing
Yaekari Building 3rd Floor
5-4-12 Osaki
Shinagawa-ku
Tokyo 141-0032
Tel: (81) 3 5437-0171;Fax: (81) 3 5437-0755
sales@tuttle.co.jp; www.tuttle.co.jp

Asia Pacific
Berkeley Books Pte. Ltd.
3 Kallang Sector, #04-01
Singapore 349278
Tel: (65) 67412178
Fax: (65) 67412179
inquiries@periplus.com.sg
www.tuttlepublishing.com

25 24 23 22 10 9 8 7 6 5 4 3 2 1

Printed in China 2211EP